GWENLLIAN

·GWENLLIAN·

Essays on visual culture

Peter Lord

First impression—May 1994

ISBN 1 85902 019 4

This volume is published with the support of the Welsh Arts Council.

Printed at Gomer, Press, Llandysul, Dyfed.

Contents

Page

INTRODUCTION 6

JOHN GIBSON AND HUGH HUGHES—BRITISH ATTITUDES
 AND WELSH ART 9

SALEM—A NATIONAL ICON 37

THE POPULAR ICONOGRAPHY OF THE PREACHER 43

THE MEANING OF THE NAIVE IMAGE 73

A CELTIC MUDDLE 93

THE BARD—CELTICISM AND VISUAL CULTURE 103

TWO PICTURES IN A TRADITION 129

ART AND PATRIOTISM 135

THE *GENIUS LOCI* INSULTED 141

THE BEAUTIFUL EMPTY PLACE 149

THE MYTH OF RICHARD WILSON 157

LIFE BEFORE WILSON 163

CULTURAL POLICY 168

THE BELLS OF LÜBECK 187

INTRODUCTION

In 1986, when I was a member of the Art Committee of the Arts Council, I was invited to write a paper outlining my views on the development of a policy to inform the committee's funding decisions, which I regarded as incoherent. The negative reaction of many members of the committee and of Arts Council officers to 'Cultural Policy', and in particular to my comments in it on tradition, convinced me of the need for a body of critical and historical writing which would explore the indigenous visual culture of Wales, and explore other visual cultures from a Welsh point of view. The essays in this collection are selected from those I wrote between then and 1992 in an attempt to meet that need. About half of this material was written in the Welsh language and was therefore inaccessible to monoglot English speakers.

In 1846 the painter Hugh Hughes wrote a memoir of the Methodist minister David Charles of Carmarthen to accompany an English translation of his sermons. Contrary to convention, Hughes placed the memoir after the sermons since he believed that curiosity about the man would be more likely to arise from an acquaintance with his ideas, than would curiosity about his ideas arise from an acquaintance with the man. I have followed a similar principle in this collection by placing 'Cultural Policy' towards the end of the collection in the hope that curiosity about it will have been aroused by a familiarity with the work that flowed from it. In this way it will not appear without context as it did in 1986, and as a consequence, I hope, it may be received with more understanding.

Much of my early research was an exercise in thinking aloud. I was dealing with things not previously considered worth thinking about, and in an increasing number of cases, with things not previously known about. I was trying to fit unfamiliar objects and related texts into very familiar and well explored ideas about the wider culture of this nation. At first, my choice of subjects was determined by the scarcity of the available source material rather than by a strategy devised to consider the visual culture theme by theme. The great diversity of material that emerged subsequently now requires that I should try to put the essays together in a more coherent order, rather than follow the order in which they first appeared. Together, they offer a discussion of many of the main themes of our visual culture in the period from the middle of the eighteenth century to the early twentieth century.

There is, inevitably, some repetition of material in a collection such as this, and since these essays were written in one or other of two languages for audiences with different but overlapping perceptions of Wales, there is perhaps more repetition than would be found in writing from a monolingual country. Nevertheless, on the whole, I have thought it best not to edit repetitions since much of the material is still unfamiliar. I have, however, omitted material dealing with the question of the National Museum and some specific historical areas, in particular the painter Hugh Hughes, the Eisteddfod movement, and artisan painting, as these are now dealt with in longer publications. In general, I have corrected without comment errors of detail in the original scripts revealed by more recent research, but in a few cases, where new work has cast doubt on larger assertions, I have noted changes. I have tried to include different images from those published with the individual essays in order to expand the range of available material. Essays published in *Barn* were illustrated particularly thoroughly and in colour, and reference should be made to the source publications for images mentioned but not illustrated here.

I would like to thank the many individuals who have supported my work in the face of general cynicism and occasional obstruction. Most of the research into written sources has been carried out at the National Library of Wales and I would especially like to thank all the staff there for their help and encouragement.

Poster for *The Beauties of Cambria,* including wood engraving by Hugh Hughes, 1818. The view of Caernarfon Castle is approximately two thirds of the size of the prints published in the series it advertised.

PROPOSALS FOR PUBLISHING BY SUBSCRIPTION—IN SIX PARTS : PRICE SEVEN SHILLINGS EACH :

THE BEAUTIES OF CAMBRIA;

CONSISTING OF

Sixty Views

OF

THE MOST SUBLIME AND PICTURESQUE SCENERY IN THE TWELVE COUNTIES OF THE PRINCIPALITY:

ENGRAVED ON WOOD,

FROM CORRECT DRAWINGS TAKEN ON THE SPOT.

CAERNARVON CASTLE.

THE ENGRAVINGS WILL BE *A-THIRD* LARGER THAN THE ABOVE SPECIMEN.
They will be executed in the best Style, and finely printed on Chinese Paper.
A DESCRIPTIVE PAGE OF LETTER-PRESS WILL ACCOMPANY EACH VIEW, FORMING A HANDSOME QUARTO VOLUME.

BY H. HUGHES, OF LLANDUDNO, CAERNARVONSHIRE.

DEDICATED, BY PERMISSION, TO

Sir Watkin Williams Wynn, Bart. M.P.

THE Proprietor, aware of the ardent and generous love of the Fine Arts, which is diffused among the higher ranks of his countrymen, feels encouraged in thus presenting himself to their notice and soliciting their countenance to an arduous, but he trusts a laudable, undertaking; he assures his Patrons that no pains shall be spared in the exercise of his talents; and hopes to prove, by the satisfaction his Work may afford, that the patronage of his Friends will not have been ill bestowed.

N. B. *After the completion of the Work, an advance will be made in the Price to Non-Subscribers.*

PUBLISHED BY E. WILLIAMS, BOOKSELLER TO THE PRINCE REGENT, AND THE DUKE AND DUCHESS OF YORK, STRAND; CADELL AND DAVIES, STRAND; J. MAJOR, SKINNER STREET; AND R. TRIPHOOK, OLD BOND STREET, LONDON.

Johnson, Typ.

JOHN GIBSON AND HUGH HUGHES—BRITISH ATTITUDES AND WELSH ART

In 1823 Peter Bailey Williams, vicar of Llanrug and the son of Peter Williams, the writer of the first commentary on the Bible in Welsh, wrote to Richard Jones, Gwyndaf Eryri, winner of the chair at the Caernarfon Eisteddfod of 1821:

> My income is but small: the Llanberis tythe is only fifty pounds, and less than that in some years; and I cannot do much—but there is something I want to do, that is to support, to the best of my ability, every young man, in every craft and office, who is likely to be an honour to his country. I do not judge that there is a lack of genius and talent among the Welsh, more than among the English, but that it wants education and instruction. Men who bring credit to their country (in my opinion) are Mr Wm.Jones, the Painter from Beaumaris; and Mr Hugh Hughes, from near Conway, the fine Engraver and painter; and others like them.[1]

This letter is of interest for at least three reasons. First of all it demonstrates that intellectuals of the period—people whom we now associate chiefly with literature—had wider interests, which included the visual culture. Secondly, it shows that some of these people were keen to patronise Welsh painters. We can therefore say that the national spirit was at work in Peter Bailey Williams, expressed in his desire to take pride in the artistic achievements of his compatriots. But, thirdly, the letter demonstrates that the national spirit of Peter Bailey Williams was tainted by his need to measure the condition of this country against the condition of England. He talks about Welsh people bringing credit to their country.[2] It is not difficult to work out whose praise he was keen to attract for the works of the Welsh. Peter Bailey Williams longed for the praise of the English as a child longs for the praise of its parents. But a child does not speak with its own voice until it grows sufficiently confident to live without that praise. There is a fundamental inconsistency within a national spirit which, on the one hand, insists on its distinctness, while on the other hand models its cultural aspirations on those of the nation from which it considers itself distinct.

Peter Bailey Williams was not untypical in his attitudes compared to the majority of his intellectual contemporaries. It might be argued, therefore, that

This essay was first given as the Dewi Prys Thomas Memorial Lecture at the National Eisteddfod in Llanrwst, 1989, and published by Gweled as *John Gibson a Hugh Hughes—Celf Brydeinig a Chelf Gymreig*.

[1] Myrddin Fardd, *Adgof Uwch Anghof*, p.180.

[2] The expression he uses is 'dwyn clod i'w gwlad'.

there was no way in which the national spirit could do anything but fail in visual culture, since it was split in two from the beginning. But I shall not be following the history of the efforts to create a national art to their high-tide mark at the turn of the last century in this lecture. The location of the Eisteddfod this year requires that I should discuss mainly two artists born in the Conwy Valley, and therefore I want to consider attitudes to visual culture in Wales in their period, that is the first half of the nineteenth century, and how the national spirit was expressed at that time.

The only field in which the obsession of comparison with England could be avoided, in part at least, was literature, simply because the language was different. It was not possible directly to compare technique and style between the two languages, and therefore failure as a result of comparison according to a critique developed to suit a different culture was not built into the situation. And although it was possible for bilingual Welsh people to compare content and meaning, the monoglot English were in no position to deny their conclusions, since the matters under consideration were hidden in a language which was foreign to them. The potential for damage caused by the national inferiority complex was not so great within the language wall, therefore, and it seems to me that this contributed to the tendency to elevate literature to a position that has created an extreme imbalance in our indigenous culture. This is, of course, a manifestation of a lack of confidence, and it has proved a mistake to put all the eggs in the literary basket as Welsh has shrunk to the position of a minority language.

In the middle of the eighteenth century when Wales was perceived by English intellectuals as a strange and ancient place with the customs, dress and language of the people belonging to another age, these qualities were considered attractive. On the whole, therefore, it was a positive perception. One version of it—the Welsh Arcadia—was created by Richard Wilson, under the patronage of the likes of William Vaughan, Corsygedol, Watkin Williams Wynn, and a considerable number of English people. Another image of Wales, reflecting the romantic fashions of the turn of the century, was created by Turner and his contemporaries. The Welsh gentry and intellectuals were in an ideal situation. No longer 'Poor Taff', they were people who could take pride in their ancient Welsh lineage, and be a part of the English *avant garde* in London and Rome at the same time. However, by the middle of the nineteenth century the utilitarian progressive spirit was at work amongst English intellectuals, and the virtues of Wales turned to deficiencies.

Peter Bailey Williams wrote about two painters whom he knew personally. Although Williams belonged to an older generation, all three were the products

of the late eighteenth century when antiquarian Wales and the ideas of the Enlightenment were still dominant. The two painters were in their thirties when Peter Bailey Williams wrote, moving in that strange *inter regnum* between the end of the old order which came with the French Revolution, and the Victorian age which would not begin until 1837. Their Welsh credentials were strong, but they had also begun to make a mark in England. William Jones and Hugh Hughes, therefore, combined the two qualifications that were necessary for success in the mind of Peter Bailey Williams. William Jones had gone as a pupil to the Royal Academy in 1808, and by 1820 was showing subject pictures such as *The House of Sleep—Iris entering with a message from Juno* in the exhibitions there. At the same time he was painting portraits of Welsh patrons and of poets on behalf of Welsh patrons, especially amongst the circle of Dafydd Ddu Eryri in the north.[3]

Hugh Hughes had gone to London to work for the first time in 1814 and by 1821 had made a name for himself with his first engravings for his book of views, *The Beauties of Cambria*. This was one of the most ambitious projects in the field of wood engraving—a field still regarded as unproven in the landscape context—since the masterpieces of Bewick. Hughes had confirmed his Welshness not only in his choice of subject for the book, but also by painting a number of prominent Welsh people, as we shall see. At home in Llanrug, Peter Bailey Williams did not sense that a conflict would soon arise between his antiquarian Welshness and the new direction of English culture.

A quarter of a century later, in 1848, the first substantial writing about visual culture in the Welsh language was published. The painter Evan Williams wrote a long series of articles in *Y Traethodydd* under the title *'The Art of Painting'*. He contributed more in 1857, 1865 and 1867, but in none of these extensive essays does either Hugh Hughes or William Jones rate a mention. The date of the first essay, 1848, is most significant. 'I do not remember seeing anything in the Welsh Language on the above art', remarked Williams, 'and but little on the other main arts. Why this should be I do not rightly know . . .'[4]

1848 was a year of revolutions throughout Europe, of course, and these events affected the state of mind of Welsh intellectuals as they did the minds of intellectuals in the rest of Europe. In the case of Williams it seems that the effect was to confirm a Britishness that was already deeply engrained in his character. To his way of thinking, the British state had stood apart in Europe, escaping revolutionary disorder because of its enlightened system of government. But Williams's Britishness was in sore need of confirmation since he had recently had a shock which may have given him cause to question it—the publication of the reports of the Commissioners of Education. And although

[3] David Thomas, 1759-1822. Jones's portrait of Dafydd Ddu Eryri is reproduced in colour in my 'Portreadau Cymreig—Y Daith o Eisteddfod Caerfyrddin', *Barn* 318/9, July/August, 1989. The patron was probably John Williams, Treffos, one of the organisers of the Caernarfon Eisteddfod of 1821, who was also painted by William Jones. We know that Peter Bailey Williams was personally acquainted with Hugh Hughes because the painter noted in his diary that he went for a walk with him in Dyffryn Ogwen in July 1820.

[4] Evan Williams, 'Y Celfyddyd o Arlunio', *Y Traethodydd*, 1848, p.423.

Williams only made passing reference to the Commissioners, there can be little doubt that the publication of the Blue Books provided the motivation for him to write:

> Better late than never, therefore, let us begin with some simple and straightforward lessons in that art which is not yet familiar to the Welshman in his own language. And there is no doubt that if we go forward with this as with other things, before long no other nation will stand on higher ground in these branches of profitable knowledge. In these days there are some, as we know, who try to blacken our character as a nation, accusing us of being far behind other nations in every sense; but we know that this is a great untruth, and that we are, mercifully, much elevated above our neighbours in religion and morality, if not so in general knowledge. [5]

This paragraph is a rich source for interpreting the Welsh state of mind in the period. We can perceive two fundamentally important elements in the reaction of Williams to the Blue Books. Firstly, Williams's pride as a Welsh person was severely hurt by the observations of the Commissioners about the moral condition of the nation. As Williams would become a minister with the Calvinistic Methodists this is not surprising. His pride in his Welshness was already, by 1848, bound firmly to his pride in his Nonconformist faith. As a result, Evan Williams's image of the paternalistic relationship between England and the child Wales was considerably shaken. It would no longer be possible, without the self-deceit that came to dominate the Welsh mind, to hide the fundamental inconsistency between Welshness and Britishness.

The second element in his reaction to the Blue Books was his admission that the Welsh were ignorant, an opinion consistent with that of Peter Bailey Williams, expressed without the stimulus of the Commissioner's reports, twenty five years earlier. The literary efforts of Evan Williams to enlighten his contemporaries about visual art are full of references to this ignorance, and to its connection with the language. Reviewing the Manchester art exhibition of 1857[6] he confessed that he 'felt a degree of difficulty in writing about this exhibition, at present, because of the unfamiliarity of the matters concerned to the language and literature of the Welsh... I could not feel as free and easy in talking about them in Welsh as I could in English.'[7]

This was not a denial of the value of Welsh, but an expression of the idea that it was an ancient and literary language and that visual art belonged to another world—the modern world of English. The fact of the matter is that Evan Williams was able to write perfectly adequately about visual culture in Welsh. He was manifesting a quite unreasonable sense of inferiority in his apology for

[5] ibid.

[6] Evan Williams, 'Arddangosiad Trysorau Celfyddyd', *Y Traethodydd*, 1857, p.332.

[7] This brings to mind a remark made by Maurice Kyffin over two hundred years previously, introducing a volume written in Welsh: 'Lord knows, it would be much simpler for me, and of more value to my reputation, to write such a thing in another language than Welsh.'

the language. Equally unreasonable was his assertion that there was a comparative general ignorance concerning visual art in Wales. The comparison was with England, of course, and as far as I am aware there is no evidence to suggest that ordinary English people knew any more about Praxitiles and Michaelangelo than the monoglot Welsh. I do not believe that Williams's main sources for his art history, including Vasari and Winckelmann, were normal bedtime reading in the slums of London any more than they were in the cottages of the Conwy valley.

As far as the increasing middle class in Wales is concerned, the evidence of primary sources suggests to me that a substantial number of them, people like David Charles and his circle in Carmarthen, read English newspapers and magazines and were familiar with contemporary European literature and art. They had pictures on their walls, and the recent work of Paul Joyner has shown that art teachers were available in some of the larger towns in Wales to give classes as a part of their wider genteel education. For example, Sarah Charles's scrapbook, begun in the early years of the nineteenth century, as well as containing quotations from the work of Southey, Byron and Scott, also includes quotations from Reynolds's writings on art. In my essay 'Portreadau Cymreig—Y Daith o Eisteddfod Caerfyrddin'[8] I have suggested that the perception we have of ignorance and disinterest on the part of the middle class and the intellectual community about visual culture is inconsistent with the evidence of their activities.

The unusual element in visual culture in the Welsh nation was the lack of an urban centre where intellectuals, artists and patrons were gathered together inside the country—a centre like Edinburgh in Scotland. Although Joyner has demonstrated the presence of a substantial number of artists—close to 90—in Swansea between 1750 and 1850 (the majority of them in the second half of the period) the town was in no sense a home for the mainstream of Welsh intellectual activity. The home was London, and this phenomenon is the main source of our difficulties with visual culture. It was in London that the taste of our intellectuals was formed, outside the language wall and according to contemporary English values, and their ideas filtered through to their brothers and sisters resident in Wales itself. Therefore, although it is untrue to accuse the middle class and the intellectual community of particular ignorance and indifference in these matters, the critique which was adopted by most of them—the critique on the basis of which Evan Williams wrote in *Y Traethodydd*—was entirely inappropriate for a positive assessment of the needs and products of a largely rural nation rooted in a cultural tradition different from that of England.

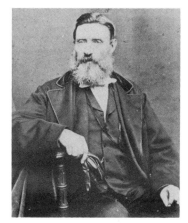

Evan Williams, by an unknown photographer, c.1870.

[8] op.cit. Sarah Charles's scrapbook is kept in the National Library of Wales, CMA 9643/4. Paul Joyner's work is available in his PhD thesis, 'A Place for a Poussin', Cambridge, 1988.

[9] Evan Williams, 'Sefyllfa Celfyddyd ym Mhrydain', *Y Traethodydd*, 1865, p.429.

[10] ibid, p.430.

[11] 'Arddangosiad Trysorau Celfyddyd', op.cit. Williams quotes Dewi Wyn: 'oll agos a llewygu'. It is instructive to compare Williams's remarks with those of Robert Owen, Eryron Gwyllt Walia, artisan painter, poet, and later minister, who was a friend of Hugh Hughes in London. In 1830 he wrote to his mother in Caernarfon: 'The country is at present in a dire state—thousands wanting bread, and many dying of starvation. But it is not Providence that has brought us into this state; it is blasphemy to say that the Providence of our creator is at present spreading destruction and desolation through the whole of Britain. No, the disarray of our governors is the cause of all, and their waste occasions the grave misfortune which presses on all the land.' G. Parry, *Cofiant a Chasgliad o Weithiau Barddonol y Parch. Robert Owen*, 1880.

According to Evan Williams's perception, art began seriously with the Greeks whose tradition was maintained in Rome. Then, until the arrival of the great Italian painters of the fifteenth and sixteenth centuries, art was dead. Williams perceived the art of the middle ages that he saw at the Manchester exhibition as 'the most awkward, raw, and immature that could be seen; with a childish look to all of it. But come to think of it, is this surprising? It was an age of childish art.' Williams extended his prejudice against the art of the middle ages to the contemporary products of the Pre-Raphaelite Brotherhood, a movement that looked back to that period as a golden age. According to Williams, 'it is a conceited and half-barbaric style . . . something like the Puseyite tendency in religion in England.'[9]

In his reference to Puseyism we come to the root of his difficulty with this art. It was connected in his Calvinistic mind with the superstitious religion of the Papists, a religion as childish as its art. Williams's religion was founded on principles that he considered rational, and so he believed in rational art as well, that is, an art founded on the Classical tradition. In retrospect it seems most irrational of him to elevate this Pagan art above the masterpieces of the religious art of the middle ages in the name of Christianity, but Williams and his contemporaries saw the tradition as a progressive development from the classical period, through the Renaissance and the work of Leonardo, Raphael and Michaelangelo, to the new Classicism that arose in the eighteenth century. By contrast, 'the style of Mr Hunt and his friend Mr Maddox Brown is totally and fundamentally astray, along with all those who follow them.'[10]

Between 1852 and 1855 Ford Maddox Brown painted *The Last of England,* a picture which commented upon the condition of the poor and of the dispossessed in the splendid Victorian age. As a comparison, we may consider the glimpse of the social attitudes of Evan Williams revealed in his comments on the arrival of Victoria and Albert at the Manchester art exhibition in 1857. Williams noted the poor of the city trying to secure places where they could see the royal party:

> Here comes the Queen; and here is a contrast. Oh what a strange world this is! These extremes between the classes in society are in large measure the result of sin, I suppose; but it is a mercy that it is not worse—that we are not all close to starvation.[11]

To be fair to Williams, I must emphasise that his view of art history largely reflected the mainstream thought of the age in England. William Roos—the most talented painter amongst Williams's contemporaries in Wales—tells more

or less the same story because he regurgitates the same sources. In 1845 Roos gave an art history lesson (in very ungrammatical Welsh) to Hugh Derfel:

> the Greeks became so perfect in the two arts that is carving and painting that they challenged nature Alexander's painter Apelles and also Phidias the carver in marble the most famous that ever were. After the death of Alexander—the arts gradually died amongst the Greeks because of civil wars; after two thousand years, she, the goddess, rose up in Michael Angelo Bunorate about the year 1450 . . . [12]

[12] UCW Bangor Ms.5709 (5).

But ten years earlier Roos had written to another friend, David Owen, Dewi Wyn o Eifion, enabling us to see that some attitudes would have changed by the time that Evan Williams was writing in mid-century. Roos had recently returned from his first visit to London:

> . . . I had my desire to see one of the great Cities of the world the next place in my sights is the Paradise of the arts that is Rome I hope to be able to see before the end of a year and a half . . . [13]

[13] NLW Ms. Cwrt Mawr 74c (38).

Rome was much less important than London to Evan Williams. To him, art history was a pyramid, with its peak in the neo-Classical English art of his own time. This change was a reflection of the growing economic and military power of England in the world in mid-century. Williams saw historical painting as central to the English tradition and he sang the praises of Maclise and others. [14] Through the medium of a combination of neo-Classical style and historical subject matter the English school constructed the image of Britain as a reincarnation of the Roman Empire. Evan Williams closed his essay on 'The Situation of Art in Britain' [15] as follows:

[14] Maclise was Irish but made his career in London.

[15] 'Sefyllfa Celfyddyd ym Mhrydain', op.cit., p.431.

> Given natural wisdom and the defence of providence in the kingdom, and the continuance of present circumstances, we are full of hope for Britain in every branch of knowledge and art, believing that she will carry out the instruction of the poet—'England is not to forget her right to teach the nations how to live.'

By 1865 therefore, Williams had put the shock of the Blue Books firmly out of his mind, and plumbed the servile depths of Anglo-philia.

In his first writings in 1848 and 1849 Williams only once mentioned Welsh artists, and that was in a footnote. He referred to the success of Penry Williams and John Gibson in Rome. At first sight the small amount of attention that he

[16] UCW Bangor, op.cit. The English patron was Joseph Mayer and the remark is quoted from NLW Ms.4915D.

[17] T. Matthews, *The Biography of John Gibson*, 1911. Subsequent Gibson quotations are from the same source unless otherwise stated.

[18] The architect may well have been Owen Jones who designed the setting for the exhibition in London of Gibson's *Tinted Venus*. Jones was the author of *The Grammer of Ornament*, and the son of Owain Myfyr, patron of William Owen Pughe and Iolo Morganwg.

paid to Gibson is surprising, even allowing for the decline in the importance of Rome by that time. In 1844, a famous English patron and collector had named him as 'the greatest sculptor in the world' and William Roos in referring to him the following year as the greatest carver of marble[16] in the world was only reflecting a widely held view. Gibson had already completed a number of commissions for Victoria and Albert in his pure classical style, as well as working for a long list of English aristocrats, and since he was also Welsh we might expect that Evan Williams would have heaped praise upon him. But Williams was a British modernist while Gibson essentially belonged to the eighteenth century, as his commitment to Rome demonstrated. He had spent only a few months in London, and that was back in 1817, and he did not return again until 1844 on a short visit. By 1848 he was severe in his criticism of the condition of English sculpture which was beginning to reflect the utilitarianism of the new age by portraying the great and the good in their contemporary clothes. According to John Gibson, 'the human figure, concealed under a frock coat and trousers, is not a fit subject for sculpture, and I would rather avoid contemplating such objects.'[17] Although Gibson's ability to transform modern Englishmen into classical heroes had met one of the requirements of the new empire, that was the appeal to Rome for historical legitimacy, it could not fulfil the other, that was to confirm the cultural superiority of the brilliant present. To him, the Golden Age was truly the age of the Greeks:

> To surpass the best works of the Greeks is a hopeless task; to approach them is a triumph to the modern artist. How few come near to them.

One of the 'most classical' London architects had said in a letter to him 'that he could not agree with my idea of masquerading John Bull as an ancient Greek.'[18] And as the modernist principles of the New Sculpture came to dominate London, so Gibson's commitment to classical principles deepened. In the end he even returned to the practice of colouring his carvings, causing a great debate amongst his admirers. The idea of the competition with the Greeks ruled his thinking. By the 1840s London meant almost nothing to him:

> As I advanced, my ambition for fame became stronger and stronger—'go to London' thought I—'no, what is local fame? If I live I will try for universal celebrity.'

Passing through London in 1817 on his way from Liverpool to Rome, nearly all of the most important English artists—eighteenth-century men such as

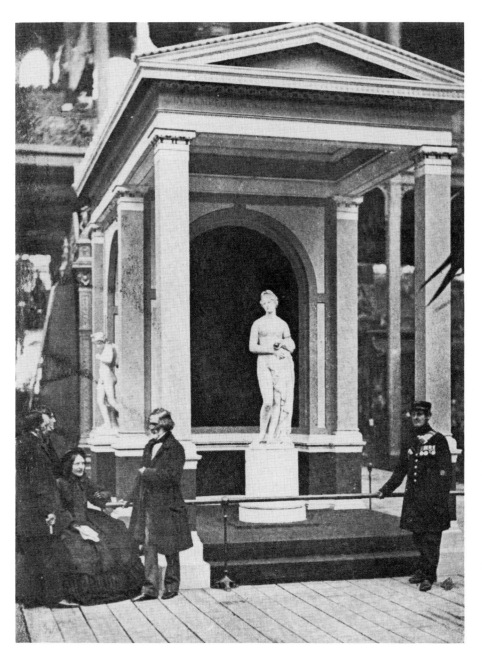

John Gibson and Mr and Mrs Preston with The Tinted Venus at the Great Exhibition in London, 1862, by an unknown photographer. Gibson visited London infrequently—in 1817, 1844, for a period from 1850, briefly in 1861 and again in 1862. The Preston's had commissioned the sculpture—'The most carefully laboured work I ever executed . . . I tinted the flesh like warm ivory scarcely red, the eyes blue, the hair blonde, and the net which contains the hair golden.' The setting for the sculpture was designed by Owen Jones, son of Owain Myfyr.

Hera and Hypnos, ink drawing by John Gibson, c.1810-17. Hera was both sister and wife of Zeus and the queen of the Greek's heaven, worshipped as the goddess of power and riches.

[19] Lady Eastlake, *The Life of John Gibson*, 1870, p.231.

[20] ibid., p.10.

Nollekens and Flaxman—had been of the same opinion. The only one who gave him contradictory advice was Francis Chantrey. The next time they met was in Rome, where Gibson was a student of Canova. 'How long have you been here?' asked Chantrey. 'Three years', replied Gibson. 'Three years is enough to spoil you or any other artist', was Chantrey's response. In his autobiography Gibson added just one sentence to the end of this story: 'Chantrey was a man of no genius', he remarked.

At the national level Gibson's personal sense of identity was confused. In Rome he lived within a community of ex-patriates. He referred to himself sometimes as English, sometimes as Welsh. The Duke of Wellington visited him in Rome, to discover that Gibson had not followed his instructions concerning a commission he had been given:

> 'You have not followed my own idea,' observed the Duke. 'No,' responded Gibson, 'I have treated the subject according to my own idea.' 'You are very stubborn!' said the irritated Wellington. 'Duke,' said Gibson, 'I am a Welshman, and all the world knows that we are a stubborn race.'

Gibson worked his whole life largely unconscious of the political implications of the idea of nation that was gaining ground throughout Europe. He was out of touch with the age which saw the development of modern nationalism, despite his living in one of its geographical foci. However acute his observation of the tangible world which was the foundation, once purified and perfected, of his art, he was ultimately an other-worldly character—and despite the Classicism of his style, he escaped into a world of romantic ideas about art which set the Muse above all else. His pupil Hariet Hosmer was of a rather different turn of mind. According to this worldly American, 'He is a God in his studio, but God help him when he is out of it.'[19]

According to most of those who knew him, the innocence to which Hosmer alluded was not simply an affectation, and the numerous statements about art which fill his letters are free of the self-conscious excess which undermines the observations of many Romantics. This example is dated 1842:

> In my art, what do I feel? What do I encounter?—happiness: love which does not depress me, difficulties which I do not fear, resolutions which never abate, flights which carry me above the crowd, ambition which tramples no one down.[20]

Life was an aesthetic experience for John Gibson. But in 1848 and 1849, there was no way even for him to ignore totally a less agreeable reality as

first the Republicans and then the French battled for control of Rome. Welsh radicals were excited by Garibaldi, and Hugh Hughes amongst them, but all we have from Gibson, who was an eye-witness to the revolution, is descriptions of little incidents on the streets and notes of the colours of the flags. His confidante, Lady Eastlake, made the best of the political blindness of Gibson: 'If he has no pretentions to be considered as a political oracle, he at any rate records events and registers impressions indicative of the spirit of the time', she remarked, rather apologetically.[21]

[21] ibid., p.135.

Gibson was far too far away from Wales, both physically and spiritually, to react to the reports of the Education Commissioners that had shaken his fellow countrymen and women so deeply, of course. Even if he had been in close touch with the country in 1847, he would not have reacted as an artist to the situation, because in his opinion, art had no role to play in these matters. According to John Gibson, 'The muses are said to be silent amidst the clash of arms':

> When the French army was 4 miles from our walls, I ran away and left my companion to his fate, as well as all my statues to take their chance.

Hugh Hughes saw things differently. The Blue Books were to him a call to arms. By 1847 public campaigning was something with which he was very familiar. He went into battle against the Commissioners as an artist, producing his series of cartoons, *Pictures for the Million of Wales*. While Gibson eyed the activism of his age from a safe distance, Hugh Hughes participated directly in the political process, believing by then that the condition of people on this earth was in their own hands. It would be hard to imagine two more different attitudes to the world and to the visual image. Yet Gibson and Hughes were born within a few miles, and four months of each other, at the head of the Conwy valley, in 1790.

John Gibson was born in the parish of Gyffin, on the west side of the Conwy, and Hugh Hughes was born on the other side, in a farmhouse called Pwll-y-Gwichiaid which stood under the cliffs of the Great Orme in Llandudno. The two spent some of the years of their childhood in even closer proximity. In 1790, the sculptor's father, William Gibson, was baptised by John Evans, a Baptist minister, in Ffordd Las, Glan Conwy, and it seems that the family moved there to live in the chapel house between 1792 and 1795. Hugh Hughes was brought up amongst the first Calvinistic Methodists in the area. Hugh Williams, his grandfather on his mother's side, was very active in the cause, and Hugh Hughes spent some time in his home, Meddiant, Glan Conwy, where he

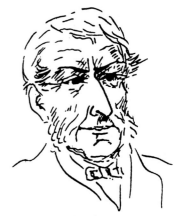

Hugh Hughes, ink drawing by William Morgan Williams, ab Caledfryn, 1894. The drawing, made over thirty years after Hughes's death, is from a letter about the artist written by ab Caledfryn to T.H. Thomas.

19

kept a Sunday school. There he learnt to read with his grandfather, and by the time he was twelve years old, he too was keeping a Sunday school in the barn at Pwll-y-Gwichiaid. But it was Meddiant that Hughes would come to consider as his family home, and there that he would engrave the blocks for *The Beauties of Cambria*.

These were years of economic depression brought on by the war, and the families of both Gibson and Hughes joined the thousands who migrated to Liverpool in search of work. The intention of Gibson's parents was to sail from Liverpool to America, but according to the mythology that John Gibson was fond of creating around his life-story, his mother decided not to go after dreaming of a disaster at sea. Whether the story was true or not, it underlines the fact that Jane Gibson was a strong influence on her son. 'My mother was an excellent woman', he remarked, 'passionate and strong minded; she ruled my father always and continued to govern us all as long as she lived.' It was from her that Gibson received his early encouragement to draw.

Having arrived in Liverpool the family came into contact with Daniel Jones, son of Robert Jones, Rhoslan, and as a result they attended the Calvinistic Methodist chapel at Pall Mall, where John Gibson went to the Sunday school. Three years later, in 1802, Hugh Hughes's family also arrived in Liverpool, although without his mother who had died earlier that year. They too attended Pall Mall, and it is hard to imagine that the two adolescents did not know each other at that time, even if they had not met before.

In this period, before the Irish arrived in Liverpool, the Welsh were on the bottom of the social ladder, living in a substantially monoglot ghetto. At fourteen years of age the two young men took their first steps upward through becoming apprentices. Gibson already wanted to paint, but his family could not afford the premium demanded by portrait painters for taking a pupil. He therefore went to a cabinet maker. Nothing is known for certain of Hughes's apprenticeship, except that when he finished it he could engrave on wood and copper. The little evidence that survives suggests that he was apprenticed in the working-class environment of a printing office, rather than to a well known engraver such as Bewick's pupil Henry Hole, who worked in the city. Another youth from the Conwy valley, John Jones of Llansanffraid, went as an apprentice in Liverpool to the printer Joseph Nevett at the same time as Hughes and Gibson. Nevett was an early printer of Welsh-language material in the city. As we shall see, Hughes knew John Jones and my suspicion is that he was trained in a similar office, if not with Nevett himself, or with an ordinary engraver producing wood blocks for jobbing printers.

There is no mystery about Gibson's training. He tired of woodwork and

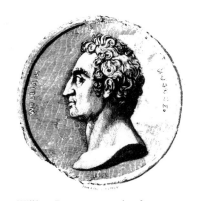

William Roscoe, engraving from a medallion by John Gibson, c.1810-17.

succeeded in changing his master to Franceys, the marble mason, a move which proved fateful for him:

> One day there came a tall, magnificent old gentleman, his hair was white as snow, aquiline nose, thick brows, benevolent in manner. This was William Roscoe.

This was the starting point of Gibson's art career. Roscoe was a Unitarian, a classicist and a rich patron of the arts, and he interested himself in Gibson as he would interest himself in a rather different young Welsh person—Dic Aberdaron—later on.[22] Roscoe was doubtless aware of the history of numerous painters and sculptors who having started life in poverty had achieved great stature under the patronage of gentlemen such as himself. This was the age of the prodigy, and Gibson fulfilled admirably the expectations of the role created for him. He was taken to Allerton Hall, his patron's home, to study his collection of prints, casts, and classical drawings, and he was introduced into fashionable society. He studied anatomy and drawing and by 1812 the classical character of his art and his ambition to work in Rome were fully formed. The guidelines set down for his philosophy in Liverpool would never change.

It is not clear whether the public success of Gibson encouraged Hughes, but by 1812 he too was painting. He had the opportunity to study the work of his contemporaries, as well as the work of some of the most prominent London artists, in the exhibitions of the Academy in Liverpool from 1810 on. But his work would take an entirely different direction. While Gibson experimented with classical themes, and some historical subjects such as *The Death of Nelson*, Hughes's subjects were the contemporary leaders of the world on which the sculptor had turned his back, that is, the world of Welsh Nonconformism.

Hughes had been much excited by the events of 1811, the year of the ordination of the first Methodist ministers at Bala. He had been present there, and was probably aware of the political implications of that act of rejection of the Church of England. In a period of wars, the ordination was taken as an act of disloyalty by English conservatives and Welsh church people. According to the leaders, it was nothing of the sort, but no matter how energetically Thomas Charles and Thomas Jones protested their loyalty they had recognised through their actions that, at the very least, the situation of Wales was different from that of England. Between 1811 and 1814 Hughes took the portraits of at least six prominant figures in the movement,[23] that is, Thomas Charles, Thomas Jones, John Roberts, John Elias, John Evans and Robert Dafydd, and it is hard to believe that he was not aware of the national significance of the sitters as a

[22] Richard Robert Jones, Dic Aberdaron, 1780-1843, self taught linguist and tramp. Roscoe wrote *A Memoir of Richard Robert Jones of Aberdaron*, London, 1822, which included an engraving by Clements.

[23] This list has now been extended to fourteen.

John Gibson, pencil drawing by
Joseph Severn, 1828. Severn was born
about 1795 and like Gibson went to
Rome as a young man, from where he
exhibited at the Royal Academy. He
died in 1879.

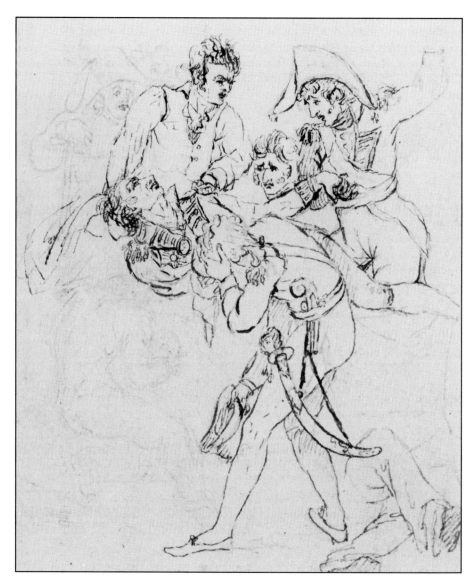

The Death of Nelson, ink drawing by
John Gibson, c.1810-17. Nelson's
death at Trafalgar in 1805 inspired a
flood of English patriotic imagery,
mostly neo-classical in style.

group. These pictures are not to be considered as isolated portraits of prominent Welsh people. The circumstances of the sitters at that time and what we know of the painter's subsequent history entitle us to consider these pictures as a series—the first series of national Welsh portraits.

The art of Hugh Hughes was from the beginning an expression of the confused and complicated experience of the Welsh in Britain, therefore. The national implications of Welsh Nonconformism which were suggested by him in the portraits of the Methodist Fathers were totally irrelevant to John Gibson's way of thinking. These are the same implications that Evan Williams would perceive later on and smother. They were expressed in Hughes's work by an artist brought up in the craft tradition of printing, and by a man who believed with passion in self-improvement through education and personal effort, outside educational establishments. These two elements would also set the man outside the framework of academic art for the most part, and therefore beyond the notice of critics and academic British historians as well. Following the success of *The Beauties of Cambria*, by 1823 the door was open for him to go on in the increasingly fashionable field of wood engraving in London, making a career for himself reproducing the works of prominent English painters,[24] and developing a portrait practice at the same time. But ultimately Hugh Hughes chose to work amongst his own people because art was to him a medium, not an end in itself. His activity as an artist had to take its place as part of a wider vision, and that vision, however confused it might have been, was concerned with the condition of Wales.

As we have seen, its first expression came in terms of Nonconformism. Then, when for a time Hughes moved in the circle of the Anglican literati in Wales, receiving in particular the patronage of John Jenkins, Ifor Ceri,[25] it manifested itself in terms of antiquarianism. Lastly, from the 1830s onward, it manifested itself increasingly in Radicalism and Modernism. During this development Hugh Hughes became estranged from the church in which he had been brought up, the church whose Calvinism was reshaped by John Elias. Through the observations of Evan Williams on the condition of the poor we glimpsed this Calvinism at work. In the years 1828-32 Hughes attempted to build a philosophy which would reconcile the Calvinism of his youth with a fact—that became increasingly clear to him later on—that the sad condition of his fellow man was not a punishment for sin.[26] Neither was it to be understood in terms of the argument that the apparatus of government was set in place at the command of God and that it was, therefore, the duty of man to obey the established order whatever the consequences. By 1830, Hugh Hughes believed that the greatest gift of God to man was the freedom of the individual to follow his or her own

[24] He engraved for John Glover in 1826, for instance, and also for David Cox in 1827, although Cox was not, at that time, the celebrated party he would later become.

[25] This commission is discussed in detail and illustrated in colour in my 'Portreadau Cymreig . . .', op.cit.

[26] Hughes published his opinions in 'Rhagluniaeth yn Gyffredinol', *Seren Gomer*, 1830, p.161, and 'Rhyddid, Cymdeithas a Llywodraeth', *Seren Gomer*, 1831, p.289.

Brynllys Castle, wood engraving by
Hugh Hughes, 1822. From *The
Beauties of Cambria*, 1819-23.

conscience, whether or not that was in conflict with the prevailing order. The
visual image, along with the word through the printing press, was a weapon to
be used in the fight against oppression. Hughes went on his own way, taking up
ideas which often seem eccentric. But along that way, he left behind him works
in which there is a core of a kind of national sentiment manifested half a
century before its time. We will consider a few graphic works which illustrate
his attitude towards art and towards Wales.

In 1822 Hughes drew one of the small number of historical illustrations which
had been produced up to that time. He had probably been in contact with the
printer John Jones of Trefriw, later Llanrwst, for many years, but by the 1820s,
as we have seen, he had established a reputation as a highly skilled wood
engraver. John Jones had decided to reprint *Drych y Prif Oesoedd*[27] and
Hughes produced a frontispiece for it. The chosen subject, the treachery of *The
Night of the Long Knives,* lay deep in the national psyche. We should
differentiate clearly between the choice of this subject and the Celticism which
had occasioned other artists, including Thomas Jones, Pencerrig, in 1774, and
William Jones, as late as 1819, to illustrate the subject of *The Bard*. These
pictures arose from a different aspiration and were produced for a different

[27] Literally, *The Mirror of the Great
Ages*. Theophilus Evans's classic
account of the origins and history of
the Welsh was first published in 1716.

24

audience—both were displayed at the Royal Academy. Hughes's print was a piece of popular art, produced for the market that would be central to him throughout his career, the ordinary literate Welsh person.

The very small number of references to art in the hundreds of thousands of words that Hughes wrote in pamphlets, articles and letters, is in itself characteristic of his practical attitude towards it. John Gibson could hardly talk about anything else. But in another pioneering venture, *Yr Addysgydd,*[28] the first original work in Welsh for children to include pictures, Hughes made a small but revealing comment. It is unclear whether Hughes felt the need to justify his venture as a result of criticism by someone who associated the pictures with popular ballad sheets and therefore considered them inappropriate for a religious publication or as a result of his own uncertainty:

> There are three aims in view in publishing pictures in the *Addysgydd.*
> 1. Everybody's entertainment. 2. An aid for some to understand and consider the point of the subject, and its circumstances. 3. Having an occasion to display the remarkable things spoken of in the scriptures.
> It is expected that the present picture[29] will answer three requirements.
> 1. It will be an adornment to the pamphlet in the eyes of all who see it; 2. It will stimulate the desire to read Acts, 3, in order to understand it, 3. Everyone of those who does so will be more knowledgable as a result.

[28] Literally, *The Educator*. It was published in monthly issues in 1823 by John Evans of Carmarthen.

[29] *The Healing of the Lame Man by Peter*, published in the November issue, 1823. The picture is most unusual in depicting an event in the New Testament, which may be why Hughes felt the need to add the justification.

Brad y Cyllyll Hirion (The Night of the Long Knives), wood engraving by Hugh Hughes, 1822. Frontispiece to the edition of *Drych y Prif Oesoedd* published by John Jones, Trefriw.

25

As Hugh Hughes painted the portrait of W.J.Rees in 1826, his last patron among the old Anglican *avant garde*, William Owen Pughe paid him a visit. Hughes would portray Pughe at least three times during the next five years, and the two became friends. The decoration in the title page of Pughes's dictionary[30] is the work of Hugh Hughes. The Cymmrodorion commissioned the first of the portraits—the 'Royal Cambrian Institution' mentioned in the following report published in the *Cambrian Quarterly Magazine* in 1830:

> We are enabled to state that a new institution under the title of the Cambro British Picture Gallery will in a few months be open for the inspection of the public in London. It has long been regretted that Welshmen of eminence often sink into the grave without any memorial remaining to inform strangers and posterity of the form of their features; and any steps likely to remedy this defect, as far as circumstances will allow, will be valued by all who are interested in the affairs of Wales. A committee of Gentlemen attatched to the Royal Cambrian Institution will undertake the management of the plan, and fix upon the individuals whose portraits shall be deemed of sufficient public interest to occupy a place in the gallery. Excellent likenesses of several literary men connected with Wales have already been painted by the individual with whom the suggestion originated. The gentleman alluded to is Mr H Hughes, . . . a native of Wales, who has, with a liberality which does him honour, proposed to paint, in his best style, the portraits of persons introduced to his notice by the committee.

In fact, there was little common ground between Hughes and the friends of Pughe amongst the gentry and the conservatives who associated themselves with the Cymmrodorion. Hughes found his spiritual home in the Cymreigyddion Society, the only one of the societies to have a Welsh-language rule, and the home of the radicals of the revolutionary period such as Jac Glan y Gors. The rooms of the Cymreigyddion in a variety of inns became home to a small group of portraits that could have formed the core of the national portrait gallery suggested by Hughes. One of them was of Thomas Roberts, Llwyn'rhudol, who was still active in the society that he had helped to found. He was a strong influence on Hughes and confirmed the artist's incipient disike of the established church and the gentry. When considering Hughes's political cartoons we should, therefore, remember that one of the first political cartoons to appear in a Welsh language publication was the frontispiece piece to Llwyn'rhudol's *Cwyn yn erbyn Gorthrymder* of 1798.[31]

In 1830 the first monthly issue of *Y Cymro* was published, a magazine produced mainly by members of the Cymreigyddion Society. By that time the

[30] William Owen Pughe, *A Dictionary of the Welsh Language* . . . , Denbigh, 1832. The decoration shows a cromlech. The frontis has a portrait of Pughe by Hughes's friend Thomas George. Both are illustrated in my 'Portreadau Cymreig . . .', op.cit.

[31] Literally, *A Complaint against Oppression*. The pamphlet was against the established church. Llwyn'rhudol was probably a Quaker, or certainly very strongly influenced by the movement.

Peter Healing the Lame Man, wood engraving by Hugh Hughes, 1823. Illustration from *Yr Addysgydd*, published by John Evans, Carmarthen.

Cwyn yn erbyn Gorthrymder (A Complaint against Oppression) by an unknown caricaturist, 1798. The frontispiece to the pamphlet written against the established church by Thomas Roberts, Llwyn'rhudol.

27

idea of a free Welsh-language press filled Hugh Hughes's mind. As well as a medium for change and improvement by spreading information amongst ordinary people, it was also a powerful symbol of personal freedom in its own right. Hughes was much involved with *Y Cymro* as a writer and illustrator from its inception. In his engraving for the frontispiece he expressed his concept of the new *Cymro*—the new Welshman—in both senses of the word.

Here we could hardly be further from *Narcissus* and *Flora,* John Gibsons's latest sculptures, produced in 1829 and 1830. While Gibson was looking back over his shoulder two thousand years to Greek mythology, Hughes looked forward to a new Wales, egalitarian and modern. As his picture made clear, the new Wales would be proud of its ancient indigenous tradition, but by the efforts of the 'plain' Welsh people referred to in the explanation published on the same page, it would renew itself on scientific and industrial principles. The key to the enlightened future would be knowledge, a word repeated like a mantra by Hughes and his colleagues. The medium and symbol of knowledge was the pen, the focus of this didactic picture. [32]

There is no direct evidence to suggest why Hugh Hughes chose to leave the artistic, literary and political world of the Welsh intellectuals in London in order to return to Wales to live in 1832. However, from this period comes one of the few portraits he made that is not directly related to Wales. His double portrait of the Lords Russell and Holland is indicative of his concerns at the time. It was Russell who steered the Reform Bill through parliament raising the hopes of radicals like Hughes for democracy and freedom to new heights. [33] The dawn of the new age would be a promising moment for Hughes to attempt to renew his nation from the inside as an artist and a writer, according to the principles he had worked out in such detail over the previous three years. By 1834 he was in Caernarfon and for a decade invested his extraordinary energy, in the company of other radicals such as William Williams, Caledfryn, in an attempt to create the kind of capital city life that was absent from the country, and that would be necessary to reform the nation. But 1832 was a false dawn and Hughes was disappointed and became disillusioned. In 1842 he was working in Liverpool where he painted his friends John Jones and Mary Ann Roberts, his wife. This John Jones was the boy who had gone from Llansainffraid to Liverpool as an apprentice at about the same time as Hughes. By now he was the owner of Nevett's printing office, and a few months after the painting of the portraits, John Jones launched *Yr Amserau*, the newspaper that would succeed in establishing a weekly Welsh-language press where Hughes's own attempt at

[32] It has subsequently become apparent that Hughes was one of the editors of *Y Cymro*. It is difficult to perceive the magazine today as it was perceived in the 1830s, but the comments of a churchman from Bala called Thomas give some indication of contemporary attitudes: 'I am glad to tell you that the Cymro, that revolutionary Welsh periodical, is dead, and peace, I say, be to his memory. It would be no loss if the Seren were to get to rise no more and if a few more of the same tendency were to share the same fate—we should then have the Principality more peaceable and less disposed to revolution . . .' UCW Bangor Ms.Amlwch 4.

[33] But the picture was occasioned by their Lordships' support for the emancipation of Catholics in 1828. Hughes dedicated it to the 'Friends of Religious Freedom'.

Y Cymro Newydd (the New Welshman), wood engraving by Hugh Hughes, 1830. Prepared for the first number of the radical periodical *Y Cymro* and subsequently used as a logo.

the same thing, *Y Papyr Newydd Cymraeg,* had failed in 1837. It is difficult to believe that Hughes did not have an influence on encouraging John Jones to begin the venture. In 1847 he drew a portrait of Gwilym Hiraethog, the young man whose writing gave direction to the paper. We see that Hughes, who was by this time nearly sixty, was now moving amongst the generation of intellectuals who would lead Welsh public life in the second half of the century. In 1848, as Gibson was running away from the French in Rome, and Evan Williams was writing his first piece for *Y Traethodydd,* Hugh Hughes drew his cartoons against the Commissioners of Education, his last pioneering venture— a venture which confirmed the effectiveness of the activist role that Hughes saw for the artist in the community.

It was R.J. Derfel who coined the term *'Brad y Llyfrau Gleision*—The Treachery of the Blue Books'—to describe the Commissioners' report, playing

The Friends of Religious Freedom—Lord Holland and Lord Russell, by Hugh Hughes, mezzotint, c. 1828-31.

30

on the nation's memory of that other treachery portrayed by Hughes in 1822 in his drawing of *The Night of the Long Knives*. However, R.J. Derfel's drama did not appear until 1854, first published in parts in *Yr Amserau*, until the contents put the editor in fear of a libel suit, and he refused to publish more. We should note how closely the drama follows the scheme of the cartoons of Hugh Hughes. The three commissioners are portrayed as asses, the same symbol of stupidity used by Hughes over five years earlier. In the play, John Griffiths, one of the villains of the piece in almost everyone's eyes because of the objectionable evidence he gave, is characterised as the Wolf of Aberdare. He had been portrayed by Hughes in the same guise, caught in a cage and jabbed with a huge quill pen, Hughes's favourite symbol.[34] The second act of the drama follows the cartoons closely. We have Beelzebub plotting, the three spies meeting in Builth Wells, a scene in a Sunday School, and the taking of evidence in a vicarage. In the cartoons also we see Lord Russell, fallen from his previous grace in Hughes's eyes, as a sort of Beelzebub in the hell of the Privy Council, the three spies receiving their instructions, Symons in the Sunday School, and the vicar libelling the people of Wales in the manse. The written language of the cartoons was also as plain as that of R.J. Derfel:

> Commissioner: Have the goodness to give me such an account of the morals and manners of the Welsh as I require for their Lordships.
> Parson: All the women of Wales are prostitutes when they have opportunities—and of opportunities they have enough in their prayer meetings. The men and the women are drunken, when they can afford it, and in order to afford it, they are continually lying, and cheating, and thieving.
> Commissioner: I thank you, Rev.Sir, that's exactly what I want . . .

In the third act, we see Beeelzebub suffering the counter-attack of the Welsh people, symbolised by Hugh Hughes as Jane Williams, the historian, whipping the commissioners with her birch Artegall—the pen once more victorious over ignorance and prejudice.[35]

A well known historian asked me recently if there was enough material to justify the study of Welsh visual art. I had two aims in view in the preparation of this lecture. The first was, as I said at the start, to convey to you some sense of the attitudes of Welsh people towards visual culture in the first half of the last century. The second aim was wider, prompted by the doubts of that historian. I wanted to demonstrate to you that the field of study I have called Welsh Visual Culture is both a practical and a significant one. There is a strong connection between these two points, of course, since it is the idea that the

[34] The pen is wielded by Evan Jones, Ieuan Gwynedd, 1820-52, editor of *The Principality*, from whose office in Cardiff the cartoons were published.

[35] Jane Williams, *Artegall; or Remarks on the Reports of the Commissioners of Inquiry into the State of Education in Wales*, Llandovery and London, 1848. Jane Williams, Ysgafell, 1806-85, was a close friend of Augusta Hall, Lady Llanofer. Artegall is the Knight of Justice in Arthurian legend.

31

Gathercoal Scuttleworth's Final Charge to the Spies, lithograph by Hugh Hughes, c.1848. One of the series of cartoons against the Blue Books, *Pictures for the Million of Wales.*

Welsh people have neither attitudes towards visual culture nor a body of works, that has led to the belief that the field is not practical. This is to found history—and as a result, to form contemporary ideas about the nature of our culture—on prejudice and ignorance. It is clear to me that the problem is deeply rooted in the nature of this nation's relationship with the English.

In considering John Gibson and Hugh Hughes we saw how, in their very different ways, the consciousness of our artists was affected by the British concepts that came to dominate the minds of the majority of Welsh people in the nineteenth century. In considering Evan Williams as a critic and historian, we saw that adopting an English critique not only implicitly denied the existence of Welsh art but also the potential for the consideration of art from a Welsh point of view. This second point is vitally important. A confident culture, by adopting an appropriate critique for the positive consideration of its own product, is also in a position to consider art in general, and works belonging to other cultures, from its own point of view, thereby enriching rather than drowning the indigenous culture. We saw, for instance, how Hugh Hughes was ignored by Evan Williams because his activities were not aimed at ends defined as significant by a neo-Classical English critique. In the book *A Treatise on Wood Engraving* [36] we find another example of this phenomenon, connected with the same artist. The edition which I will quote was published in 1861, while Hughes was still alive and painting:

[36] Chatto and Jackson, *Treatise on Wood Engraving*, 1861. This was the standard work on the subject in the nineteenth century.

32

. . . . Hugh Hughes, of whom scarcely anything is now known, executed a whole volume of beautiful wood engravings, entitled *The Beauties of Cambria* . . . The annexed four examples will give an idea of the high finish and perfection of this elegant series.

It is clear that the meaning of being unknown to the English is having turned one's back on London in order to work in Wales. The tragedy is that it is not only the English who exhibit this mentality, but those who work in the visual culture in Wales itself to this day. Despite their physical presence in Wales, and the commitment that some of them might claim to the nation, they follow, almost without exception, an English critique and every ephemeral fashion that arises there. They are unwilling or unable to work towards a critique which is appropriate to our own particular circumstances. Our institutions are still back in 1848, with Evan Williams.

We have an Arts Council which is a sub-committee of the Arts Council of Great Britain and which rejected the recommendation I made in my paper *Cultural Policy* in 1986 that they should campaign for independent status and funding through the Welsh Office.[37] We have no art schools which include a course in Welsh studies, not to mention a course through the medium of Welsh, something proposed by R.J. Derfel back in 1864.[38] We have a network of public galleries scarcely one of which is administered by a Welsh person. We have a visual art department in our University which did not have the vision, fifteen years ago, to establish an arts administration course—the sort of course that was springing up everywhere else—that could have trained Welsh and Welsh-speaking administrators to fill these jobs.

We have two national public collections of artworks, without a clear definition of the relationship between them. Despite its undoubted commitment to the indigenous culture, until recently the National Library had only the most primitive notion of the purpose of its collection. We have allowed the Art Department of the National Museum to be run by a man who was not only thoroughly contemptuous in his attitude to Wales but who also administered the Department in a way that bordered on the illegal.

It appears that the adoption of the Hudson Davies Report, commissioned by the Welsh Office from a man who appears to be quite ignorant of the special needs of the country under consideration, has yet again shut the door in the face of the establishment of a National Gallery. As we saw, Hugh Hughes was aware of the need for such a gallery a hundred and fifty years ago. Over the next few years the National Museum will open a series of new rooms, and the likelihood is, unless we have an energetic campaign very soon, that these will convey to the

[37] The situation changed in 1993 when the new Director of the Arts Council announced that funding would henceforth be through the Welsh Office.

[38] R.J. Derfel, 'Pethau a wnawn pe bai genyf arian', *Traethodau ac Areithiau*, 1864, p.229.

public the same tired old story. The new curator has not seen fit to publish his curatorial policy, but I understand that it is unlikely that we will even have a Welsh room. And thank goodness for that, it must be said, because a superficial concession of that sort would only confirm the marginalisation of the indigenous culture which has been central to the policy of the Department for years. As I have tried to show, what is required is a view of visual culture in general through Welsh eyes—something quite different—and a hanging policy which reflects that vision. What hope is there of such a vision in a department that has no one with an understanding of the history of the country it is supposed to serve, nor the slightest commitment to learn about it? I hardly need to say that there is no one there who speaks Welsh. However, I make the point not in the context of the ability of the Department to deal with the public in Welsh, but to question how on earth can a department dealing with Welsh history work without a single member of staff who can make use of the primary sources of information? The situation is laughable. What is not laughable is the attitude of the staff to the policies of the National Library. The Library has a policy of buying work by indigenous practitioners such as Hugh Hughes and William Roos. This is openly referred to by staff in the Museum as the 'Oxfam Policy'.

As I have researched visual culture in Wales over the last three years I have become increasingly aware of a similarity between our situation and that of the United States in this field, half a century and more ago. This situation is manifested not only in institutional attitudes but also in the nature of the art that was produced there in the period of John Gibson and Hugh Hughes. I would like to quote an essay called *Misinforming a Nation,* which is the work of an American art historian writing about half a century ago: [39]

[39] Willard Huntington Wright, 'Misinforming a Nation', quoted by Jean Lipman in 'American Primitive Portraiture, A Revaluation', *Antiques Magazine*, New York, 1941.

> In our slavish imitation of England—the only country in Europe of which we have any intimate knowledge—we have de-Americanised ourselves to such an extent that there has grown up in us a typical British contempt for our own native achievements.

By replacing the word 'American' with the word 'Welsh' we have a fair description of our own situation. The Americans chose to change their attitude by looking at the visual evidence afresh and from a standpoint within the indigenous culture. They developed a new critique appropriate to their own situation, with two results. In the first place, a body of indigenous work was revealed which had previously been ignored and which began to be appreciated for the first time. This was the brilliant tradition of what the Americans call

Folk Painting. Secondly, this revelation laid down one of the foundation stones of the great tradition of modern painting in that country.

The words 'Wales' and 'Welshness', not to mention 'Nationalism', have no meaning if we are not able to go through the same process as the Americans, in our own way. The old excuse, 'No art in Wales' is no longer adequate. We now know that the work is there and that the task is practical. Nationalism is not a defensive and an inward looking philosophy, but an extrovert and positive philosophy which celebrates cultural diversity everywhere in the world. But that positive spirit will not flourish until we first develop some self-respect. In visual culture we continue to suffer from that mental block which prevented Evan Williams from contributing constructively as a critic and historian to his own culture after 1848. It is high time we freed ourselves from that state of mind in order to reconsider the nature of our own product, and work out the implications for new and creative work in Wales in the future. If this requires depressing political action in the short term, challenging institutions and individuals, it may yet prove to be an exciting and a fruitful path to follow in the end.

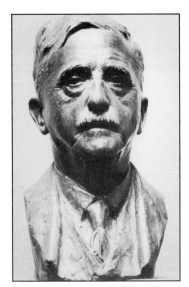

S. Curnow Vosper, by William
Goscombe John, bronze, c.1935.
The bust was shown at the Royal
Academy in 1935.

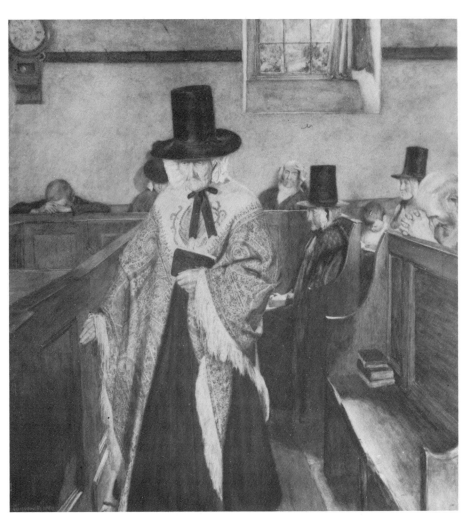

Salem, by S. Curnow Vosper,
watercolour, 1908.

SALEM: A NATIONAL ICON

A friend of mine staying in Porthmadog just before the 1987 National Eisteddfod came across an interesting visual art double on offer on the hotel walls. Hanging near to each other in the lounge she found that embodiment of the English rural idyl, Constable's *Haywain,* and another readily identifiable national image, this time rather closer to home, S. Curnow Vosper's *Salem.* Whether *Salem* had been hung consciously to complement the *Haywain* as a sort of cultural safety precaution prior to the influx of *eisteddfodwyr* in August, or whether the pairing was simply an innocent reflection of a split national personality, I don't know. My friend did not report seeing Andy Warhol's Coca Cola bottles anywhere in the hotel—which is a pity because their presence would have tidily completed a powerful triumvirate of visual symbols of our time and condition. Perhaps Andy Warhol is still a little *avant garde* for hotel walls—certainly not a problem which ever afflicted *Salem* which was a conservative image both in terms of its subject and its execution even when it was painted in 1908. But conservative or not, it certainly fills a remarkably similar cultural niche to the other two. There is no doubt that Constable's *Haywain* has become absorbed into the English consciousness in such a way that for many years it has been understood as a token of Englishness, even being afforded recently that ultimate contemporary accolade of transformation into a television advertisement. It has provided for the English an image of stability and unchanging calm beyond the reach of all the unpleasant things that subsequently happened to the way that country looked—as indeed it was meant to. Industrialisation was already going on when the picture was painted in 1821 and no one was more aware of it, and averse to it, than the artist. Constable combined the apparent contradiction of being a formal visual innovator with being at the same time a cultural conservative.[1] The picture remains a potent encapsulation of the conservative part of the English self-image.

As an equivalent token of Wales, we have *Salem*—the only art image which has achieved comparable absorption into Welsh consciousness. The painting instantly struck a chord with a wide public and within only a few years was finding its way onto thousands of walls all over the country. The irony is that this was almost entirely due to a particularly English mixture of nineteenth-century capitalism and benefaction embodied in the person of Lord Leverhulme who, having paid 100 guineas for the picture at the Royal Academy of 1909,

This essay was first published in *Planet*, 67, February/March, 1988.

[1] See Peter Fuller, 'Constable', in *Beyond the Crisis in Art*, London, 1980.

[2] This story was told by D.F.C. Vosper, the artist's son, in a letter to the *Western Mail*, 21 December, 1956. For the sitters, see *Y Ford Gron*, April, 1933.

[3] He says this quite clearly in a letter dated 12 March, 1940, kept at the Lady Lever Art Gallery, Port Sunlight.

[4] In a private collection in England. The year was 1987.

[5] See Deirdre Beddoe in *Wales: The Imagined Nation: Studies in Cultural and National Identity*, ed.Tony Curtis, Bridgend, 1986.

promptly made it available for free to anyone willing to purchase 7lbs of Sunlight Soap at the local emporium. Leverhulme's altruism did not extend as far as the artist, who found out the fate of his masterpiece by accident six months later when he saw one of the reproductions hanging behind the counter in a village shop. [2]

The picture rapidly developed a life of its own and outgrew the artist, whose comments on the phenomenon in letters have a slightly bemused air, and his intentions. A narrative developed around the characters (local people hired at 6d an hour to sit) which was soon infused with a high moral content in the puritan tradition. The Devil perceived to be lurking in the Paisley shawl implied that Siân Owen was to be understood as the embodiment of the sin of pride. The narrative acquired the character of a contemporary myth, and the fact that Vosper had had no intention of suggesting the face of the Devil served the development of the myth all the better—a truly miraculous incarnation. [3] T. Rowland Hughes contributed his well-known poem ending with the lines:

Mor felys, wedyn, yw eich byd di-sôn
Siân Owen Ty'n-y-Fawnog, Wiliam Siôn!

How sweet, then, is your private world
Siân Owen Ty'n-y-Fawnog, Wiliam Siôn!

In 1974 Endaf Emlyn produced an LP in a similar vein. And *Salem*'s capacity for stimulating public interest continues unabated—this year a second original by Vosper has come to light, minus the famous clock on the wall and the portrait of Wiliam Siôn. [4]

Certainly some people do manifest a high degree of irritation at others' readiness to adopt it. Many coming from a Marxist point of view, and more recently from a feminist position [5] have cried 'ideologically unsound'—and not without cause. But despite any shortcomings in terms of what we might wish such an icon to convey in an ideal world, I think we might be thankful that Leverhulme made available to us at least one such national icon, for even if we object to its particular meanings we can learn a lot from it.

There are two reasons for *Salem*'s elevation to the status of national icon, and the first clearly lies in the picture itself and in perceptions of those particular meanings. No force other than Nonconformist Christianity could have provided such a broad base for an image of ourselves at the time of its painting. The picture was made in the wake of the Methodist revival of 1904 and although it was in no way intended to be evangelistic, its quiet intensity and mixture of individual introspection and communal worship linked by the

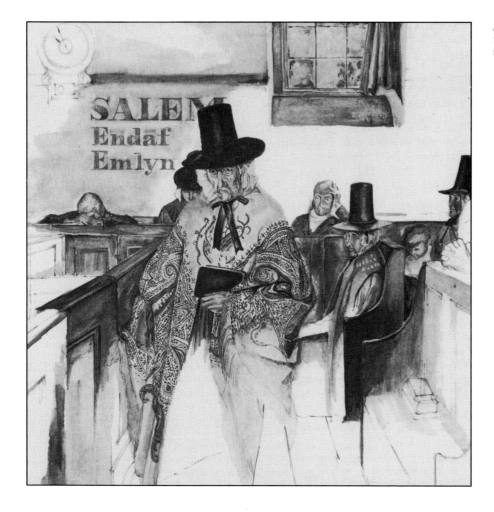

Salem, by Elwyn Davies, 1974. Sleeve for the recording of Endaf Emlyn's music inspired by the painting.

symbol of the hymn book at the centre of the picture are all close to the core of that matter. The revival was initially a phenomenon of industialised Wales, and it is true that *Salem* is an evocation of quite another place. But when the picture was painted, industrial Wales was less than 100 years old and had a workforce drawn from an older, rural way of life which many could themselves remember and to which most must have had access through the memories of old people or branches of their families left behind. *Salem* evoked that world, left behind but

not yet completely separate; and Siân Owen, born in 1837, embodied a perception of its calm rhythms and deep roots.

But above all else this is an unambiguously Welsh picture—the costumes, however much they were the construct of Lady Llanofer's romantic imagination, tell us that with absolute clarity. They bind together all the other elements into a core of essential values understood as particular to Wales. That the world depicted was no more like the actuality of everyday life for most people in 1910 than it is for us now, is not important. The picture's success was and is a matter of allegiance—for all the vagaries of its social history, it became ours.

The irony is that we had to acquire this dominant visual token of ourselves in the way we did. For what the extraordinary enthusiasm for *Salem* must suggest is the existence of a great latent desire for such tokens, and of our having been deprived of this essential element in a national culture. This brings me to the second reason for *Salem*'s elevation to national icon—a simple matter of availability. Images of Englishness were readily available—such nineteenth-century pictures as *The Death of Nelson* and *The Boyhood of Raleigh* were mass-produced as engravings, and later as colour prints, making them and their attendant national mythology as familiar as the *Haywain* is today—and as familiar in Wales as in England. Indeed, the pervasiveness of these images of somebody else's national culture and mythology was extraordinary, and not confined to Queen Victoria over the middle-class mantlepiece. A photograph of the inside of a lead miners' barracks in Ceredigion at the turn of the century shows that images of English imperialism were absorbed in Wales even by those experiencing the most dire economic oppression.

No mechanism existed within Wales for making available images of such an explicitly national character. Images of Nonconformist Christianity, including many whose subjects were Welsh men and women, such as the famous engraving of Williams Pantycelyn, the composite photographs of leading preachers, and the engravings of the story of Mary Jones, were widely distributed. But though far from devoid of political implications in the period of the twin campaigns for Disestablishment and Home Rule, they do not seem to have caught the public imagination in the same way as *Salem*. There was no shortage of candidates for the role of the token of our aspiration to a political national identity at that time—both images of national heroes such as the Cardiff City Hall sculptures and paintings of mythological subjects by Christopher Williams and others—but none seems to have taken root at a domestic level through reproductions.[6] The reasons for this are complicated and not simply to do with mechanisms for making them available, but also involve

[6] Thomas Matthews apparently intended to have a print of Christopher Williams's *Wales Awakening* published, although what became of the plan is unclear. The intention is expressed in his book on art education, *Perthynas y Cain a'r Ysgol*, 1916.

Lead Miner's Barracks, mid-Wales,
by an unknown photographer, 1901.

the nature of the images themselves and the complexity of an audience which
was very far from being politically coherent. *Salem* emerged in the period
immediately following the political intensity of *Cymru Fydd* and the collapse of
the Home Rule movement and grew to its greatest popularity after the war.

 Salem has things to tell us about today's perceptions as well as yesterday's.
There are only two recent full-length books about art in Wales,[7] both
thoroughly negative in tone. The national icon does not rate a mention in either
of them. On the face of it this is an extraordinary omission, but not one for
which it is difficult to find an explanation. Both books are written with an
outsider's perception—David Bell sets out 'to treat Wales not as a people but
as a geographical entity'—and from a particular standpoint within mainstream
Western art historical tradition. 'We should regard Welsh art as a small but
vigorous tributary to the mainstream of modern art', is Eric Rowan's basic
standpoint. This view understands images in terms of their role in generating
other images—in terms of their capacity for being fitted into a linear process of
formal innovation. Art is regarded as a detached specialism in which particular

[7] David Bell, *The Artist in Wales*,
London, 1957, and Eric Rowan, *Art
in Wales*, two volumes, Cardiff, 1978
and 1985.

examples are evaluated in terms of other examples which exist only in the context of themselves. This allows the image of Wales as a landscape, for instance, full rein in these books by virtue of the participation of Wilson and Turner in the invention of an image which was subsequently elevated to a high status in the formal development of European painting, but excludes *Salem* (and a great deal more) which is irrelevant to that process of formal development in art history.

But *Salem* is plainly not an irrelevant image. On the contrary, it is by popular assent the most relevant art image we have. But its perception as relevant by art historians would require them to operate a quite different understanding of what art is about than the understanding of Rowan and Bell.

Perceptions of Welsh visual culture can be changed dramatically by understanding that the significance of an image lies primarily in its meaning for people within the culture where it is to be found. Peter Fuller has written, echoing a remark of Ivor Davies, that 'the value of a painting cannot be determined by its art-historical position'. *Salem* is a classic demonstration of the truth of that assertion. The value of the picture for us, now, is not merely *as* a national icon—but in terms of what it tells us about the received history of images which we have and which sadly our teachers, on the whole, pass on to our children in schools. This is a history which deprives us of a visual tradition. Understanding *Salem* is a first step in understanding the need and potential within our culture for constructing a different and appropriate history of our images.

THE POPULAR ICONOGRAPHY OF THE PREACHER

A visual image is not static in a culture. As it gets older, the culture around it develops, and as a result its audience's perception of it changes. In 1770 Richard Wilson began painting two large landscapes to celebrate the coming of age of Sir Watkin Williams Wynn. The artist's task was to create an image which would reflect Sir Watkin's perception of the world order, and his privileged place in it. He boasted that he owned every square inch that could be seen in the wide panorama of *Castell Dinas Bran from Llangollen*. The castle was a symbol of his ancient lineage which had brought order to Wild Wales, and the happy and productive peasants to be seen in the foreground symbolised the blessings of this social order, embodied in the substantial person of Sir Watkin himself.[1] These meanings were clear to the patron, of course, and to the contemporary aristocratic audience. But this kind of picture is perceived in a very different way today. Today's audience sees a beautiful and limpid scene, idealised on the Italian model. Few people are aware of why Wilson idealised in this way. His manner is perceived largely as a matter of aesthetic fashion, rather than as a reflection of social engineering.

Because *Castell Dinas Bran from Llangollen* has not been popularised in the same way as, for instance, *The Haywain* of Constable, we might say that, until it arrived at the Yale Centre for British Art in 1971, its audience had not greatly expanded since Sir Watkin's day. Some images that were created in the first instance for a fairly narrow audience have travelled much further. Not only has their meaning changed, but so also has the social status of their audience, and in one famous instance, even the nationality of the audience. Curnow Vosper painted *Salem* to please the upper class English audience that frequented the Royal Academy exhibitions, where it was shown in 1909. If it had not been for the intervention of Lord Leverhulme, the likelihood is that the picture would have been bought by a well-off private collector and would have disappeared for ever from public view, like dozens of similar works. That is not what happened, of course, as a result of the business acumen of his *nouveau riche* Lordship. First of all through the medium of the coloured print and then through reproductions on a host of ephemeral objects, it came to play an active part in the evolution of Welsh popular consciousness in the first half of this century.

This essay was first published in *Barn,* 330/331, July/August, 1990, as 'Iconograffeg Poblogaidd y Pregethwr'.

[1] See the cartoon by Thomas Patch, 1768, BM, for evidence of Sir Watkin's prodigeous girth at an early age.

Salem also offers us an example of yet another sort of transformation that a visual image may undergo over a period of years. The image itself can be changed, without it losing entirely its original identity. In visual terms Leverhulme's lithographs of *Salem* are very close to the original watercolour, but once the image began to be widely reproduced as prints of varying size down to the postcard, the audience began to feel able to impose upon it in its own special way. It was no longer unique and deserving of the hallowed status that exhibition in a public gallery gave to it. The new image was ephemeral and we could do what we liked with it. We could draw a moustache on the face of *Mona Lisa*. The psychological change that occurs when an image becomes the property of a large public releases it to be developed and distorted for purposes as far from the artist's original purpose as was Leverhulme's use of *Salem* as an advertisement. New elements are added and parts of the image removed if they are no longer relevant. This is what happened to *Salem*.

Salem is also notable as one of those images which became so much part of public consciousness—that travelled so far, as it were—that it arrived back at its starting point. In Hywel Harris's pictures *Salem* was returned to the elevated status of the unique art work.[2] It is clear that in such cases the intentions of the painter who produced the original are of little importance in understanding the image, except to the sort of art historian who perceives the purpose of the discipline as sorting out good from bad art. The meaning of *Salem*—and the thing which can make art history a meaningful discipline for us all—is to be found in the nature of the process that transfers the image from one social group to another, in the nature of the interaction of the image with various audiences, and in the effect that living images of this sort have on the overall evolution of a culture.

About 1880, four volumes about the history of Nonconformism under the title *Enwogion y Ffydd*—The Famous of the Faith—were published.[3] They were attractively produced but not so expensive as to be beyond the reach of a wide public. Introducing each volume is a series of steel engravings of ministers and preachers. It is difficult for us now to see these engravings as they were seen when they were new. The aura of a particular period hovers about them. Like some smell which brings alive a half forgotten memory, these images bring to the minds of many middle aged Welsh people the less than cheerful atmosphere of the chapel and the vestry in the period of its decline, or a wet Sunday in Grandma's house, many years ago. The reputation of these engravings has also suffered as a result of them being poorly reproduced in many a boring history book, all of which is a pity because they have an important place in our history, and if seen in good condition, they have a beauty of their own. Many of them

[2] Illustrated in colour on the cover of *Planet*, 67, February/March, 1988.

[3] John Peter and Gweirydd ap Rhys, *Enwogion y Ffydd: neu Hanes Crefydd y Genedl Gymreig . . .*, London.

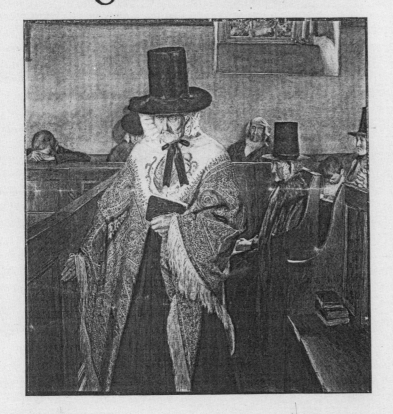

deffrwch y bastads

mae cymru'n marw

Deffrwch y Bastards (Wake the Bastards Up), political pamphlet, photocopy, 1989.

were based on photographs but their reality becomes almost surreal as engravings because of their unnatural cleanliness and their silky tonal quality.

Amongst the sitters included in *Enwogion y Ffydd* was Thomas Charles. Over many years, this image, engraved here by one E. Pick, had become so familiar that we can say that this was the only Thomas Charles carried in the imaginations of thousands of Welsh people. But of course, by the time Pick received the commission to make the engraving, Charles had been in his grave for sixty years or so, and the engraver had to create the picture by reinterpreting earlier portraits. The image is the result of a long process of evolution.

Despite the Methodism which hindered his career in the Established Church, by 1797 Thomas Charles was well enough known as a result of his work in organising the network of Sunday Schools to deserve attention in his professional journal, *The Evangelical Magazine*. A portrait engraved by Ridley was published, probably based on a miniature, although it may be after a lost oil painting. Ridley worked regularly for the magazine. The contemporary public would have perceived a young man, on the up—the Thomas Charles of Jesus College, Oxford, a gentleman who kept the company of influential churchmen in London, rather than the farmer's son from Carmarthen. The picture belongs to the *genre* of whizz-kid photographs seen today in business magazines. By 1805, he had made his mark strongly enough to motivate the Bible Society to commission an oil painting to hang in the Society's rooms in London. Nevertheless, although Thomas Charles's face was familiar to his colleagues as a result of the engraving in the *Evangelical Magazine*, neither of these pictures would be the foundation of the image which became, in time, as familiar as the front door of the local chapel to generations of ordinary Welsh people. Rather, it was a picture produced inside the other community in which Thomas Charles moved. In the early years of the nineteenth century Calvinistic Methodism was still a minority movement and one based amongst the ordinary people. In the atmosphere generated by the French wars it was accused of disloyalty and of republican tendencies by conservative church people who saw it as a threat to the establishment and to their privileged status. For all that, it was spreading rapidly amongst substantial farmers like Thomas Charles's own father, successful craftspeople, merchants and manufacturers like his brother David Charles, and professional people in the small towns, who would become the backbone of Nonconformist Wales in the second half of the century. The third portrait of Thomas Charles, the portrait which was the foundation of the popular image of the man, belonged to this world, rather than to the academic world of Oxford or London. The general history of the popular iconography of

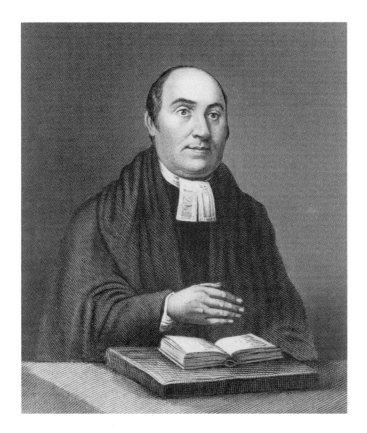

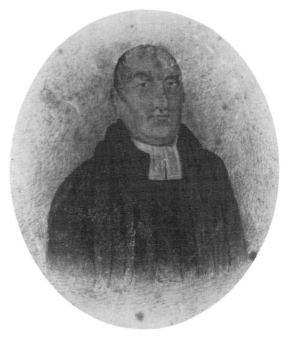

the preacher, of which the image of Thomas Charles is a part, is bound up with the emergence of this stratum of society.

Hugh Hughes was among this upwardly-mobile stratum, a farmer's son from Llandudno who became an apprentice engraver in Liverpool, and who had by 1811, to his own way of thinking, risen well above his rural roots. As a Methodist and as an urban craftsperson, by 1830 Hughes had come to consider himself a model of the new, confident Welsh person. Early in the process of this upward mobility he exhibited a patronising if not contemptuous attitude, on occasions, towards his rural and unenlightened compatriots, which only emphasised his closeness to them, in fact. In 1811 Thomas Charles had been pushed by more radical forces to lead the Methodists out of the Church of England. To Hugh Hughes and others like him, this was an event of great significance, and he was a witness to the symbolic culmination of the process in

Thomas Charles, steel engraving by E. Pick after Hugh Hughes, c.1880.

Thomas Charles, watercolour miniature by Hugh Hughes, c.1812.

Bala in June that year. During the subsequent three years he took portraits of several leaders of the denomination, including Thomas Charles. But he was an untrained painter, learning, like the movement of which he was a part, as he went along. In his work in this period there is a quality which truly reflects the innocent confidence of that movement, and of the belief of those who were a part of it that they could secure their material and spiritual future through their own efforts.[4] We are given a taste of the excitement of this early period of the independent denomination in Hughes's own description of the Association of 1820 in Bala:

Wednesday, June 14th, 1820. I heard seven sermons . . . the congregation swelled to seventeen or eighteen thousand . . . I felt highly pleased and delighted here with the appearance and conduct of this multitude of my countrymen, decent in their dresses and clean in their persons, with scarcely an exception civil and quiet, and serious in their behaviour without any exception, in every respect becoming of the occasion of the meeting. Some indeed were blamed by their friends for being too warm in expressing their love and admiration of the goodness and the power which had but recently made them men and Christians. Blind indeed must that wretch be who in this country now can say that preaching salvation through faith alone is favourable to immorality and licentiousness. The contrary is so evident that ignorance and bigotry themselves are convinced, and malignity alone remains to be overcome. 'Tis as clear as noonday that this preaching does not only effectually render more strictly moral those who value and believe it; but that it has changed the whole face of our country, by raising, humanising, taming, enlightening and moralising the mass of the population.

It is appropriate, therefore, that it was Hugh Hughes's portrait, so characteristic of the period, that led in the end to Pick's engraving, which, with its sophisticated technique, its smooth and comfortable quality, would be equally characteristic of the establishment Methodism that grew from the naive excitement of 1811.

From a technical point of view the portrait of Thomas Charles is the most primitive of all Hughes's surviving works, and it is therefore likely to be the earliest. It was first engraved by Joseph Collyer, who followed a successful career in London, and was published in the memoir of 1817. Thomas Jones of Denbigh collected the material together for the memoir and it is possible that it was he who commissioned the engraving—he was amongst the other early sitters to the artist, and may well have known of the existence of the miniature. By this time, Hughes himself was living in London, and the painting may have been still

in his possession.[5] As a publisher himself Thomas Jones would know that an experienced engraver could turn the most primitive image into a portrait which conformed satisfactorily with the conventions of the *genre*. Joseph Collyer tidied up the image and added a hand hovering over a Bible. It must be said that this addition was not totally satisfactory and as a result the image would retain a somewhat awkward quality through various transformations down to the days of Pick.[6]

Like Thomas Charles, Christmas Evans was painted at least three times, and the original portraits spawned a family of engravings. In the early years of the last century the Welsh Baptists did not have a college of their own and as a consequence, aspirants to the ministry were obliged to travel to Bristol for their instruction. The Bristol college had, indeed, been founded by two Welsh Baptists, Hugh Evans and his son Caleb, and had a tradition of commissioning portraits which extended back to the period of these founders in the mid-eighteenth century. Their two portraits by local painters survive, and both were engraved before the end of the century. By 1819 Christmas Evans was the most prominent figure in the denomination in Wales, travelling extensively from his home in Anglesey to every part of the country and to the college in Bristol. In that year the Welsh students paid for a miniature of him by Nathan C. Branwhite who worked in Bristol and who exhibited at the Royal Academy between 1802 and 1825. It was a skilled piece of work and was engraved for the *Baptist Magazine* three years later.

In 1832 Christmas Evans moved to Caernarfon to live, after a period in the south. Two years later Hugh Hughes established himself in the town after eight years of commuting between London, Carmarthen and Glan Conwy. It is not clear exactly how soon after this he was commissioned to paint Christmas Evans but we know something of the story of the commission from a letter written by the patron's son to T.H. Thomas, Arlunydd Penygarn, in 1894. It was a highly ecumenical portrait—the sitter was a Baptist, the artist had been brought up a Methodist, and the patron was the leader of the Independents in the town, William Williams, Caledfryn:

> My father got him to paint Christmas Evans at Caernarfon and paid for it . . . [The] engraving, I think, is from the original with one hand holding a book which does not add much to the work. I think this as Christmas Evans had a great aversion to sit at all. My father had to go with him each time to endeavour to cheer him and keep him still. Hugh Hughes was so slow in his work, and considered in going along instead of deciding the pose at first and the best attitude . . .[7]

[5] It is not clear whether the pictures were painted at Hugh Hughes's own expense, were commissioned by the sitters on an individual basis, or were commissioned as a group.

[6] Additional information about the development of this image and the central role of the patron, rather than the artist, in determining its character, has come to light since writing this essay. It is published in: Peter Lord, *Artisan Painters*, Aberystwyth, 1993, p.38 and note 22.

[7] NLW Ms.6358B. It has subsequently emerged that Daniel Jones, minister of the Baptist chapel at Great Cross Hall Street in Liverpool, was also involved in this commission. This, of course, may have implications for my speculation on how the portrait arrived in London. Hugh Hughes was notoriously slow in working and a similar story to that of the painting of Christmas Evans is told concerning his portrait of David Williams, Troedrhiwdalar, 1854, in *Y Tyst a'r Dydd*, 18 December, 1874, p.2.

The story must have been repeated ever afterwards in the family since ab Caledfryn was not born until 1837. He does not specify the cause of the sitter's aversion to sitting, whether it was impatience or ethical doubts about the rectitude of the proceedings. It is possible that he would have considered a display of unwillingness as appropriate, for fear of the accusation of vanity. There is a measure of sourness in the remarks of ab Caledfryn, which it is reasonable to attribute to professional jealousy. About 1843 or 1844 he received his first drawing lessons from Hughes, and later became a painter. By the 1880s he had something of a monopoly on painting Independent ministers. Among his sitters were John Roberts, Samuel Roberts and Michael D. Jones. Nevertheless, it is difficult to argue with his low opinion of the mezzotint, which was done by Hughes himself. This can be accounted for to a degree by the same difficulty that affected Collyer, that is, the addition of a hand to the portrait, but the engraving is generally poor in technique—heavy handed and dingy. In fact, Hugh Hughes was able to work to very high standards in this medium, as his double portrait of *Lord Holland and Lord Russell*, done between 1828 and 1832, demonstrates. But Hughes was an uneven painter throughout his career, something ab Caledfryn put down to his mooody character:

> He was a very impulsive man—if he did not feel quite up to work, although engaged by appointment, he would call and tell his sitters so, and retire without any explanation, only that he did not feel equal to work then. [8]

[8] ibid.

The later history of the portrait is of some interest. Although Caledfryn had paid for it, the picture seems to have been kept by Christmas Evans, and by his widow after him. The next time we hear of it is in 1894, when it was hanging in Spurgeon's Tabernacle Library, that is the library of the Metropolitan Tabernacle Church in London. It seems likely that it found its way there following Spurgeon's visit to Anglesey in 1860. Whilst in Holyhead, the great man from London was introduced to Mary Evans, Christmas Evans's widow, and we know that she gave some of her husband's books to Spurgeon. It is reasonable to suppose that the portrait also came into his possession at that time, although it is possible, of course, that Spurgeon—who was a great admirer of Evans—bought it somewhere else at a later date. During the Second World War the Tabernacle was burnt to the ground and the portrait was lost. But although ab Caledfryn did not mention it in his letter to T.H. Thomas, it is easy to see why he was so familiar with the picture. In 1867 he had painted a copy of it in London at the request either of the Baptist College or someone closely connected with it, and it still hangs in the present college in Cardiff. The date—

a year after the centenary of the minister's birth—suggests it was commissioned to celebrate that event.

By 1835 Hugh Hughes faced competition from a younger generation of painters in portraying the religious leaders of the nation. William Roos of Amlwch was painting in Caernarfon in that year as well as an artisan painter called William Griffith who remained active in the town until at least 1850. Hugh Jones of Beaumaris took rooms in Segontium Terrace in 1838, and by 1844 another painter, about whom very little is known, Thomas Jones Williams, was also selling his work there. Williams was described by his mother as 'the poor sickly artist'. William Roos and Hugh Jones painted John Elias, another of Hughes's early sitters,[9] and while William Roos was living next door to Christmas Evans in Pwllheli Road, he took his chance and also painted a portrait of the great Baptist minister. He completed his trinity of famous Nonconformist leaders by painting a picture of Thomas Charles, sometime after 1838. He already faced the problem which Pick would face later on, of course,

[9] See my *Artisan Painters*, op.cit., for fuller details. I now realise that, despite his clear implications to the contrary in inscriptions and letters, Roos's portraits of Elias are all copies after Hugh Jones, probably done from the engraving.

The Bala Association of 1816, wood engraving by Hugh Hughes. There is no surviving original. This copy was published in a memoir of Thomas Jones, Denbigh, published in 1897. Jones took an important and controversial part in the Association of 1816.

since the Methodist leader had died when the painter was only about nine years old. He turned to a new engraving by Bailey, which had developed his competitor Hugh Hughes's original with the addition of a reading glass, and so the popular print returned, like *Salem* a century later, to the world of fine art.

It appears that Hugh Hughes's mezzotint portrait of Christmas Evans was commissioned for the memoir of the minister published in the year following his death in 1838. Roos published an engraving of his own picture at about the same time, and it was a much more accomplished performance. It was larger and so more suitable for framing, and included an element which became common in portraits of this sort later on, a classical pillar. This seems to be the first time that a pillar was used in a Nonconformist portrait in order to dignify the sitter—it would not have occurred to Hughes back in 1811 to make such an association. The author of the memoir of Christmas Evans published in *Enwogion y Ffydd* made use of a literary version of the same association in order to elevate his subject into the classical mainstream:

> He also composed a variety of splendid hymns: indeed, Christmas Evans's inventiveness, imagery and imagination were so strong, lively and brilliant that, had he given himself over as much to poetry as he did to preaching and to prose, he might, in all likelihood, have been listed along with Homer, Dante, Milton and Williams of Pant-y-Celyn.

This is indeed an elevated company, and well reflects the cultural lineage considered appropriate for the Welsh nation by intellectuals of the period.

Christmas was bound tightly to his pillar in the next development of the image, although, for technical reasons, it was necessary to rearrange Roos's composition somewhat. In England a small industry based on reproductions of images of John Wesley was already flourishing, and through the century the ceramic factories of Staffordshire added colourful images of other religious leaders to their range. The ancestors of these pieces were the sculptures of the shepherdesses and mythological subjects popular with well-off customers throughout Europe before the turn of the century, made in England at the Chelsea and Bow factories. Their Nonconformist descendants had a considerably less pretentious aura, appropriate to their market among the social groups that were the backbone of those churches. Several Welsh ministers were immortalised by the Staffordshire sculptors, including John Elias and John Bryan, as well as Christmas Evans. The images were not modelled from the originals, of course, but from the prints. In the case of Christmas Evans it is quite clear that William Roos's print was the source, which dates it to the late 1830s or 1840s. It is sometimes said that these images were produced to be

Christmas Evans, oil on panel, by an unknown painter, mid-nineteenth century.

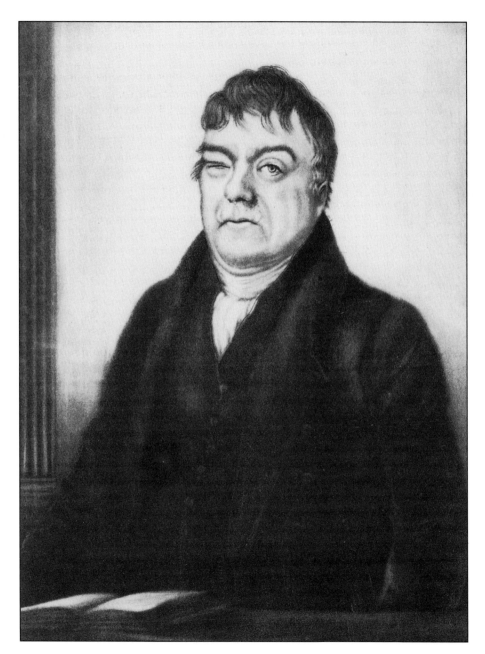

Christmas Evans, mezzotint by William Roos after his own original, 1835.

'distributed' amongst the faithful, but this seems most unlikely. Certainly, no one is likely to get one for nothing today—these figures have fetched over a thousand pounds at auction.

William Roos was not a wealthy person who could please himself about whom and what he painted. He was an artisan painter who depended on meeting the needs of the market in order to survive. The question as to who commissioned his portraits of Christmas Evans and Thomas Charles is an important one, therefore, if we are to understand the context in which Welsh painters worked at this time. We have only a little direct evidence, but the very existence of the pictures, and the work of the publishers who were willing to commission engravings after them, is evidence of a substantial market. The presence of three or four professional painters in Caernarfon—still a small town at the time—emphasises the depth of this new market, quite distinct from that for gentry portraits. However, it is difficult to be precise because of the loss of so many works. Photographs of interiors from the middle of the century which might indicate the place afforded these images in the home are also scarce. But the work of naive painters who copied some of the most popular images provides substantial evidence of their psychological importance. For instance, probably at some time in the second half of the century, an unknown artist painted a portrait of Christmas Evans based on the work of William Roos. The portrait was done on a panel about 9″ x 7″, and presents the sitter within a colourful frame as if inside a television set. The pillar on the left of the original engraving melts into this frame, suggesting that the classical reference was either not understood or not valued by the painter. On top of the panel is a brass ring to enable the picture to be hung on a wall. In the simplicity of its style, its striking colours, and its form (which suggests how it was to be used), it closely resembles the icon of a saint of the medieval church. In this painting the icon returns to the religious practices of nonconformist Wales in everything but name, having been excluded from the practice of worship for more than two centuries.

The painted icon of Christmas Evans is not an isolated example. In 1839 Hugh Jones painted his portrait of Evans's great contemporary amongst the Methodists, John Elias. At the time, Hugh's elder brother William was working as a portrait painter in Chester, and amongst his acquaintances there was the Welsh publisher Edward Parry. It may well have been through this contact that Parry commissioned an engraving of the portrait, published the following year, having realised the market potential for a new image of the high-profile minister. The following advertisement appeared in the *Carnarvon and Denbigh Herald* on June 11th:

Just finished. A highly finished Engraved Portrait of the Rev. John Elias, after a most beautiful painting, and admirable likeness, by Mr Hugh Jones, Beaumaris. Size of plate, 12 inch x 9 inch. First Proofs, before Letters, with Mr Elias's own genuine Autograph—7s.6d. Second Proofs on India Paper, with correct facsimile of Ditto—5s.6d. Common Impressions—2s.6d. Those persons who are anxious to secure early impressions can be supplied through the principal Booksellers in North Wales, and the publisher.

Unfortunately, we do not know how many copies were published but Parry's engraving became the standard image of the preacher, and Hugh Jones's most famous picture by a long way. Forty years later, the Reverend Robert Hughes of Uwchlaw'r Ffynnon made a copy of the image on card, about 10″ x 6″. He followed the original more closely than the painter of the naive copy of Roos's Christmas Evans, but in the last year of his life, when he was over eighty years old, he made a more original composition, based on the same source. His imagination was stimulated by a story about the only occasion on which the leaders of three generations of Methodists, that is Thomas Charles, John Elias and Henry Rees, met together. Henry Rees was sixteen in 1814 and he had walked to Bala to listen to the two stars of the movement preach, and—

[10] The story was published in: Owen Thomas, *Cofiant y Parchedig Henry Rees . . .* , Wrexham, 1891. There is a strong echo here of the story of Mary Jones and her Bible, of course. For Robert Hughes, 1811-92, see below, 'The Meaning of the Naive Image'.

[11] The albums are in NLW. For John Thomas see: Hilary Woollen and Alistair Crawford, *John Thomas, 1838-1905, Photographer*, Llandysul, 1977. However, in my view this volume fails to come to grips with the meaning of the images and their national cultural context. I realise, now, that my remarks on John Thomas as a portraitist should have been balanced by a reference to the work of William Griffith, Tydain, in the same *genre* in the 1860s. For Tydain, see: Peter Lord, *Y Chwaer Dduwies-Celf, Crefft a'r Eisteddfod*, Llandysul, 1992.

according to the legend—to buy a copy of Charles's *Geiriadur Ysgrythyrol*. [10] As he was poor, he had to ask Charles to give him a copy on the promise of being paid later. By the time of his death in 1869, Henry Rees was as celebrated as his predecessors had been when in their prime, and Robert Hughes decided to record the meeting in a picture. This is an unusual portrait in the extensive *oeuvre* of Robert Hughes since it includes more than one sitter. As a result, it has less of the quality of the icon than many of his other pictures. These are divided between portraits of local characters, and portraits of ministers and preachers based on his own visual memory, engravings and photographs, and on descriptions. The paintings of Robert Hughes are of great importance both because such a large group of works by a naive painter about whom we have considerable personal information is most unusual, and also because the portraits testify to the significance and influence of the image of the preacher in the culture of the age.

By the time that Robert Hughes turned to painting, about 1871, the photograph had deposed the painted image and the engraving as the main media of portraiture. It had become the fashion for the middle classes to sit for a photograph which was often printed as a *carte de visite*—a visiting card of about 4″ x 2″. It did not take photographers long to realise the potential market for portraits to this format of the great and the good. The public enthusiastically collected the *cartes*, as children would later on collect cigarette cards. These collections are a mirror to the state of mind of Welsh people in the period, and further help to fill the gap in our knowledge about the place of visual images in the everyday life of the period. The album of John Jones, Talhaiarn, for instance, opens with the royal family—Victoria and Albert, and the Prince and Princess of Wales—followed by English politicians—Derby, Disraeli and others. Next come the great English literary figures—Dickens and Tennyson—and lastly the Welsh contributors to the great imperial culture, our poets and musicians. We have Pencerdd Gwalia, Eos Cymru, Ceiriog, and several others of Talhaiarn's circle in London. Talhaiarn's collection is, however, unusual in one respect, since it contains few preachers. Talhaiarn was a churchman and so Gwilym Hiraethog and Caledfryn gain admittance only on the basis of their literary reputations. The album of one J. Jones of Clocaenog is much more typical. In it there are fifty preachers and ministers, most of them photographed by John Thomas, the first entrepreneur to realise the market potential of the cheap portrait of the nation's famous men and women. [11]

The mind of John Thomas truly reflects the spirit of the age, and he contributed much to encouraging the progress of that spirit. Indeed, his images are frequently reproduced today and so are still a factor at work in our culture.

His account of the event that motivated him to begin work is well known, but nevertheless worth quoting again since it emphasises the importance of patriotism in the popular art of the period. He learnt his trade, like Hugh Hughes half a century earlier, in Liverpool, where he got work as a young man selling a series of photographic portraits called *Great Personalities of the World*. The only Welsh people considered worthy of a place in the series were Bishop Short of St. Asaph and Watkin Williams Wynn, and as a result some of his customers made fun of him, since he was obviously Welsh himself. 'I took the hint', he said, 'and considered whether it would be possible to include Wales as a part of the world. And I felt the blood of Glyn Dŵr and Llywelyn rising in me since I was jealous for my country and my nation at that time when its tide was only just on the turn.' From 1863 on, John Thomas was photographing the famous musicians, poets and preachers of his day, and selling them as *cartes de visites*. Thomas was breaking new ground and of necessity had to fulfil the roles both of a creator of original images and of the entrepreneur who marketed them. He was very conscious of the creative aspect of his work. 'I became what I am now—an Artist', he remarked of his decision to begin work in the field. He soon extended his range to include the famous of another age, people such as Thomas Charles and Thomas Jones. He borrowed, without acknowledgement, images made by the painters of the first half of the century, reproducing them on his *cartes*. He published a catologue which included over 450 images, of which only 34 were not ministers, preachers or priests. Compared to engravings these images were very cheap, and therefore within reach of a wide audience. He charged 6d. each or 5s. a dozen. John Thomas combined individual portraits in groups such as *Naw o'r Hen Dadau Methodistaidd*—Nine of the Old Methodist Fathers—and *Y Pulpud Cymreig (hen a diweddar)*—The Welsh Pulpit (past and present). These composite pictures are related to a high-art convention developed to record great historical events such as *The Oath in the Tennis Court* and important parliamentary occasions in England. John Thomas's early composites are primitive in technique, but they travelled up market in the hands of engravers who set the portraits in decorative frames. They are still to be found mouldering on vestry walls up and down the country, their significance and their special visual quality hidden from us by that blindness which has set in following the decay of the values they represent. Through the medium of the individual photographs of John Thomas and the photographic and engraved composites, the unpretentious images of Hugh Hughes—as well as those of Hugh Jones, William Jones and Evan Williams—were given a new lease of life and a continued active role amongst an even wider audience.

Naw o'r Hen Dadau Methodistaidd, composite photograph by John Thomas, c.1880. Thomas and David Charles are after originals by Hugh Hughes, John Jones and William Morris are after Evan Williams, and John Elias is after Hugh Jones. The portrait of Daniel Rowland is after a miniature by Robert Bowyer.

John Thomas was the pioneer in the field—the person who saw clearly why there would be a market for such images—and he made a success of it. There is no reason to suppose that his entrepreneurial vision was a cynical one. The mentality of the age was one in which public spirit and self interest—patriotism and money-making, in this case—happily coexisted. Many followed in his footsteps, all over the country. At the end of the century, for instance, Edward Jones, a Bala publisher, produced a *carte* to meet the needs of the tourists who came in increasing numbers to the town by railway. Edward Jones's *carte* is of particular interest in that he returned to Hugh Hughes's original image of Thomas Charles, omitting the hand added early on by Collyer. This may suggest that Hughes's original was available to him as a source.

Amongst the art entrepreneurs, Hugh Humphreys of Caernarfon has a prominent place. He might, indeed, be considered a model of the Nonconformist business person who prospered financially and socially as a result of his own enterprise. He was born in the town and was apprenticed to the printer Peter Evans. By 1845 he had his own busines in Tan-y-Bont which grew rapidly. The 1851 census confirms that he had moved to his well known premises on Castle Square, and that at the age of 34 he was employing 13 people. In 1858 he commissioned William Roos to paint his wife Mary Crane, a picture clearly intended as a partner to his own earlier portrait painted perhaps by Roos or by Hugh Jones. These commissions suggest that his interest in visual culture began early. He knew Hugh Hughes well and in 1849 printed a pamphlet for him:

> I knew him for many years ... I printed a book for him called *Y Drefn Ddwyfol* which was extremely original. Before it was published he invited the preachers of the various denominations in the town to listen to him on the subject. I was amongst them and I think I have a copy of the book in my posession.[12]

[12] NLW Ms.6358B. For additional information about Humphreys, see my *Artisan Painters*, op.cit.

Hugh Humphreys was present at this meeting since he was himself a Wesleyan preacher. Indeed, by 1871 his status as a preacher was sufficiently high for him to name it as his profession on the census return, rather than publisher. It is possible that the painter Hugh Jones was also in attendance since he too was a Wesleyan lay preacher. His brother, the painter William Jones, had gone one step further, becoming a minister in 1808. According to Hugh Humphreys, Hugh Hughes was a 'powerful orator', an unexpectedly generous compliment considering the Radical political and religious views of the painter and the conservatism of Humphreys.

The precise details of Humphreys' career as an art and literary entrepreneur are difficult to ascertain since very few of his many publications are dated. He probably began to market images of famous people in the form of simple line engravings to a common format in the late 1850s. The sitters included Dewi Wyn o Eifion, Gutyn Peris, Robyn Ddu Eryri, and Richard Llwyd, Bard of Snowdon. By 1874 H.J. Hughes had opened his Victoria Portrait Gallery in Victoria Street, Twthill, offering photographic services including *cartes de visite* of the famous. It may well be that this competition stimulated Humphreys to expand into photography because by 1877 his photographic and painting studios and shop, The Fine Art Gallery, were open on Castle Square. He shamelessly appealed to human pride to attract the famous into Pater Noster Buildings:

> Poets, musicians, writers, etc, are encouraged to pay a visit to the above establishment since H. Humphreys is forming a gallery of Famous Welsh People. Pictures 6d. each.

Like John Thomas, he bought, borrowed and appropriated paintings and engravings by Hugh and William Jones, Hugh Hughes and others in order to expand his series of *cartes de visite* to include famous people of the past.

As a rule, Hugh Humphreys showed a strong instinct for going down market. This is true of his literary as well as of his visual ventures. When he began, probably in the 1860s, to publish books of views, he opted for a small format and simple line engravings rather than the generous format and lithographs that had been favoured by Shone and Prichard in Bangor and Caernarfon in the 1840s. Even when he did venture up market by employing painters to make oil portraits based on *cartes*, his marketing strategy remained practical and no-nonsense:

> H.H. keeps in his establishment craftsmen of the highest quality for making oil painting portraits at the most reasonable prices, in English gilt frames of the best manufacture, at various and unusually low prices from five guineas to fifty guineas each.

> These pictures are painted from 'carte de visite' obviating the need for many sittings. It is therefore possible to paint the dead as well as the living if a carte is available.

This sort of copying was common before the age of colour photography and cheap colour printing. It was a long established practice amongst the gentry to commission copies of their portraits to hang in their second or third homes.

William Jones was commissioned by the Grosvenor family in Chester to copy portraits by Jean Baptise van Loo and Benjamin West to decorate the family house in Westminster, for instance. William Roos copied for the middle-class market [13] as we have seen with the portraits of Thomas Charles and John Elias and his own portrait of Christmas Evans. In October, 1870, Roos was in London, apparently in a parlous financial state, when he offered one of his portraits of Christmas Evans to William Roberts, Nefydd. He suggested in his letter that the portrait being offered was the original, without saying so in plain language, but this seems most unlikely considering his wandering life-style and the thirty-five years that had gone by since the portrait had been painted. Nevertheless, Nefydd had a bargain—William Roos charged £2 for one of the most celebrated images of the culture. Roos was a romantic. The inscription on the back of one of the copies dedicates it 'To Christmas Evans. The most ideal preacher Wales ever produced'. By 1899 the artist's star had sunk well below the horizon. Portraits of Christmas Evans and John Elias were found in a lumber sale in Islington that year. Their owner was of the opinion that Christmas Evans had 'the physiognomy of a well known prize fighter' and these classics were sold for half a crown each. [14]

John Thomas offered a copying service in the Cambrian Gallery in Liverpool, as did H.J. Hughes in Twthill, and at cheaper rates than Hugh Humphreys. Thomas asked between £2 and £20 for an oil portrait. In Liverpool he could call on a wide range of artisan painters to carry out the work, but in Caernarfon in the 1870s it was less easy. Hugh Jones left to work in Birkenhead in 1859 and Hugh Hughes died in 1863, and by the time Humphreys was expanding his business in this direction William Roos was also nearing the end of his career. Evan Williams arrived in the town in about 1851, another of the preacher-painters of the period, and he produced portraits in the area until his death in the same year as Roos, 1878. Among his best known works, engraved and distributed widely, was *John Jones of Talysarn,* a portrait presented to the sitter in 1848. There are oil copies of this picture which we may perhaps attribute to Hugh Humphreys's enterprise. John Cambrian Rowlands also settled in Caernarfon sometime in the 1850s and would practise as a portrait painter (of animals as well as of people) and as a landscapist, until 1890. Samuel Maurice Jones had arrived in the town by 1889 but as yet, the only painter whom we can certainly associate with Humphreys was Peter Leon. He was apparently known to the locals as Mr Lyons but his full name was Leon Turgeny Kieweci and he came originally from Poland. He worked in the town between 1871 and 1878 and he copied the famous portrait of Lewis Morris for Humphreys. [15]

[13] There is also an isolated copy by Roos of an academic portrait of a young woman, 1740, made at Windsor in 1861. The letter to Nefydd, mentioned below, is NLW Ms.7165, and is quoted in *Artisan Painters*, op.cit., p.36.

[14] Oil copy portraits by unknown painters of religious leaders are not uncommon. The portraits of *John Davies, Nantglyn,* by Henry Room, and *Simon Lloyd, Y Bala,* by an unknown painter, were both copied to a small size, apparently by the same hand. These portraits and a copy of Hugh Hughes's portrait of *John Evans, Y Bala,* are displayed in the permanent exhibition of the history of Welsh Calvinistic Methodsism in NLW. The originals are in the collection of the United Theological College, Aberystwyth.

[15] A portrait of *The Reverend David Hughes* by Peter Leon, has subsequently been found. It is dated 1887 which considerably extends the period of his activity in Caernarfon.

This scene of intense activity is quite at variance with the received wisdom which has depicted Wales as a visual desert. It is clear that Caernarfon was a centre of artisan painting. Entrepreneurs like Hugh Humphreys turned the portraits of religious leaders into familiar and popular icons—an active force in the cultural process. Although poets were also a popular subject, portraits of ministers and preachers were by far the largest single category.

In their unpretentious honesty, naive paintings such as those of Robert Hughes suggest one of the fundamental reasons for the popularity of these images among middle-class and working-class people. They signify the need for a visual expression of religious faith. We see clearly in the literature of the period the same tendency to return to the ways of the pre-Puritan church. The popular form of the memoir constructed the mythology of the new church as the lives of the saints had of the early church. Like the lives, the memoirs were often written to a formula, and the same story elements recur with very little variety in many volumes. A number of these elements appear in various memoirs of Christmas Evans. For instance, as a young man he escaped mortal dangers several times as a result of circumstances interpreted as the direct intervention of God, who had a purpose for the young sinner in later life. His conversion is followed by persecution by former friends. Authors often showed particular interest in bodily suffering for the faith. Motifs of this kind are to be found in the stories of Mary Jones and her Bible. The emphasis on the cuts on her feet which were bleeding freely by the time she arrived at Bala is very reminiscent of the self-inflicted wounds so prominent in the lives of the saints. The visual icon kept the company of these literary motifs as the portrait frontispiece established itself as a part of the *genre*. [16]

Mary Jones was remarkable for being one of the few women to appear in popular Nonconformist visual culture. In this respect, the return to the practices of the early church was not complete. Nevertheless, it is not, in my view, a distortion of the psychology of the age to suggest that the relationship between Mary Jones and Thomas Charles resonated deeply with that between Mary Magdelene and Jesus Christ, for nineteenth-century readers. In engravings Mary Jones stands in respectful adulation below Thomas Charles, echoing both the medieval iconography of the women around Christ and the supportive and respectful role defined for women in the new church by Williams Pantycelyn.

The prominence of the image of the preacher in nineteenth-century Wales is also related to the secular aspect of the sermon as popular entertainment. The image is similar in meaning to today's posters of footballers and pop stars. Despite the protestations frequently heard concerning the rationality of the faith and the evil of uncontrolled emotionalism, the aim of the preacher was to excite

[16] Hugh Hughes noted the traditional formula in his own memoir of David Charles, 1846, before ignoring it. This memoir does not include a portrait, a most peculiar omission since Hughes himself painted the sitter at least three times.

the senses just as a football match or a pop concert excites them today. The best exponents could be the cause of quite undignified behaviour even by rationalists like Hugh Hughes who had complimented the crowd at the Association of 1820 on its 'civil and quiet' behaviour:

> At four o'clock in the afternoon I go to the parish church of Prendergast, half a mile from the town, where one Griffiths of Nevern was preaching. I see large crowds gathering here along the whole way, and already in the churchyard a crush of men by the door unable to get in, and also pressing against the windows round about, some coming out . . . and others panting and groaning, unable to get their breath. After a great deal of pushing and shoving some women almost to the point of shouting I managed to get in. It was packed and hot, and everyone practically suffocating. Having finished the vespers the preacher came and preached exceptionally well, but I and many others were longing for him to finish because of the press. [17]

[17] Diary of Hugh Hughes, 30 September, 1821. The town was Haverfordwest.

Images of Nonconformist leaders were common in England as well as in Wales. John Wesley became a cult and his iconography is extensive but contemporary figures reached popular art as well. Many of these images were also bought by Welsh people and especially images of well known preachers who came to Wales, or who, like Dr. Raffles in Liverpool, were prominent in places where Welsh people lived together in exile. Nevertheless there can be no doubting the existence of an extra layer of meaning underlying the popularity of the images of Welsh Nonconformist leaders, not present in their English equivalents. This extra layer is the most important cause of their dominance in our visual culture. The Methodists' departure from the Church of England in 1811, which stimulated the production of a generation of these images, was certainly not a nationalistic act. Nevertheless, the furious reaction to the event by many conservatives at the time was caused by an instinctive perception that an element of national pride was somehow involved. It was a specifically Welsh, and a linguistically Welsh action, in so far as it recognised that the situation of Welsh Methodists in the English church was different from that of English (Calvinistic) Methodists, however close the two groups might be in terms of theology. In time, the implications of this first public rejection of an English state institution since Glyndŵr would become a significant factor in the culture. Thomas Charles, Thomas Jones, and even the conservative and ultra-loyal John Elias, were perceived as symbols of Welshness and that meaning is embodied in their portraits.

Pictures of John Wesley in no sense became images of English nationality since the English had a range of national institutions which fulfilled that role.

Mary Jones and Thomas Charles, engraving after T.H. Thomas, 1883. From *Echoes from the Welsh Hills*, by David Davies.

Tri Chedyrn Cymru—John Elias, Christmas Evans, Williams o'r Wern, by William Morgan Williams, ab Caledfryn, c.1890. The portrait of Christmas Evans was based on the original by Hugh Hughes, not that by Roos. Hughes also painted a portrait of Williams o'r Wern, c.1836, but that copied for the print was by Wildman. Ab Caledfryn, who had his first drawing lessons from Hugh Hughes, made similar copy portraits in the form of large scale banners for National Eisteddfodau for many years. He signed this print in bardic script. The resonance of the title, 'Tri Chedyrn Cymru', is difficult to translate, but it means 'the three firm in the faith'.

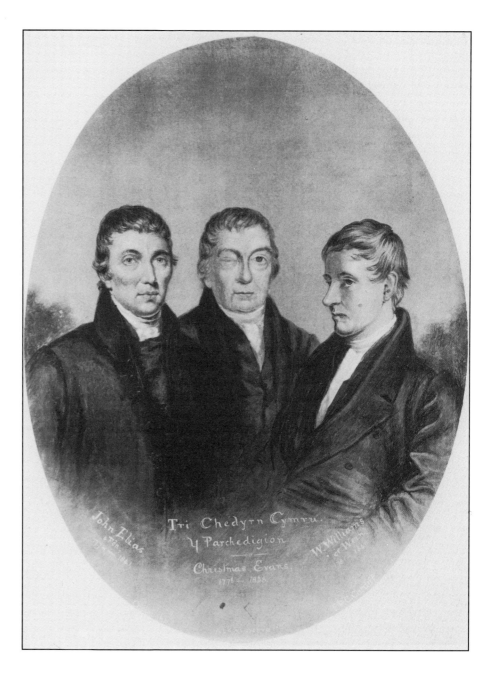

The drama of the act of dissent of 1811 gave to Methodism a national aspect which very few other movements had in the nineteenth century. Becoming a well known figure inside the movement amounted to becoming a national leader, and the popular engravings were a part of the process of developing and maintaining both individual mythologies and the collective mythology of the religious superiority of the nation.

The narrow foundation of this national leadership had important negative implications. The national mythology of the English was developed not by an iconography of confused notions of fulfilment of national expectations in the next world (and a self-satisfied belief in moral superiority whatever the political status of the nation), but by unambiguous images of praise to the institutions that fulfilled national expectations in this world. The historical painting, especially of heroic subjects, played an important role in this process. Welsh critics like Evan Williams understood the importance of pictures of this kind, and as a loyal British subject he took pride in the recent growth of the *genre* in England in the middle of the nineteenth century:[18]

[18] 'Sefyllfa Celfyddyd ym Mhrydain', op.cit., p.426.

Llywelyn Pugh addresses his friends at the Smithy on the rise and virtues of Welsh Nonconformity, engraving after T.H. Thomas, 1883. Thomas contributed numerous illustrations to *Echoes from the Welsh Hills*, by David Davies. This was the frontispiece.

Also deserving attention as a situation favourable to art in the highest sense of the word, indeed to the highest form of art, is the support recently given to it by the government in the construction of the Houses of Parliament. High art, or historical painting, have been chiefly indebted for their existence and maintainence to the aspiration to decorate public buildings of this sort, which have been neglected almost entirely in England for a long time.

Evan Williams did not extend his analysis in order to come to any conclusions about the condition or needs of Wales in this respect. Images from the new buildings, such as 'that profoundly moving picture, dear to the hearts of Englishmen',[19] *The Death of Nelson,* by Daniel Maclise, were popularised through engravings published on a large scale by organisations such as the Art Union of London, and on the more homely level by the sculptors of Staffordshire. Equivalent Welsh images in our popular art in the nineteenth century are very scarce. Hugh Hughes's *Brad y Cyllyll Hirion*—The Night of the Long Knives, published for John Jones, Llanrwst's edition of *Drych y Prif Oesoedd*—is exceptional. In Wales, on the whole, it was English imperial imagery that fed the desire for worldly heroes. These images took their place over the fireplace side by side with Christmas Evans and Williams Pantycelyn, according to denominational taste. The question arises as to whether this characteristic Welsh combination indicates a lack of demand for indigenous historical images, or a lack of supply. Was British patriotism as much a part of the Welsh psyche by the middle of the last century as the limited national pride being satisfied by the iconography of the preacher?

Popular art was defined in a book published in the 1940s as 'things manufactured in the taste of the people'.[20] The assumption that there is such a thing as a pre-existing public taste, and that the market which expresses it develops as a consequence, incorporates a number of fanciful English notions about the cultural characteristics of the British Isles. This is, in fact, an inversion of the process. Popular art contributed substantially to the cultural homogenisation that followed industrialisation and that gives credence to such a notion as 'British taste'. The rural cultures of the British Isles were still diverse in the mid-eighteenth century when popular art started to develop rapidly, and there is no reason to suppose that the taste of the people was not every bit as varied. Popular art developed when a mass market, worth exploiting from the centre, emerged with industrialisation. The means—new methods of reproducing images and distribution systems—soon followed.[21] In the process of developing the market, manufacturers appealed to the few common factors at work throughout the economic unit, and the most important of these was of course the state itself, which defined the unit. Royal portraits and events in the

[19] T. Leman Hare, *The World's Greatest Paintings,* London.

[20] The title of the book, by Noel Carrington, is confused in a most revealing manner. The cover has *Popular English Art,* while the title page has *Popular Art in Britain,* London, 1945. In the introduction Carrington reverts from Britain to England and says that popular art 'reflected faithfully the national character'.

[21] Before the nineteenth century popular art was the product of a few urban centres and in particular took the form of prints and cartoons. Ballad sheets, of course, found their way into the countryside. For an interesting example of distribution systems see Carey Morris, 'Art and Religion in Wales', quoted in: Peter Lord, *The Aesthetics of Relevance,* Llandysul, 1992, p.22.

mythology of the formation of the state are therefore prominent in popular art. As a result the acquiescent loyalty of the peoples at the fringes of the order—who were affected very little by it in their everyday lives—was transformed into a positive bonding to the English state in the period of its imperial dominance.

One might incline to argue, therefore, that pictures of Nonconformist ministers were in some sense oppositional images, considering the increasing campaign for disestablishment of the Church of England in Wales that was led by the Welsh middle class, the main consumers of these images. But although the seeds of a wider national consciousness were present in the kind of Welsh national pride that Hugh Hughes expressed in the achievements of Methodism in 1820, the pragmatism of the establishment faith, expressed in the economic and social progress of the class that maintained the movement later on, was sufficient to stifle it.

By the 1870s the image of the Nonconformist minister represented self-satisfaction and the dubious belief that the English respected Wales for its religiosity, rather than mocked it. The respectable conservatism of the images commissioned by the new colleges and the sophisticated steel engravings are redolent of the myth of Radicalism in an establishment that was, in fact, profoundly conservative in virtually all contentious matters. We can see the extent of the change in comparing these pictures with the portrait that Hugh Hughes took in 1812 of John Evans of Bala, and which he later engraved. John Evans has been described as 'the embodiment of the old Methodism of the north'.[22] The engraving is a mirror to the Methodism that Hughes himself never turned his back upon. The artist went through the disagreeable experience not of leaving his church but of seeing his church leave him, to adapt the famous remark of J.R. Jones. He came to detest the Victorian ministry as much as he detested the gentry and all other privileged and self-satisfied establishments, and he expressed his distaste in barbed satire—'sarcasm was abundant'—remarked ab Caledfryn, a portraitist of the new age. In 1842 Hughes wrote:

> The call of God is made a part of a mere farce in these days. A young man at 16 or 17 . . . knows that if he goes to the Academy, and comes out again, saying he knows Greek and Latin and can 'do' a talk, which he calls preaching, that some church will certainly call him, for churches beyond a doubt love Greek and Latin. The church must in pity call him, he has made himself learned for the sole purpose of being called and can do nothing but learned work. And unless a church is already supplied or has no respect for what Academies teach and bestow, he must have a call and he will and shall have it! . . . He is called for the Academy's sake, for Latin's sake, and for the church's destitutions sake! He is henceforth a minister of the Gospel for

[22] 'Ymgorfforiad o hen Fethodistiaeth y gogledd'. J. Morgan Jones and W. Morgan, *Y Tadau Methodistaidd*, II, p.33.

Lewis Edwards, by Jerry Barrett, oil on canvas, 1877.

John Evans, Y Bala, aged 90, copper engraving by Hugh Hughes, c. 1812-19. John Evans was a close friend of Thomas Charles. The inscription on the engraving translates as 'The gift of H. Hughes to the readers of Y Drysorfa' and it was published as a frontispiece to that magazine in 1819. The date 1812 probably refers only to Hughes's original oil painting.

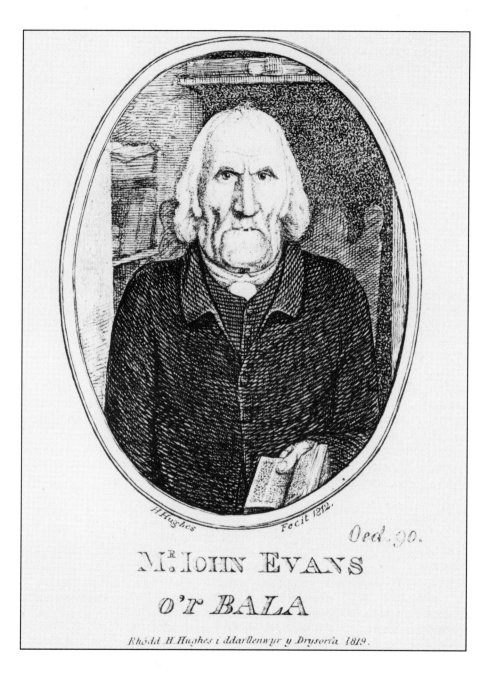

M.ᴿ IOHN EVANS

O'r BALA

Rhôdd H. Hughes i ddarllenwyr y Drysorfa 1819.

life! And he drives all the life, if he finds any, in the miserable church which gave the divine call, out of it, and their rotting together makes the world more corrupt than before.

These observations were made in a letter to his sixteen year old nephew, David Charles Davies, who became a leading figure in the Methodist hierarchy in middle age. In a letter to T.H. Thomas, written towards the end of his life, D.C. Davies denied his uncle—'I scarcely knew him', he remarked.

Artists were commissioned to paint the portraits of prominent ministers like Davies at the end of the century as they had been at the beginning. But in the age of the photograph the meaning of original portraits of this kind had changed. The photograph fulfilled the simple function of recording the appearance of the middle-class sitter, and the painted portrait was reserved for bestowing the sitter with especial dignity, the confirmation of social elevation or success in public life. By this time the academies that Hugh Hughes resented so much were in their prime, and some of them gave work to Welsh painters. Ab Caledfryn was commissioned by the Independents in Bangor and Bernard Samuel Marks by the Baptists in Cardiff, for instance. The Methodists seem to have emulated the gentry and turned to English painters. In 1877 a portrait was unveiled which tends to confirm Hughes's remarks about driving the life out of the church and which epitomises the change which had occurred since he painted John Evans in 1812. The sitter was Lewis Edwards, headmaster of the Bala College, and the painter was Jerry Barrett of London. Barrett had been responsible for one of the most famous of Imperial images, *Florence Nightingale receiving the Wounded at Scutari*. O.M. Edwards, who fled the unctuous ceremony, noted the comments of a more diligent friend who stayed behind: 'The unveiling of the Dr's picture was a scene of awful seboni', he elegantly remarked. By elevating the 'theological Doctors', as Hugh Hughes called them, to the status of national heroes, the middle class was singing its own praises, celebrating the material and social progress built in to the tenets of the faith. Daniel Owen symbolised the same change of atmosphere when he set the Reverend Obediah Simon in the place of Rhys Lewis in his novel *Enoch Huws*.

The golden age of the popular iconography of the preacher had passed its high point. Few of the new oil portraits reached a wide public through the medium of the engraving. In books such as *Enwogion y Ffydd* the achievements of the present day were praised in the context of a mythologised heroic age and illustrated by engravings designed to be visually consistent with the new. Only the paintings of Robert Hughes maintained something of the energy and spirit

of the early movement. Robert Hughes spared his Methodist Fathers the comfortable overlay they generally aquired in the 1880s.

Images of preachers stood side by side with images of the Empire in the Welsh Victorian parlour and the audience could rest easy in the knowledge that there was no conflict between them. Some efforts were made to elevate imperialists and soldiers to the level of national heroes. In 1827 an ambitious and splendid memorial to Picton was raised in Carmarthen, designed by John Nash, but it was demolished by the next generation who did not regard it as of sufficient value to justify restoration. *The Death of Captain Wynn at Alma* was the subject of the painting competition at the 1858 Eisteddfod, and Picton was resurrected in the Pantheon of National Heroes in the City Hall in Cardiff more than half a century later, but these images did not grip the popular imagination. The moral leadership of middle-class Nonconformism obviated the need for military heroes of the old aristocratic order. On the other hand, the English gentry were sufficiently remote to elevate into Alexandrians without conflicting with the new Welsh order. Some among the generation of Cymry Fydd who understood the significance of the visual image, including T. Mardy Rees, Thomas Matthews, Llandybïe, and T.H. Thomas, Arlunydd Penygarn, clearly perceived a gap in the indigenous culture in comparing its product to English historical painting. But it is significant that the only historical images to come out of the artists of this circle and which had any impact on popular consciousness through the medium of the print were two images from the history of Nonconformism. [23] The loose quality of T.H. Thomas's original painting suggests that he intended *John Elias Preaching at the Bala Association* to be reproduced as a print from the beginning. A version of it was first published in David Davies's *Echoes from the Welsh Hills* in 1883, but by 1892 it was transformed into an attractive coloured poster which was used as a base onto which shopkeepers could have printed a personalised calender to advertise their businesses. In twenty years time, *Salem* would follow, in a more complex way, in its Nonconformist wake.

We saw how Robert Hughes, in his unpretentious way, had attempted a composite historical picture using engravings as his source material. A not dissimilar method was adopted by a professional painter, Hugh Williams, in 1912. *Y Sasiwn Gyntaf*—The First Association, was based on familiar engravings of Williams Pantycelyn, Daniel Rowland and Howel Harris— another example of the artistic round-trip being completed. But Hugh Williams's original, which is a rather uninspired affair, is mainly of importance as the source of the lithograph made from it. Williams also made portraits of Llywelyn, Hywel Dda, and a variety of other historical figures, but *Y Sasiwn*

[23] I think that this statement ignores the impact of Thomas Prytherch's illustrations for Owen Rhoscomyl's *Flame Bearers of Welsh History*, Merthyr Tydfil, 1905. Although they seem unremarkable now, a number of people who grew up with them have told me of their inspirational effect.

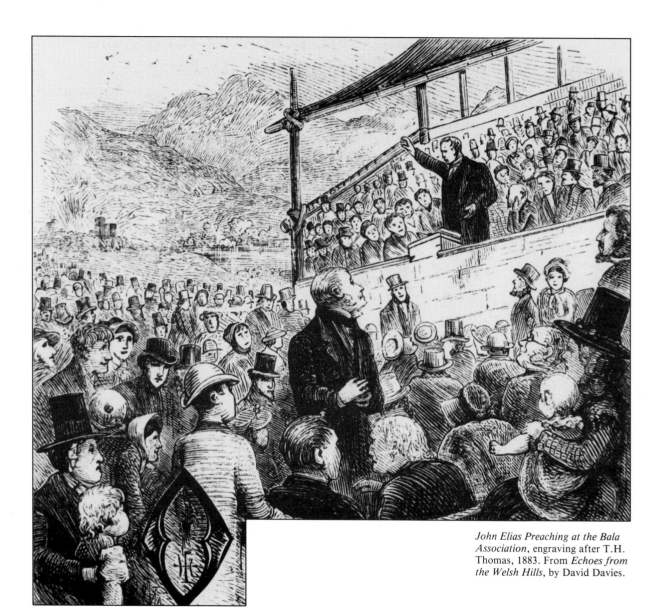

John Elias Preaching at the Bala Association, engraving after T.H. Thomas, 1883. From *Echoes from the Welsh Hills*, by David Davies.

[24] For details of the picture see: K. Monica Davies, 'Y Sasiwn Gyntaf', *Cylchgrawn Cymdeithas Hanes y Methodistiaid*, 1982, p.61.

Calendar for 1940, with portrait of Samuel Roberts, Llanbrynmair. This calendar is one of a series published in the 1930s and early 1940s with portraits including Christmas Evans and Twm o'r Nant.

Gyntaf alone caught the public imagination, finding a place in the vestry and in the parlour early in this century. [24]

The image of the preacher certainly expressed national pride, but it was also a part of the wider structure that allowed Welshness and Britishness to coexist. It was an expression of a kind of introverted and self-congratulatory patriotism which might prosper within Wales, and within a particular stratum of society in Wales, without threatening a broader British loyalty. The image of the preacher fed the myth of the moral superiority of the nation, and set in the context of imperial imagery it succeeded in giving the vague impression of Wales as the moral conscience of the Empire. What better assurance could the Welsh middle class create for itself than this combination of moral superiority as Welsh people, and economic and military superiority as surrogate English people, at one and the same time?

Elegy for Arthur, by Iwan Bala, oil on board, 1989.

(*Private collection*)

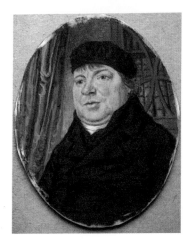

Thomas Jones, Denbigh, and Mrs Jones, by Hugh Hughes, watercolour on ivory, c.1812. This miniature was the source of the familiar engraved image of Thomas Jones. Mrs Jones was not engraved.

(*Amgueddfa Hynafiaethau Cymreig, Bangor*)

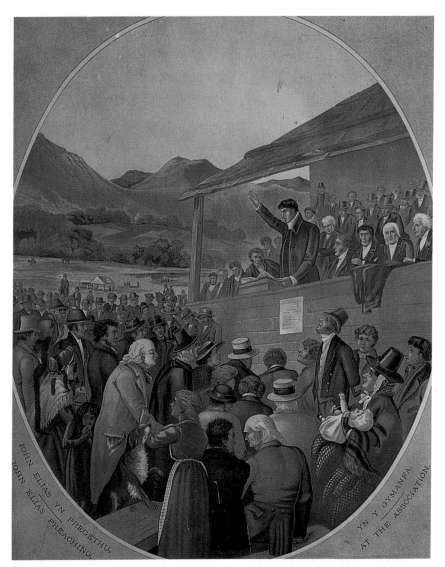

John Elias Preaching at the Bala Association, colour lithograph, by T.H. Thomas, 1892. The colour print, sold as a customised calendar, was preceeded by a black and white version in *Echoes from the Welsh Hills*, by David Davies. The National Museum has a large but sketchy painting of the subject.

(*Cymdeithas Hanes y Methodistiaid*)

The Myddleton Memorial, Chirk, by
Robert Wynne, Italian marble, 1720.
(*The Church in Wales*)

Dic Aberdaron, by an unknown sculptor, stone, unknown date. This carving bears a striking resemblance to the carving made by Robert Rees Jones of Aberdaron in about 1910, who claimed that work as his only sculpture.

(*The National Library of Wales*)

The Millstream at Swydd y Ffynnon (opposite page, bottom left), *Pendinas and the River Ystwyth* (opposite page, bottom right) and *A Baptism at Llanbadarn,* by the Aberystwyth naive painter, watercolour on paper, c.1845.

(*The National Library of Wales*)

Y Berl Briodas, by Robert Hughes, Uwchlaw'r Ffynnon, oil on board, 1888. Although the picture is inscribed with the words 'The Pearl Wedding' it was in fact a diamond wedding. Hugh Jones was 98 years old and Jane Jones was 100 when they celebrated seventy five years of marriage at their home, Tŷ Uchaf, Clynnog. The picture has not been restored.

(*Private collection*)

The Last Bard, by Thomas Jones, Pencerrig, oil on canvas, 1774.

(*The National Museum of Wales*)

Swansea Pottery Tankard, c.1803. The painting closely follows de Loutherbourg's print, and may be by William Weston Young. It was gilded by Pardoe.

(*The National Museum of Wales*)

Llywelyn ap Gruffydd, by Harry Pegram, plaster, c.1914. This is a maquette for the statue in the pantheon of National Heroes in the City Hall, Cardiff. Pegram was a student of Goscombe John.

(*The National Library of Wales*)

The Hywel Dda Building, Whitland, Dyfed, by David Thomas, 1985. The building incorporates artwork by Peter Lord, Maggie Humphrey, David Peterson and Glyn Rees.

(*Photograph: Michael Murray*)

THE MEANING OF THE NAIVE IMAGE

In my essay 'The Popular Iconography of the Preacher' I used portraits of Christmas Evans and John Elias made by naive painters to suggest how deeply the image of the preacher had established itself in the Welsh consciousness, and how important the visual culture was in the formation of that consciousness. The advantage of the picture over the word is that it can crystalise a complex net of understandings in a single image, comprehensible in a moment. That image may become an icon if the understandings it represents are sufficiently important in the culture. The culture of Wales has a number of such icons—The Preacher, The Bard, the landscape of Wild Wales, and so on.

As we saw, in 1886 Robert Hughes of Uwchlaw'r Ffynnon recreated the only meeting of Thomas Charles, John Elias and Henry Rees, in the form of a naive painting. Thomas Charles in particular was on the nation's mind at the time. The year before Robert Hughes painted his historical picture, the centenary of the establishment of the Sunday School movement was celebrated. Community events were staged all over the country based on literature and music. The following advertisement appeared in *Yr Amserau* on 11 October 1884, for example:

This essay was first published in *Barn*, 348/349, January/February, 1992, as 'Ystyr y Llun Naif'.

A Simple and Dramatic Cantata
Charles of Bala or The Jubilee
by H. Davies AC (Pencerdd Maelor).
The words by Elias Hughes, Colwyn Bay.
Sol-fa version, 6d, Old Notation, 2s 6d, Words only, 2d.
The music has been arranged in such a way that ordinary soloists
may take the solos and the duets, etc., and to enable everyone to take part in
the work, etc.

The Jubilee was celebrated visually as well. A medal with a picture of Thomas Charles on it, based on the engraving after Hugh Hughes's original miniature, was cast. It was very widely distributed, and in the same way as the naive painter, Robert Hughes, took advantage of engravings as a basis for his work, a naive sculptor took advantage of the mass-produced medal to create a unique art object to celebrate the occasion. *The Jubilee Sculpture* is further evidence of the breadth of an indigenous visual culture supposed not to exist, and of the

correspondence between the musical, the literary, and the visual, unexplored by our cultural historians.

The name of the sculptor is unknown but he was probably male and from Dyffryn Ogwen, or thereabouts, since a tradition of decorative slate carving had flourished there amongst the quarrymen over several generations by 1885. Gwenno Caffell's pioneering work in the recovery of this tradition[1] has shown that the period up to 1850 was the most important for the massive carved fireplaces—there are only a few later examples. Nevertheless, Gwenno Caffell suggests that the carving carried on in the form of numerous small objects such as fans, and *The Jubilee Sculpture* confirms this. Further evidence for the continuing tradition comes in the form of slate-carving competitions in the National Eisteddfod from 1866 on, although self-conscious efforts like this by intellectuals to encourage a tradition can often be more indicative of a decline than of a flowering. Some of the Eisteddfod productions were highly skilled and correct, but essentially sterile work, consistent with the designs of the pattern books but quite different from the individualistic domestic examples.

[1] Gwenno Caffell, *The Carved Slates of Dyffryn Ogwen*, Cardiff, 1983.

Sunday School Movement Jubilee Sculpture, by an unknown sculptor, slate, c.1885.

Nevertheless, it is fair to use the word 'tradition' in this context—the competitions show that carving slate was recognised as a specialist field with its own history. Robert Hughes, Uwchlaw'r Ffynnon, did not work in such a recognised tradition. The category of 'Naive Painter' had not yet been identified.

Nevertheless, he was well known in his day. In August 1884 the local scientific and literary society took a trip around the antiquarian sites of the north coast of the Llŷn peninsula:

> Having arrived at Llanaelhaiarn, a visit was first made to the famous old well of Uwchlaw'r Ffynnon . . . Then the studio of the Rev. Robert Hughes was visited, and there the faces of the famous people painted by the self-taught artist of Uwchlaw'r Ffynnon, of whom it is said that he was over fifty years old before he started to paint, were inspected . . . [2]

[2] *Yr Amseroedd*, 23 August, 1884.

The 'Old Patriarch' was clearly considered an eccentric by these intellectuals. Robert Hughes was a Methodist minister and his son saw the same eccentricity manifested in his professional life: 'Originality was the particular quality that characterised his sermons, in which he was on his own', he remarked, rather defensively. Robert Hughes was something of a failure in the eyes of a son who had had the benefits of a formal education, through which he had absorbed thoroughly the improving spirit of the age:

> I always felt in hearing him preach that it was a great pity that he had not had the advantage of disciplining his mind . . . But he was bereft of the ability to cook well a tasty dish for his listeners out of the ingredients he had at hand for the purpose. His clumsy and awkward style of address was a barrier against the beauty of his images and metaphors becoming apparent in the minds of the listeners. [3]

[3] This and following quotations concerning Robert Hughes are translated from: Robert Hughes, *Hunan-Gofiant ynghyd â Phregethau a Barddoniaeth* . . . , Pwllheli, 1893.

A patron had once offered Robert Hughes the chance to attend university in order to discipline and improve his independent mind. He had refused on the grounds of family responsibilities, and it was a good job for us that he did since we have inherited some fifty pictures of great importance as a result. It is highly unlikely that we should have had them had the sophisticated mentality of Oxford taken hold of him, making him self-conscious about the conventions of visual correctness in his period. There is very little of that correctness in his work, and very little development over thirty years of painting, either. Indeed, in terms of the values of the period, Robert Hughes deteriorated over that time.

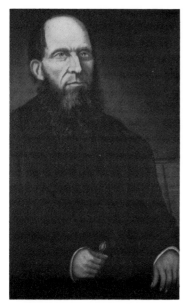

Self Portrait, by Robert Hughes, Uwchlaw'r Ffynnon, oil on canvas, c.1870-80.

His earlier works, including the two self-portraits and the portrait of his 'amiable, orderly and intelligent wife', show an awareness of the conventions of academic portraits.[4] He learnt these not only from the engravings on which many of his portraits of the famous are based, but also from photography, since photographic conventions such as classical pillars and landscape backgrounds were derived from academic painting. Robert Hughes painted his self-portrait on canvas, probably copying the photograph subsequently published in his memoir. But by the 1880s he had forgotten about any attempt at academic correctness, adopting a style which is today categorised as naive.

Although Robert Hughes avoided the fate, several of our painters suffered improvement in a manner consistent with the aspirations of the organisers of the 1865 Eisteddfod at Aberystwyth. They had sought to discover the 'artistic talent that may yet lie dormant in our secluded vallies and to correct the taste of our aspirants' to the world of art. Hugh Hughes was improved about 1825 when he began to adopt academic portrait conventions in place of the simpler artisan manner which characterised his work in the previous fifteen years. This is the style of his masterpieces such as *Huw Griffith, Bodwrdda* and *The Family of John Evans, Carmarthen, at Breakfast*. At about the same time, Penry Williams was undergoing an improvement that would prove even more destructive. On the basis of the promise of such pictures as the two which portray *The Merthyr Riots of 1816*, he went to London to study art at the expense of the local gentry. Although he returned to Merthyr for a period, he spent most of his life in Rome producing dozens of scenes of picturesque Italian ladies amongst the ruins of the decayed splendour of that place. Despite the academism of their style, I do not think it fanciful to perceive, under the surface, an essential naivety of vision. It is interesting to speculate how this mixture of facility and simplicity, had it been put to work in his homeland, might have enriched the indigenous culture. As it is, his pictures have scarcely enriched either academic art culture or our indigenous visual culture. They stand rather in the wasteland, lost between two worlds.

Penry Williams's close friend in Rome, John Gibson, certainly did contribute considerably to the culture of academic art. Nevertheless, for all his classical erudition, according to his contemporaries, Gibson was something of a naive character. His American pupil Harriet Hosmer had remarked: 'He is a God in his studio but God help him when he is out of it.' There is not, then, always an obvious correspondence between the personality of the artist and the style of the work. In the same way, turning the example of Gibson upside down, it does not always follow that the naive painter is a naive person, a point which we often loose sight of when considering the work of unknown painters. Robert Hughes had

read widely, for instance, and was used to discussing obscure theological matters, as well as having some familiarity with 'proper' painting.

Robert Hughes taught himself to paint, and the 'originality' to which his son referred so disparagingly is often a characteristic of the auto-didact. His knowledge was not channelled into conventional intellectual patterns, but into the pattern of a life influenced by many considerations outside the experience or interest of the academic artist. These directed his painting and fill it with significance for us. Unpretentious portraits such as *Sion Griffith, Bryn-yr-odyn*, painted about 1888, are a mirror to that experience. Its dark colours, which are unusual in the work of naive painters, take us straight to the hearth at Uwchlaw'r Ffynnon, the peat fire and the candles. Nevertheless, in his memoir—which is in part an autobiography—we find a story which warns us against romanticising and over simplifying the nature of his community, and against constructing the naive painter into a sort of grown-up who is still a child. The story also throws an unexpected and interesting light on the character of one of the icons of convention and respectability in the period, Lewis Edwards:

Dr Edwards had been preaching that morning in Gyrn Goch, near Clynog . . . It was arranged that he would come from Gyrn Goch to Uwchlaw'r Ffynnon for a 'cup of tea and a fag' before setting out to cross the slopes of the Eifl. Having finished tea, Dr Edwards and Robert Hughes were to be seen, one on each side of the fire, chatting and smoking in comfort. Who should come to Uwchlaw'r Ffynnon with the cart from Pwllheli market . . . but the Rev. Griffith Hughes, the greatest anti-smoker of his period! He entered the house without ceremony, as was his custom; and having gone some way in stood stiff with amazement in the middle of the floor, as the two ministers eyed him through columns of smoke. 'Well, this is the end', said Griffith Hughes, 'Two ministers of the gospel in mad contention.' 'You know what Gruffydd', said Robert Hughes, puffing out another column of smoke from his mouth, 'You know what Gruffydd, seriously now, they say that they have just recently discovered a fag-end belonging to the Apostle Paul.' 'Well don't talk such nonsense Robert', said Griffith Hughes. 'Well, I'll tell you this anyway', began Robert Hughes again, 'They are searching the old ruins and remains of Athens these days, and they've certainly found an old fag-end in a terrible state amongst the ruins; and another thing, it's certain that the Apostle Paul was near Athens. Well, now then Gruffydd, I bet you can't prove to me that the fag-end that they found in the ruins of Athens *didn't* belong to the Apostle Paul!' Griffith Hughes went silent, and Dr Edwards burst out laughing with all his might . . .

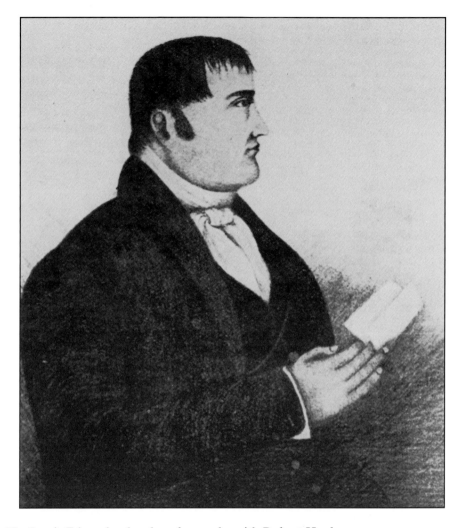

Robert Evans, elder of Moriah, Caernarfon, by an unknown painter, c.1835-45. Like so many other fine naive and artisan paintings, the original is lost, known only through a half-tone reproduction. The sitter was school superviser at Moriah from 1817, secretary of the chapel, and became an elder in 1828.

The Lewis Edwards who shared a smoke with Robert Hughes was a very different person from the one painted by Jerry Barrett at the expense of Bala College. The business of the academic painter, even in portraiture, was to communicate a value system. Whereas academic painters are self-conscious and didactic, naive painters, generally speaking, are a mirror to the great ideas only when they have filtered through to the subconscious of ordinary people, in a fairly confused condition. Through the eyes of the naive painter we have a

different view of the state of mind of a culture from that which we are shown in works of high art.

The academic painter adapts and generalises the subject so that the finished image is consistent with an aesthetic. The naive painter, on the other hand, tends to note in detail everything that is idiosyncratic about a person or a view. He or she is a realist, but more particularly, a narrative realist. In the portraits of Robert Hughes, for instance, we see the full face of the sitter and at the same time are given a view of the side of the nose and face, so that we are in possession of as much information as possible. This is not the photographic vision of the camera but the literary vision of the story teller. Again, the painter of *The French Landing at Fishguard* seeks to explain to us every element in the story and so chooses an imaginary viewpoint high in the air, following the archaic convention of the estate view of the seventeenth century. The woman in the tall black hat in Sargeant-Major Hanson's portrait of *The Toll Gate by the Coopers Arms in Aberystwyth*, painted in 1863, is not a picturesque device to add national character to a Welsh scene. This is a realistic portrait of a particular person, Mrs Ann Jones, one of his neighbours, who would live to be a hundred years old, and the dogs in the street are not any dogs, but the Sargeant-Major's own, each one a portrait.

One of the characteristics of the national psyche which is expressed clearly in nineteenth-century naive art is the mix of national pride and Britishness. Between 1842 and 1852 James Williams, a tailor from Wrexham, made one of the masterpieces of our visual culture in the form of an appliqué bedspread. It is on a large scale, measuring some ten feet by nine feet. Within a border linking the symbols of the constituent parts of the union with the crown at its centre, James Williams designed a parable of human progress and improvement, beginning with Adam naming the animals and ending with the technological high points of his age, the Menai Bridge and the railway viaduct over the Dee. Amongst the Biblical images are the stories of Cain and Abel and of Jonah and the Whale. James Williams gave them all a sunny, optimistic gloss, perhaps reflecting the confidence of his faith, and certainly the confidence of his period. He chose to portray the flood with the dove returning to the ark with an olive branch.

Balancing the Menai Bridge in James Williams's composition is an oriental temple, and along the bottom, an eagle riding on the back of a stag. Perhaps this image reflects the folk tale theme of the oldest beasts, common to many cultures, a version of which is to be found in *Culhwch ac Olwen*. Balancing this striking image there is a black man hunting and a wild horse. The exact meaning to James Hughes of images of other continents is unclear, but it is hard to

Appliqué Bedspread, by James Williams, 1842-52.

believe that their choice was random—the whole nature of the work suggests that a clear concept lay behind it. In the imperial period ordinary people developed a new consciousness of the wider world through newspapers, relatives abroad in the army or navy, and the interest in missionary activity expressed in the religious press. Visual representations of all the corners of the earth appeared on everything from advertisements for tea to the willow pattern cups and saucers from which it was drunk. These were James Williams's most important sources, although perhaps his Adam owes something to the academic nude.

Pride in Victorian technology was often symbolised by bridges. The Menai Bridge, opened in 1826, before Victoria came to the throne, was an early icon of technology. Artists came to Bangor to admire and to sketch it for a deluge of engravings and oil and water colour paintings. Hugh Hughes was amongst the first, arriving in 1820 as the bridge was still being constructed: 'Stop an hour at the ferry house', he noted in his diary, and 'view the new bridge, which I can conceive will be an astonishingly grand and magnificent object when finished.' In London William Owen Pughe considered buying a print of it, 'the first for sale', an event of sufficient importance to note in his diary. And before long the new bridge—'Uchelgaer uwch y weilgi'[5]—sank into the popular consciousness of the nation in poetic as well as in visual form. It is not known whether James Williams ever visited the bridge, but even if he had been in Bangor it is unlikely that he would have sketched the technological wonder. Generally it was not the habit of naive artists to make preparatory sketches. James Williams probably created his image by simplifying one of the prints that suggested its significance to him in the first place. There are several similar representations of the bridge made by the slate carvers of Dyffryn Ogwen, and other examples survive in the form of embroidery and paper collage.

James Williams would have used prints as a source for his Biblical imagery as well. This is one reason for the striking similarity in the imagery of naive painters throughout the Western world. The style of the tailor from Wrexham is similar to that of Edward Hicks, the most famous of the artisan painters of the United States. Hicks painted some sixty versions of one particular image on the basis of an engraving of a painting by an English academic artist, Richard Westall, *The Peaceable Kingdom of the Branch*. This interpretation of Isaiah 11.6 was reproduced as an engraving in nineteenth-century Bibles. The same are source was available to James Williams, either in the original or in the form of popular art derivatives on ballad sheets, common in the 1840s. The same is true of his animals. The magazines of the period brought the animal wonders of Africa and India to public attention in the name of education. *Seren Gomer*

[5] Literally, 'The high castle above the ocean', the beginning of a popular *englyn*. William Owen Pughe is translated from his diary, Mysevin collection, NLW Ms.13248.

The Menai Suspension Bridge, by an unknown slate carver from Dyffryn Ogwen, c.1835. The carving is on a fireplace.

published such a series in 1829, for instance, which included the elephant, the giraffe and the ape. The editor suggested that these had been drawn from life especially for his periodical at the new zoo in Regents Park (probably by Hugh Hughes) but most pictures of this sort derive from Thomas Bewick's famous *The General History of Quadrupeds*. This masterpiece was published in 1790 and proved a rich source for generations of engravers of popular prints and illustrations. But even in the original work of Bewick are to be found signs of an older visual language.

In the work of James Williams there is an archaic, heraldic quality which wells up from the depths of the consciousness of the naive painter. In the work of Edward Hicks it was nearer the surface since he was trained as a sign painter. The popular prints were a medium for the continuation of this heraldic language into the last century and an important part of the visual environment which informed the style of naive artists. We see their influence in a complicated zodiac made for a fireplace in 1837 by two carvers from Dyffryn Ogwen, Thomas and William Jones. The almanacs were one of the vehicles of popular art and certainly the source of the information and visual language used by the Joneses. Welsh almanacs were produced by John and Robert Roberts of Holyhead and by John Jones of Trefriw, amongst others. The woodcuts sometimes used to illustrate them were also used to illustrate ballads, and there are Welsh-language examples with pictures from the 1730s on. A century later Hugh Hughes was producing blocks for John Jones and also possibly for Robert Roberts who visited him in his studio in London in 1826. Of a younger

Adam.and Eve—The Earthly Paradise, by James Cope, woodcut, published by John Jones, Llanrwst, c. 1840.

generation was Ellis Owen Ellis, who created some of the most striking images of the period in the form of political and religious satires for *Y Punch Cymraeg*. Ellis also produced simple wood engravings for a number of pamphlets and books, some of them published by the art entrepreneur Hugh Humphreys in Caernarfon. It is not difficult to imagine Robert Hughes, Uwchlaw'r Ffynnon, and his friends reading publications such as *Hanes Dic Turpin* and *Hyfforddwr y Ffermwr* (The Farmer's Instructor). We see clearly in drawings such as *The Funeral of Dic Aberdaron*, possibly prepared for an unpublished volume, the common ground of heraldic convention on which stood the visual language both of the professional popular artist, Ellis Owen Ellis, and of Robert Hughes and other naive painters. Indeed, in 1855 Ellis Owen Ellis was 'up to his ears' in work, 'preparing illustrations and Armorial Flags and figures for the Liverpool Corporation, who are making great preparations to welcome the visit of His Royal Highness the Duke of Cambridge to the town ...'[6]

[6] NLW Ms.1889E.

Among the characteristics of the heraldic language is drawing objects from the point of view which explains them most clearly, that is the side or the front, rather than somewhere between the two. It is observable in the work of artisans, as well as in naive painting. Some of Hugh Hughes's early portraits were archetypical in this respect. Robert Hughes was more complex because of his habit of copying from prints of more sophisticated paintings and from photographs. His work is also devoid of another aspect of the heraldic tradition, the inscription on the front of the painting, but *The Jubilee Sculpture* retains this characteristic. Its lettering style belongs to the eighteenth century when it was used on gravestones and in painted inscriptions on church walls. The source of the style was printing type-faces that had long disappeared from newspapers and periodicals by the 1880s, but which were still to be seen as models in the churches and churchyards. The tradition of the inscription persisted in the work of some artisan painters as late as the mid-nineteenth century. William Roos added inscriptions to his portraits of Dic Aberdaron, for instance.

John Gibson wrote in one of his letters to Mrs Sandbach, Hafodunnos, about the influence of this kind of visual language on him when he was a child in Conwy:

When I was about seven years old I began to admire the signs painted over ale houses, and used constantly to gaze up at them with great admiration. One day I made my first attempt to draw a composition from nature: my attention had been frequently attracted to a pretty scene; it was a line of geese sailing upon the smooth glassy water. I drew the geese upon my

Richard Robert Jones, Dic Aberdaron, by Robert Rees Jones, limestone, c.1910. Photograph by Geoff Charles. The sculpture was made for an Eisteddfod competition in Aberdaron, and clearly based on the engraving by William Clements. It won the prize of £1.

Robert Rees Jones, photograph by Geoff Charles, 1961. Jones was a cobbler. The story accompanying this newspaper photograph notes that this was the only stone carving he ever made. However, the National Library has a strikingly similar stone carving of Dic Aberdaron by an unknown sculptor.

father's casting-slate, all in procession, every one in profile. When my father looked at my performance, he smiled, but when my mother cast her eyes upon the drawing she praised me, and said, 'Indeed Jac, this is very like the geese.'[7]

[7] *The Biography of John Gibson*, op.cit., p.3.

Gibson's geese, sailing in profile, parallel to the picture plane, were an example of nature copying heraldic visual language, which is perhaps why they took his eye as a child. There is a tendency to compare the work of naive painters to the work of children because of this simplicity of design, but in making the comparison there is a danger of concluding that the naive artist retains some sort of instinctive and therefore universal human way of representation—a natural style. I read recently in a learned American journal that the appeal of naive painting was to be found in 'its instinctiveness, its natural qualities'.[8]
The roots of this misunderstanding are to be found in Rousseauesque ideas of modern human beings having descended from some ideal and natural condition. The child, or the adult with a child-like visual imagination, sometimes perceived in the naive painter, is portrayed as being closer to this condition than anyone else in the modern world. The Garden of Eden imagery of Hicks and others reinforces the supposition. But it is a myth. The images of children are the

[8] Eugene W. Metcalf, Jr. and Claudine Weatherford, 'Modernism, Edith Halpert, Holger Cahill, and the Fine Art Meaning of American Folk Art', *Folk Roots, New Roots*, ed. Jane S. Becker and Barbara Franco, Massachusetts, 1988, p.146.

learned product of a particular visual culture, an expression of visual conventions which sink into their consciousness from their environment from their earliest days.

Heraldic conventions are evident in the work of the unknown artist who made *The Banner of the North Wales Quarrymen's Union* probably around the turn of the century. This work is known to us only in an old photograph. No visual record at all remains of a splendid table cloth made by Messrs Roberts of Pool Street, Caernarfon, which was exhibited in the National Eisteddfod in the town in 1862. It attracted a great deal of attention at the time—'A magnificent table cloth, home made, containing eight representations of the castle.' It would be interesting to know if those representations were heraldic, like the union banner, or whether the picturesque and naturalistic influence of contemporary landscape painting was to be seen there, since the subject was so much painted and engraved. The table cloth and the union banner would have set the masterpiece of James Williams in a wider context than that in which it now appears, as an isolated phenomenon, categorised as folk art.

Generally speaking, the landscape was not as attractive to the naive painter as animals, people, and man-made objects. The works of a naive painter who

A Fountain near Aberystwyth, by the
Aberystwyth naive painter,
watercolour, c.1845.

Market Day in Wales, engraving after
R. Griffiths, 1851. No other works by
R. Griffiths are known, if he or she
was not also the Aberystwyth naive
painter, and perhaps the painter of
the portrait of Robert Evans, Moriah,
Caernarfon, where he or she is known
to have worked.

worked mainly in the Aberystwyth area in the 1840s are of particular interest, therefore. A number of the pictures, especially *A Fountain near Aberystwyth* and the masterly *Baptism at Llanbadarn,* show the usual interest of the naive painter in the everyday life of ordinary people. But the artist shows an awareness of picturesque conventions in a number of pure landscapes. Nevertheless, the visual language of the constituent elements of even these pictures clearly suggests that the works should be categorised as naive. Indeed, the works are to be considered as masterpieces of naive painting.

The name of the painter is unknown, but there are two clues to his or her identity. In the foreground of *Fall on the Rheidol* we see an artist in a blue coat at work. If we take this to be a self-portrait then the painter was a man. The other clue comes in the form of an engraving published in 1851 as the tourist taste for souvenirs in the form of images of the old fashioned clothes and customs of the Welsh grew. A number of Welsh painters worked to meet the needs of this market, in particular John Cambrian Rowlands. However, despite the simple quality of his early work, Rowlands cannot have been responsible for this print. The style, composition and characterisation of the individuals are strikingly similar to the work of the naive painter of Aberystwyth. According to an inscription, the name of the artist was R. Griffiths, but nothing more is known.

It is difficult to decide, in the absence of any background information, whether the interest of the Aberystwyth naive in the ordinary people arose from the influence of costume prints, or directly from belonging to that world. There is a tendency to assume a simple correspondence between the naive painting and the social status of the painter, similar to that other doubtful correspondence between style and personality. The naive painter is not necessarily one of *Y Werin.*

Much work in a naive manner was produced by the gentry and the middle classes, and especially by women within these social groups. Augusta Hall, Lady Llanofer, is well known as the vital figure in the development of the fashion for Welsh costume, but her visual interests extended much further. Lady Llanofer was the first editor of the extensive correspondence of Mrs Delaney, one of the most remarkable of eighteenth-century women. Mrs Delaney filled the long leisure hours of her genteel existence by producing all sorts of craft work, such as miniature painting, paper mosaic, and embroidery. Lady Llanofer formed a substantial collection of her works, and we may trace her own deep interest in textiles and in painting back to this source. Through the influence of Mrs Delaney on the fashions of her period, 'Ladies Occupations' became popular. Instruction books were published, with genteel titles such as *The Young Ladies*

Book: A Manual of Elegant Recreations, Exercises and Pursuits, and the fashion spread down into the middle classes in the nineteenth century. There are Welsh examples of work in a naive manner probably made by women of this class, including a series of straw pictures of views in the Colwyn Bay area produced in the middle of the nineteenth century. It is perfectly possible, therefore, despite the portrait of a painter at work, that the Aberystwyth naive was a middle-class woman. Considering the painter's awareness of landscape painting and the need for money and leisure time in order to reach the places portrayed (there are some works from the Caernarfon area as well), the possibility cannot be dismissed.

A number of naive artists who were, in fact, of humble origin also had gentry connections. A painter called Rowland worked as a gardener in the large houses of his home area in Pembrokeshire at the end of the last century. He was very productive and a collection of his works has survived. He painted dogs, cockerels, and other animals, as well as depictions of local houses, including

The Reverend Francis William Rice, 5th Baron Dinefwr, Vicar of Fairford, by an unknown sculptor, probably the Dinefwr Estate carpenter, c.1860. The estate carpenter at Dinefwr also carved a number of fine walking sticks.

Menai Road and Rail Bridges, by Helen Butcher, straw work and guache on paper, c.1860. This is one of a group of scenes portraying the area by the same artist.

[9] Further examples of Roberts's work have subsequently come to light and also another example of work by an employee of the gentry, the sculpture of the *Reverend F.W. Rice, 5th Baron Dinefwr,* perhaps made by the Dinefwr estate carpenter. For Cornwallis West, see: *Y Chwaer-Dduwies, Celf, Crefft a'r Eisteddfod,* op.cit.

[10] A classic example of the promulgation of this myth is Rev. David Davies, *Echoes from the Welsh Hills*, London, 1883, with illustrations by T.H. Thomas, Arlunydd Penygarn. Iorwerth C. Peate contributed more recently in the context of visual culture.

[11] At various points in his *Cambria Depicta*, London, 1816. I quote some examples in my *Artisan Painters,* op.cit., p.12 and 13.

Cressely, and castles, including Carew. W. Roberts, a porter at Rhuthun Castle, also produced a picture of his master's house, but by inlaying ivory into a heavy piece of wood in 1860.[9] The date and location of this piece are of especial interest. The owner of the castle, W. Cornwallis West, was an enthusiastic amateur painter and a connoisseur of the fine arts. He led a crusade to raise consciousness about visual culture in Wales, especially amongst the working class, from the 1860s on, using the new reformed National Eisteddfod as a platform. He was the organiser of the first very large exhibition of the fine arts to be held in Wales, at Rhuthun in 1868. It is reasonable to suppose that the art-conscious environment in which he worked was a source of encouragement to W. Roberts.

It is important, therefore, to resist the temptation simplistically to consider naive images as the exclusive expression of the working class. It is a particular danger in Wales where the myth of *Y Werin* has such appeal.[10] In general, little tends to be known about the backgrounds of naive artists, which facilitates the process of coming to simplistic conclusions about them. Robert Hughes is unusual because of the extent of our knowledge of him, and is, as we saw, a testament to the dangers of patronising over-simplification.

This is not the place to go into detail about the dangers of the myth of *Y Werin*, except perhaps to note that James Williams's masterpiece is kept at the Welsh Folk Museum, rather than at the academic art galleries of the main building of the National Museum in the centre of Cardiff. Isolating objects of this sort in categories such as folk art can lead to misunderstanding their nature and to distortion of the visual tradition as a whole. As we have seen, there was a complicated interaction between academic art, the popular print, the work of artisan painters, and the work of naive artists, which is not interpreted, as I have so often pointed out, at either institution.

For all that, it is difficult to avoid some categorisation if we are to make sense of the complexities of social organisation in eighteenth- and nineteenth-century Wales, as manifested in and affected by the visual culture. And we should remember that such categories were a part of contemporary thinking. The literature shows how, for instance, the amateur—and especially the female amateur—was a recognised category of artist by the early nineteenth century. The Eisteddfod competitions show how the slate carvers of Dyffryn Ogwen were recognised. The painter Edward Pugh had things to say, generally uncomplimentary, about artisan painters as a category at the start of the nineteenth century.[11]

Every category had its appropriate place, and although we see in Edward Pugh's comments a negative and hierarchical use of such categorisation, it had

its positive side as well. Through becoming a special category, women's work, for instance, was freed from the expectation that it should use the same visual language as academic art. Artists who were categorised as craftspeople, such as the carvers of Dyffryn Ogwen or embroiderers such as James Williams, were not accused of lack of correctness. Williams's work, for instance, was exhibited in eisteddfodau in Wales and in a large and prestigious exhibition in England.[12] But the category of naive art is different, since it was not a part of the way of thinking of the eighteenth and nineteenth centuries. It has been created in retrospect. Naive art did not have a contemporary literature, and this lack of self-consciousness is its great value.

[12] At the Wrexham National Eisteddfod, 1933, for instance, where the arts and crafts catalogue noted that it had been exhibited at the Palace of Arts, Wembley.

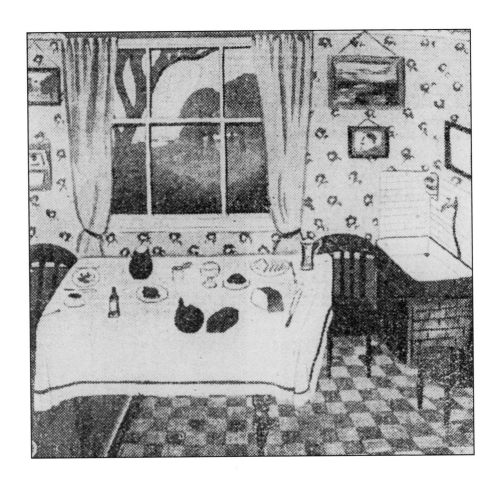

The Kitchen, by an unknown painter from Bangor, 1931.

This value was not recognised until painters of the modernist movements began to sing the praises of its visual qualities—and its political correctness, when produced by a working-class exponent—in the 1920s. In 1932, for instance, the support of the painter Richard Ll. Huws for a naive painter from Bangor attracted the attention of the newspapers: ' "The Kitchen" is the work of a young Bangor barber whose innate talent, for once, broke through and defied the deathly taste which had been instilled into him by education', he remarked. 'I have only space to say it was rejected from Bangor Eisteddfod, and that he was lectured on Art in the hope that such a thing would not happen again.'[13]

The visual conventions that persisted through the last century in naive painting (and in artisan painting and popular art) have strongly influenced subsequent academic art. We see this today in the works of painters such as Zobole, Goble and Iwan Bala. But the naive visual idioms in the works of these painters have been learned from the academic art of an older generation, and do not, on the whole, arise from a direct consideration of the Welsh cultural experience as exemplified in the work of our naive painters. There is also an abundance of artists today who are called naive as a result of their wholesale adoption of the visual conventions so characteristically displayed by the Aberystwyth naive. Most of them, however, have come to this visual language by imitating the works of others, rather than adopting it unselfconsciously from deeper cultural sources. This is not to devalue or dismiss the work of contemporary painters such as Idris Phylip Jones, Pen-y-groes, but to suggest that their art is a different kind of phenomenon, with very different meanings from the art of a painter such as Robert Hughes, and to the masterpieces of the anonymous Aberystwyth naive.

[13] This incident is discussed in *Y Chwaer-Dduwies, Celf, Crefft a'r Eisteddfod,* op.cit., p.98.

A CELTIC MUDDLE

Any exhibition of painting by artists from the Celtic countries will tend to generate speculation about the meaning of contemporary perceptions of Celticness. Given a title such as 'Celtic Vision', that speculation is likely to become the central issue. Dennis Bowen, one of the organisers of the exhibition of that name currently on tour, unsuccessfully attempted to forestall the eventuality by remarking that he had been 'very careful not to say that Celtic Vision is Celtic Art.'[1] But the argument has in the end dominated the paintings and this is unfortunate for the artists, many of whom are from Wales. Paintings by Beca, Peter Prendergast, Aneurin Jones and Ernie Zobole, for example, cover a wide range of particularly Welsh concerns—national politics, landscape, *y werin Gymraeg* and the industrial environment of the Valleys. Whether these concerns are Celtic as well as Welsh, Celtic by virtue of being Welsh, or indeed not Celtic at all, is very difficult to establish, and the attempt can be ultimately negative in its effect by detracting from the value of the work for contemporary Welsh identity. Those who want to establish the Celtic link are in constant peril of projecting something onto it rather than of perceiving something in it.

However, the continuing desire to establish a collective distinctness in terms of such an ancient culture is a remarkable thing, comparable to the extraordinary persistence of Jewish identity. It is not generally perceived as remarkable in Wales simply perhaps because it is so close to home, but also because over the last two-hundred years of successive manifestations, it has acquired associations of eccentricity and fantasy. The contemporary understanding of Celtic is highly coloured by the images of Celtic revivalism, abetted by a general ignorance of history. The process by which pan-European Celtic culture is related to Wales through insular Celtic culture, Romanisation and monastic Christianity is generally perceived only in the vaguest of terms.

The particular perceptions of Celtic as fantastical and as eccentric are modern manifestations of the same political reality which created Wales in the first place—the dominating presence of England. The Celtic is fantastical by association with the clichés of the Romantic movement—mystical rather than practical, poetic rather than rational and so on. This is interesting given that eighteenth-century Celtomania spread through Europe at the same time (and involving many of the same people) as the emergence of the ideas of the Enlightenment which ultimately provided the framework within which

The exhibition, 'Celtic Vision' was shown at Chapter Arts Centre, Cardiff, in 1987, and this essay was published to coincide with it in *Planet* 63, June/July, 1987.

[1] Interview with Ivor Davies in *Link*, 53, November/December, 1986.

[2] 'The Unitarians thought that Druidism was eminently sensible as a religion, the Dissenters worked out a version which suited them, and the Anglican clerics adapted it to their own purpose.' Prys Morgan in *The Invention of Tradition*, ed. Hobsbawm and Ranger, 1983.

nineteenth- and twentieth-century thought and science have functioned. It is that dominant framework of Rationalism and scientific method which has relegated Romanticism and Celticism (and Wales by implication with it) to a condition of unreality or fantasy. The attraction of Druidism and Bardism to eighteenth-century minds much exercised at the same time by Unitarianism and Rationalism[2] appears contradictory in retrospect. But it seems that to an eighteenth-century progressive a world directed by rational principles of toleration and scientific enquiry was entirely consistent with a concern about origins and the perception of God in all the things of the world, and quite at home within a broader Romanticism. To these minds the idea of antiquity legitimised and sustained, but in a nineteenth- and twentieth-century culture dependent on notions of material progress and expansion, a misty Celtic past became a decided handicap. Such an ineffectual image was a convenient one with which to identify a neighbour with latent aspirations to a separate political identity.

The historical works of Evan Evans and Edward Llwyd and the more adventurous constructs of Iolo Morganwg contributed to an image crystalised largely by English artists which retains its currency today. Gray's *The Bard* and the subsequent flood of paintings of the same subject were soon subtly transformed by the replacement of the Bard himself, along with his powerful masculine and supernatural connotations, with landscapes populated (if at all) by women in tall hats and shawls. Welsh artists—notably Thomas Jones and Richard Wilson—contributed to this process alongside the English Turner, Martin, Dyce and others. Ultimately the women themselves became the dominant motif which achieved its apotheosis in Curnow Vosper's *Salem*. This picture is one of the few visual images which is deeply rooted in the Welsh consciousness and its impact deserves detailed study. But the motif as viewed from the English side of the fence, and especially in a nineteenth-century social context, is clearly one of total political emasculation.

Celtic as eccentric is a parallel perception similarly related to the emergence of England as a dominant economic and political force in the world, and to the view of history constructed to legitimise that position. This view, heavily indebted to Gibbon, opposed the Classic to the Barbaric, bequeathed to us the value-loading that 'barbaric' still carries and sustained by implication England's self-image as the second coming of the Roman Empire. Victorian artists produced images by the score linking, more or less unsubtly, the Roman and the English. The implications for Wales with its barbaric Celtic past were obvious. The degree of self-deception by selection involved in this creation is truly astonishing but nonetheless effective and persistent. An interesting sidelight on

The Death of Llywelyn, engraved by J. Pass after C. Monomet, 1794. The death of Llywelyn ap Gruffydd portrayed as if it were a battle between Greeks and Trojans.

the matter is that even Saunders Lewis's view of history, although drawing out very different implications, was constructed on the standard Victorian opposition of Classic to Barbaric. Saunders sought to legitimise Wales as the final repository of Classical learning in the West through the medium of the Christian church, thereby locating us in the European mainstream. But the process seems to have necessitated the relegation of pre-Christian Celtic culture to the sidelines judging by the scant attention the early literature receives in his *Braslun o Hanes Llenyddiaeth Gymraeg.*

Throughout the nineteenth and early twentieth centuries when visual artists in other small countries, such as Gallen-Kallela in Finland, were producing images of their own history to confirm an emergent sense of national identity and seeking to find appropriate forms for these images, Welsh artists were producing conservative English-school pictures for consumption at the Royal Academy. These pictures sometimes have titles suggesting Celtic affiliations appliquéd onto them as rather servile tokens of distinctness. This incongruity of affiliation and form is well illustrated by the contrast between rhetoric and visual art in a series of articles on art in Wales which appeared in *Cymru* in 1911. The counterpoint to a text glowing with notions of *Cymru Fydd* and quotations from the *Mabinogi* is paintings of *Danae, Atalanta,* and *Paulo and Francesca* by Christopher Williams along with sculpture by Gibson in a similar vein. Despite the heroic attempts of the writer, Thomas Matthews, to detach his Welsh artists from the English school, even works with Celtic subjects such as *Ceridwen* by Williams remain stubbornly and thoroughly homogenised into Victorian Royal Academy mainstream. This unhappy conjunction of aspirations with inappropriate means reached a startling climax in Cardiff City Hall in 1916 where the sober statue of Williams Pantycelyn is surmounted by a pair of ample-bosomed and conspicuously naked mermaids.

The most recent revival of interest in the Celtic came about in the context of a throwing off of the remnants of these nineteenth-century values. The wheels having rolled on half a turn, the mystical, and especially the Eastern mystical, became in the Sixties and early Seventies a major cultural force in the Western world. The Celtic once again became included in a very generalised and multi-national package of anti-materialist values. The coupling of the interest at this time in Indian religions with a fascination for the Celtic and pre-Celtic civilisations of north-west Europe was remarkably coherent in its reflection of the common Indo-European source, and the more so because the coupling was on the whole uninformed. The events of 1968 had much in common with 1789 and 1848 in their dual aspect of spiritual renewal and political action on a European scale, but Celticism does not seem to have been prominent in the

The Defence of Sampo, by Akseli Gallen-Kallela, tempera on canvas, 1896. Gallen-Kallela was a leading figure in the national Young Finland movement from the end of the 1880s, and a close friend of Jean Sibelius.

political awakening which occurred here at that time. Indeed, the most obvious consequence of the atmosphere of the time for Wales was a flood of immigrants in search of a different way of life with dire consequences for what remained of the indigenous culture. The distinctly non-Welsh character of this latest manifestation can only have contributed to the latent suspicion of the Celtic within Wales. The 'Celtic Vision' exhibition, conceived in Windsor (as eccentric a location as was Primrose Hill for Iolo'r first *gorsedd*), has all the associations of fantasy and non-Welshness necessary to activate the latent prejudice.

While the Celtic continues to be perceived primarily in terms of revivalism, it seems unlikely that this reaction will change much. This leaves original Celtic imagery as remote from most people as the art of ancient China—a sadly wasted resource for Wales. Particular perceptions of continuity in tradition compound the problem. It can be demonstrated that the language, although undergoing periods of great change, does have a continuity of development in vocabulary and syntax from Celtic. There is no comparable organic development of visual vocabulary and syntax. The reasons for this are built into the nature and function of visual images, which are much more vulnerable to political upheaval and change than words. They are often public and therefore under scrutiny and often destroyed when the political context changes, and unlike what became of the literature in the early medieval period, not generally sustained in the folk or Bardic memory. They are expensive and therefore depend largely on the patronage of those on top of the pile where change is much more directly manifested. In fact, the discontinuity of the visual vocabulary in Welsh tradition is even greater than it is often perceived to be because of the attribution of the word Celtic equally to pre-Roman Insular art and to post-Roman monastic art. In formal terms continuity between these two is confined mainly to a passion for zoomorphism. The interlace (or Celtic knot) is not Celtic at all and is nowhere present on Hallstadt, La Tène or Insular Celtic artefacts. It was an import direct into the far west from Greece and Mesopotamia via the trade routes which also brought the monastic model of Christianity. Its assignation as Celtic stems from its glorious transformation within the Celtic Church as a part of what became the dominant visual culture of northern Europe. It is particularly remarkable therefore for being the only dominant form in European art which spread from west to east, carried by a multi-national church. The result is that many of the greatest manifestations of this Celtic are in fact Anglo-Saxon and Carolingian.

The emergent Wales was deeply involved in this complex cultural process through its relations with Ireland in the west, and Mercia, Cumbria and Northumbria in the east and north. The stone crosses, the Chad Gospels and the Llanbadarn Psalter (produced in the shadow of Normanisation as late as 1079) are among the results. Rhygyfarch, who put together the Psalter, bewailed the Norman invasion in his *Elegy*, but describes his people as the British not as the *Cymry*. This may merely reflect habitual conservatism or an appeal to historical legitimacy rather than the absence of a concept of Wales as a context for his work, but a century and a half later, at the court of Llywelyn Fawr, the images are undeniably Welsh by virtue of their context and content. On the other hand, they have both feet firmly planted in formal terms in Romanesque. Little has

survived the subsequent political calamity but what there is, and in particular the head of Llywelyn and the Siwan effigy, show that the visual tradition had well and truly parted company with the poetry. However much the aspirations of Llywelyn were influenced by the Norman view of the world, his poets praised him with at least one foot in their Celtic past. The visual art provides us with evidence of a change of consciousness different in its emphasis from that of the poetry.

The perception of these breaks in formal continuity as implying that no visual tradition exists, depends on the view that art is primarily about style. This has been the prevalent twentieth-century view and from within it came remarks such as: 'At no time, since the Norman Conquest at any rate, has the Welshman had a visual artistic tradition.'[3] Looked at from a different point of view—that content and meaning are the significant elements in art—the conclusions are quite different. The stylistic breaks become dramatic indicators of the process of Welsh culture and the images thoroughly a part of that process, allowing a tradition to be traced back to its pre-Welsh origins in Insular Celtic.

Romanticism not only bequeathed the perceptions of Celtic revivalism, but also a more recent difficulty rooted in the dissolution of content within form in visual art, a process generally perceived to have its origins in that movement. The eighteenth-century painters were able to picture the phenomenon (or paraphernalia) of Celticism without feeling the need to be formally Celtic— their language was that of a wider Romanticism and the Celtic a motif within it. For artists today, when the dominant view is that no distinction is to be made between content and form, the problem is more difficult because the expectation will always be that the work should be in some way *essentially* Celtic, and not Celtic by allusion or reference. In simple terms the distinction is between Celtic pictures and pictures of the Celtic—the latter being relegated to the status of illustration. Ceri Richards in works such as *Afal Du Brogwŷr* was one of many artists who have sought to achieve this essential Celticness in their work.

Although it may be legitimate to describe a quality called Celtic in the work of individuals (in the same way as a Gothic or Oriental quality might be described), to suggest, as unfortunately the title 'Celtic Vision' does, that this might be perceived generally in work emanating, for instance, from contemporary Ireland, simply because it comes from Ireland, is untenable. Celtic pictures could only honestly come *en masse* from a coherent Celtic culture and none of us live in that kind of culture. Dennis Bowen pointed this out himself of course. But he also went on to remark that 'even when you're in America, or wherever you are—if you're at sea[4]—you find that people who are

[3] *The Artist in Wales,* op. cit.

[4] Bowen was in the Navy.

Llywelyn Fawr, relief carving by Milo ap Griffith, c. 1870. Milo ap Griffith was born in Pembrokeshire in 1843, trained in Wales and in London, and worked for a time in San Francisco. He died in 1897. The sculpture clearly makes reference to the classical *Dying Gaul*.

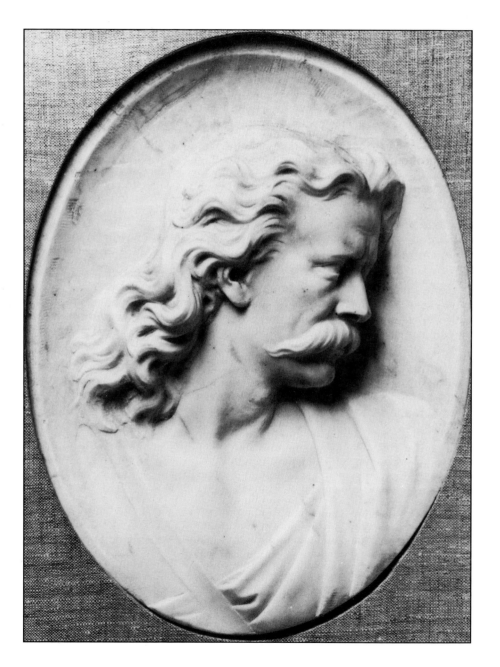

easiest to talk to have always been of Celtic stock.' Here, he is reverting to an ethnic notion of Celticness, the corollary of which should indeed be a general perception of particular qualities in the culture, including the visual art. In the context of so many other manifestations of muddled thinking about the Celtic, the effect of all this will not be helpful in the reclaiming of Celtic visual imagery as a part of Welshness. Further, it is likely to undo the strengthening effect—clearly a major part of the purpose of the exhibition—of establishing contemporary links, artistic or otherwise, with other countries which share elements of our own historical process and consequent political problems.

This is all very complicated. The core of the matter is that certain trends in art and philosophy—eighteenth- and twentieth-century revivalism, Victorian historical constructs, perceptions of the nature of tradition, and the semantic confusion between Celtic (the historical phenomenon) and Celtic (the quality) continue to inhibit the absorption of the art of the culture into a potential Welsh visual tradition. Such a tradition could be constructed, and needs to be constructed as part of the overall case for Wales. What is clear is that it cannot be done from within the discipline of mainstream European art history. Dennis Bowen wants artists from Celtic countries to be appreciated for their contribution to that mainstream, as did the author of *Art in Wales*.[5] This self-contained view of art as a closed system, or indeed as culture itself, will not work for Wales. Only a view rooted in the different notion of visual images as an element in the history of a whole culture can give meaning and substance to Welsh visual art and an appropriate context for contemporary work.

[5] Bowen remarked that the exhibition was 'merely to illustrate the contribution Celtic artists have made to mainstream movements in art.' Rowan remarked in *Art in Wales*, II, p.16., that 'we should regard Welsh art as a small but vigourous tributary to the mainstream of modern art.'

A Druid, engraved by W. Dolle, 1676. This image was based on a description of six sculptures found at Wichtelberg, Germany.

THE BARD—CELTICISM AND VISUAL CULTURE

During the second half of the eighteenth century Wales became popular in antiquarian and fashionable circles in England. It was largely visual art and literature that promoted it to this status, and amongst the hundreds of works produced in praise of the country Thomas Gray's masterpiece *The Bard* stands head and shoulders above the rest in historical importance. After having laid it aside for two years, Thomas Gray completed his poem in 1757, depending on Ieuan Fardd,[1] one of the original members of the Cymmrodorion Society, for much of the antiquarian information on which it was based. In the hands of painters and sculptors the Bard became the logo of the age, and would become in the future a mirror of the state of mind of the Welsh culture.

The historical basis of the poem is the conquest of Wales by Edward I, coupled with the myth of the murder of all the country's bards which followed:

On dreary Arvon's shore they lie,
Smeared with gore, and ghastly pale . . .

Gray's source was Thomas Carte, who said in his *General History of England* (1747-55): 'He ordered them all to be hanged, as inciters of the people to sedition.' Thomas Carte had adapted a story that he, in turn, had found in one of the Gwydir manuscripts.

Gray used a new image—and did so in a new way—in English poetry in order to reinforce an already venerable historical construct, the legitimisation of the English state by the grafting on to it of the history of Celtic Britain, represented in the modern world by Wales. In the hands of Thomas Gray the Bard became a sturdy pillar of that remarkable structure. The process of legitimisation through the lineage of Harri Tudur, Henry VII, is well known. The *primo genitor* was King Arthur, of course. Mallory and Spenser had consolidated the small pebbles of his story into a strong stone building. 'The Faerie Queene' was dedicated to Queen Elizabeth, and stated explicitly that her monarchy represented the reign of the Britons restored. A century after Thomas Gray built his extension to this building, Tennyson would use Arthur once again to extend it further, and his still potent visions would be turned into visual images by an academy of artists. Legitimisation was not Tennyson's only intention. He sought also to use the foundation myth to promote a moral agenda, making it consistent with the

This essay was first published in *Cof Cenedl VII,* 1992, as 'Y Bardd—Celtiaeth a Chelfyddyd'.

[1] Evan Evans, 1731-88.

virtues which Victoria and her court were keen to encourage amongst her subjects all over the world. Tennyson was every bit as forthright about his intentions as Spenser had been. In the first edition of *The Idylls of the King*, published after the death of Prince Albert, the following dedication was added:

These to His Memory—since he held them dear;
Perchance as finding there unconsciously
Some image of himself.

We still live in the shadow of the building erected to Anglicise the history of Celtic Britain. In his very popular book *The Quest for Arthur's Britain*, the author, Geoffrey Ashe, referred to the Arthurian myths as 'the English national legend'. The flexible national identity of English people like Geoffrey Ashe is not considered odd, despite its dependence upon the sloppy and thoughtless exchange of the words 'English' and 'British'. He described Geoffrey of Monmouth's *Historia Regum Britanniae* as one of the two 'earliest histories of England'.[2]

[2] The *Historia Regum Britanniae*, 1136, deals with the history of Celtic Britain from its foundation, and of Arthur's attempts to resist the English. It contains Merlin's prophecies and did more than any other text to establish the myth of Arthur.

For us, the historiography of King Arthur, rather than the individual stories, provides the moral instruction. It is a study in the mechanics of hegemony, with the dissolution of a nation as the objective—'genocide by assimilation' in the famous words of J.R. Jones. Whatever else we might tentatively venture to say about Arthur, we can say with confidence that he was not an Englishman. Yet in Welsh visual culture, for most of its history, there are no images of Arthur. Having been stolen, body and soul by English (and French) artists, he was unavailable to us as a symbol of our nationality, although his shadow is often to be perceived following a procession of failed redeemers, including Llywelyn ap Gruffydd.

We must read Thomas Gray's poem carefully in order to catch even a glimpse of our last prince, the cause of the events described. He was almost entirely excluded from the story, and for an obvious reason. It was not to the reborn spirit of Llywelyn—that is, the spirit of Wales—that the Bard would appeal in his prophecy concerning the Celtic succession, but to Arthur, already securely embodied as an Englishman:

Visions of Glory, spare my aching sight!
Ye unborn ages, crowd not on my soul!
No more our long lost Arthur we bewail.
All-hail, ye genuine kings! Britannia's issue, hail!

With the benefit of hindsight, Thomas Gray could ensure that his Bard would prophecy correctly and with authority. He compressed a complicated and convoluted concept of English history into a fairly short poem. On that foundation, visual artists were able to take the process a step further, crystalising the concept into a single image symbolising the antiquity of the state and its Brythonic origins. Nevertheless, we should remember that most of the high art which is considered by art historians in retrospect to be significant was *avant garde* in its own time. 'The Bard' was not an exception to this rule and at first its references were considered obscure and difficult, and it took some years for it to be accepted as a classic and understood by a wide public.

London artists sensed the potential of Gray's image straight away. The first to react was Richard Bently, friend of the poet and of Horace Walpole, one of the trend setters of the age. The painter made a number of drawings with the intention of reproducing them in an edition of the poem to be printed on Walpole's press at Strawberry Hill. Unfortunately, they were a pretty uninspired group of works, and nothing came of the project. Paul Sandby had more success, and attracted considerable attention with his painting on the subject *The Bard, from Mr Gray's Ode, 'But oh! what glorious scenes'*, which was exhibited by the Society of Artists. Sandby travelled in Wales, and perhaps based his historical landscape on his personal experience of Snowdonia rather than on the Alpine Snowdonia of Gray who had never been near the place. However, the image which would bring all the necessary elements together was not made until 1774.[3] It would be a remarkable picture, not only because of its quality— 'I think one of the best I ever painted'—but because the painter was Welsh. He was Thomas Jones of Pencerrig.

Thomas Jones was like many of the Welsh gentry of the age in his lack of interest in his mother country and his admiration of everything English.[4] It might have become necessary to consider his picture, therefore, as little more than another manifestation (although a very fine one) of the fashion that stimulated a number of 'British' historical pictures and a positive flood of similar literature in the period. But Thomas Jones's imagination had crystalised an image which would occupy a central place in the Welsh psyche for more than two centuries. For the first time the whole paraphernalia was brought together. His bearded Bard, wrapped in a loose fitting cloak, blowing in the wind, was set symbolically high above Edward's army in the mountainous scenery of Snowdonia. This figure was already associated in the mind of the contemporary *avant garde* with the Druid. An engraving signed 'A.M.' had appeared in Henry Rowlands's *Mona Antiqua Restaurata* in 1723. A.M. may have been Andrew Miller, who worked in London and in Dublin, where the volume was published.

[3] Sandby's image is lost and there is no precise description of it, so any possible influence of its iconography on Thomas Jones's picture is impossible to establish. Sandby's first documented visit to Wales was in 1770. My remark was speculative. Mason wrote in November, 1760: 'Sandby has made such a picture! such a bard! such a headlong flood! such a Snowdon! such giant oaks! such desert caves! If it is not the best picture that has been painted this century . . .', *Harcourt Papers*, ed. E. W. Harcourt, Oxford, 1880-1905, III, p.15.

[4] This is evident from his journal, kept till 1783. Later he returned to Wales to live—evidence of his attitudes in that period is scanty.

Relief carving dedicated to the Genii Cucullati, the Hooded Dieties, stone, Housteads, 3rd century AD.

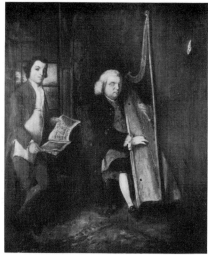

John Parry, Harper to Sir Watkin Williams Wynn, attributed to Reynolds but possibly by William Parry, oil on canvas, c.1760-80.

John Parry and his son William, copy by Mary Grace, oil on canvas, c.1850, after the original by William Parry, c.1776. The original was probably lost in the fire that destroyed Wynnstay. The copy was formerly at Llanofer.

On the engraving is a note that it was based on a sculpture, and indeed a number of Celtic or Romano-British sculptures showing hooded dieties were known at that time. Another unknown artist took this engraving as the source for the image of the Druid on the banner of the Cymmrodorion Society in 1751. But the true source was the engraving published in Aylett Sammes's *Britannia Antiqua Illustrata* of 1676 based on a description of six Celtic sculptures from Germany, written in 1502. By referring back to the same source Thomas Jones extended the meaning of the thirteenth-century Last Bard from his comparatively recent semi-historical context to a much wider and older pre-history. However, that is about all that can be said with certainty because, like King Arthur, the druids stand conveniently outside the normal temporal scale in a vaguely defined period without a single definite date, apart from the visit of Julius Caesar.[5] In order to emphasise his association of the Last Bard image with the druids Thomas Jones included a circle of Stonehenge-like standing stones in his picture. He had recently journeyed from London to Wiltshire to inspect that most famous druid temple.

By the end of the eighteenth century the enthusiasm amongst the gentry for Brythonic imagery was so intense that some of those not fortunate enough to possess genuine monuments busied themselves with transporting other people's property to convenient locations on their own estates. Lord Newborough of Glynllifon went one step further by building his own—an early version of Land Art. Sir Watkin Williams Wynn, the international art connoisseur, kept a living relic at Wynnstay and in his London house in the form of his harper John Parry. He was exhibited as an example of the continuity of the ancient British tradition in Wild Wales, which had apparently not come to an end with the dramatic suicide of Gray's Last Bard after all. Indeed, it seems that it was listening to Parry playing the harp in Cambridge that inspired the poet to finish his work: 'Mr Parry has been here', he noted, '& scratch'd out such ravishing blind Harmony, such tunes of a thousand year old with names enough to choke you, as have set all this learned body a'dancing, & inspired them with due reverence for Odikle'—that is, his incomplete poem—'whenever it shall appear.'

Sir Watkin was the patron of Richard Wilson, master of Thomas Jones, and also patron of another Welsh painter, William Parry, son of his harper. Under Sir Watkin's patronage Parry was trained in Reynolds's studio. It seems likely, at the very least, that Parry assisted with the striking portrait of his father, concentrating with an expression of great intensity on the sound of his harp. This bardic portrait has been attributed to Reynolds in the past, but irrespective of its precise authorship it must certainly be considered the first of a long series of romantic Welsh bardic portraits.

[5] Caesar's Gallic wars were conducted from 58-49BC. He invaded Britain in 55BC and described the druids in his account of the wars.

In 1784, a year after Thomas Jones returned from Italy and several years before his friend William Parry returned from that same Mecca, another expatriate Welshman of his own generation, Edward Jones, known as *Bardd y Brenin*, the King's Bard, published an important book. For the second edition of his *Musical and Poetical Relicks of the Welsh Bards*, published some years later, Philippe de Loutherbourg designed a splendid frontispiece on the theme of Thomas Gray's *Last Bard*. The Frenchman had made the pilgrimage into Wales which by that time was required of all *avant garde* artists.

In this fashionable atmosphere Welsh-born painters also travelled in their native country. Amongst them was Edward Pugh, originally of Rhuthun, who gives us striking testimony to the grip that the image of the Bard had on the Welsh imagination by that time. Edward Pugh spent nine years at the beginning of the nineteenth century travelling in Wales, taking notes and making drawings for his most important work, *Cambria Depicta*. [6] While in the Betws-y-coed area he went on a bardic expedition, apparently unaware that the location of the suicide was a figment of Thomas Gray's imagination:

> Mr Gray, in his admirable poem 'The Bard', without doubt meant no other rock than some of those near Pont y Pandy, as there are no others from Llyn Conwy to the Irish Sea that are so consistent with his description. Mr de Loutherbourg, in his design for the frontispiece to Mr Jones' beautiful collection of Welsh music seems to be of the same opinion, for the rock on which he has placed the Bard, very much resembles Craig Lwyd, and this precipice is truly portrayed in the words of Gray:
>
> > On a rock, whose haughty brow
> > Frowns o'er old Conway's foaming flood,
> > Robed in the sable garb of woe
> > With haggard eyes the poet stood . . .

Among Edward Pugh's many sitters for miniatures in London was William Owen Pughe. The good hearted Dr Pughe was busy fulfilling a similar role for the benefit of a second generation of English romantics to that which Ieuan Fardd had fulfilled for Thomas Gray. According to Robert Southey, Pughe's mind was 'the great storehouse of all Cymric tradition and lore of every kind.' Amongst those to profit from it was William Blake, who portrayed the Bard on numerous occasions, and King Arthur at least once, on the basis of Pughes' translations. Blake was in no doubt as to the importance of the image in the development of the myth of Britain, the New Jerusalem: 'The British antiquities', he remarked, 'are now in the artist's hands. All his visionary

[6] Published three years after his death in 1813.

108

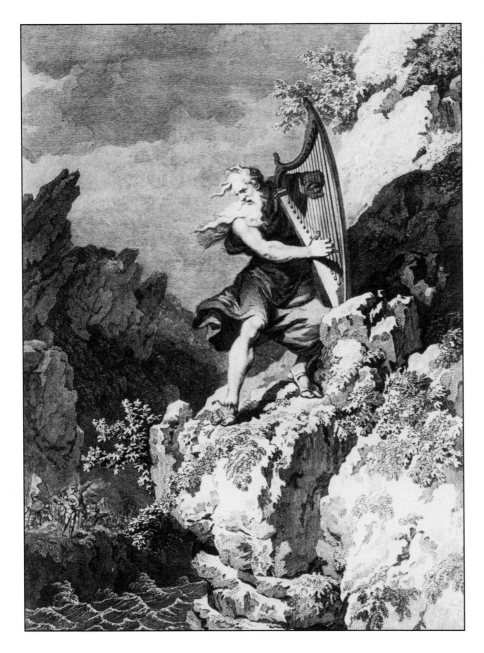

The Last Bard, engraving after Philippe de Loutherbourg, 1794. De Loutherbourg was born in Strasbourg in 1740 but settled in London in 1771 from where he toured to other parts of England and to Wales. He died in 1812.

The Bard, wash drawing by John Gibson, c.1810. This watercolour is part of a collection of early works and its Blake-like Romanticism is most unusual for Gibson. It is his only known venture into Welsh subject matter.

Iolo Morganwg on horseback, by an unknown painter, watercolour, c.1795-1800. The family provenance of this watercolour suggests that it dates from the period when Iolo kept a bookshop in Cowbridge.

[7] Rowland Williams, 1823-1905. The Archdruid was painted by Herkomer and Christopher Williams, amongst others, and much photographed. Herkomer's portrait is reproduced in *Y Chwaer-Dduwies*, op.cit., p.65.

[8] *Seren Gomer*, 1819, p.229.

110

contemplations relating to his own country and its ancient glory, when it was, as it again shall be, the course of learning and inspiration.' Some Welsh interpretations were every bit as visual. William Owen Pughe was an enthusiastic amateur painter and added illustrations to his personal copy of his *The Heroic Elegies of Llywarc Hen*, published in 1792. He portrayed the druids dressed in the green, blue and white gowns that his colleague Iolo Morganwg had devised for them, busy at the mysteries within circles of standing stones and in the shade of the oak tree. Iolo was responsible for creating much of the visual world now so familiar to us through the subsequent interpretations of other artists. By 1819 he had succeeded in persuading the Carmarthen Cymreigyddion Society to combine his *gorsedd* with their rejuvenated eisteddfod, with very theatrical results. Iolo himself played the part of the ancient Druid-Bard, the first of a long line of heavily bearded bards based on the vision of the painters which reached a climax in the very substantial personage of Hwfa Môn. [7] Iolo appeared at Carmarthen with a young bard at his side as a representative of the continuity of the tradition. This suggestion of a Celtic continuum was not lost on his audience. Amongst them was Joseph Harris, editor of *Seren Gomer*, who described the scene as follows:

At the beginning of the activities Mr Edward Williams (Iolo), *ancient* bard of Glamorgan, appeared supported by Mr Daniel Evans (Daniel ab Ieuan Ddu), *young* bard of Ceredigion; and the contrast between youth and old-age, the aspirant, and the proficient, made the circumstance very lovely. [8]

A Bard, probably by Hugh Hughes, wood engraving, 1828. Published in William Cathrall's *History of North Wales*. Hughes had known Cathrall since 1820 and the volume contains two other works certainly by Hughes.

Under the influence and patronage of the new eisteddfodau and the Welsh societies that sprang up in many parts of the country, the period between 1819 and the early 1830s was very productive of bardic imagery. In the year of the pioneering Carmarthen Eisteddfod, William Jones, an artist who would himself later frequent the eisteddfodau, exhibited an interpretation of Thomas Gray's poem at the Royal Academy. When he was a young student at the Academy, eleven years previously, he had been helped by Edward Pugh. Through the influence of the societies William Jones would live to see developments in Wales that Edward Pugh's generation had only speculated hopefully about.

In 1820 William Owen Pughe acted on behalf of the Cymmrodorion in London to commission one of the greatest sculptors of the age, John Flaxman (the two men were already friends) to design a medal which showed the Bard with a harp and *peithynen*.[9] The inscription was written in the bardic script, *Coelbren y Beirdd*, one of Iolo's many imaginative ventures. Two years later, the Gwent Cymreigyddion offered a medal for an essay on the subject 'The credibility of the massacre of the British nobles at Stonehenge'. The legend was in fashion that year—John Jones, printer of Llanrwst, reprinted Theophilus Evans's *Drych y Prif Oesoedd* at the same time, and commissioned Hugh Hughes to make a wood engraving of the subject of *Brad y Cyllyll Hirion* (The Night of the Long Knives) to illustrate it. A view of Stonehenge was engraved on the Cymreigyddion medal. It is clear that the illustrated volume *The Costume of the Original Inhabitants of the British Islands*, the joint product of the Welsh antiquarian Samuel Rush Meyrick and the English painter Charles

[9] The *peithynen* is the device on which Iolo suggested the druids composed their verse. There is an illustration in *Y Chwaer-Dduwies*, op.cit., p.8.

Hamilton Smith, published in 1815, was a strong influence on the burst of activity in this period. The most splendid illustration shows a reconstruction of the temple of Stonehenge, with the mysteries taking place within. The book would remain a valuable source of imagery for artists for many years, including Hugh Hughes who adapted its images more than once in his own works.

London intellectuals no longer stood apart from activity in Wales as they once had. In the minutes of the Gwyneddigion Society, for instance, a corresponding member tells us about the first modern sculpture of the Bard, as far as is known, made not in England but by an unknown mason in Holyhead. It was commissioned to be set in the memorial to Goronwy Owen in Bangor Cathedral at the end of the 1820s. The memorial was seven feet tall, 'and of proportionate breadth, made of black marble on Moelfre stone, highly polished, ornamented at the top with the figure of a Bard or Harper in the act of performing on his Harp. This is of white marble, sunk in the others, and the expense incurred on this alone was upwards of £3.' [10]

We can see, therefore, that the interaction between Welsh and English artists and intellectuals in the development of the image of the Bard up until the 1820s was complex. Needless to say, in the history of English art, this interaction is scarcely mentioned, and since, until recently, there has been no Welsh art history, neither has the nature of the relationship nor its significance been interpreted from our point of view. The history of the origin of the image is complicated, but the interpretation of what was produced subsequently is ten times more so. The Bard is an ambiguous image, inconsistent and riddled with self-delusion, an image of all things to all people, and yet an image central to the evolution of the Welsh mind.

Thomas Gray's Bard stood on the rocks high above the army of Edward I. Successive versions of the image increasingly emphasised this metaphor, culminating in the surreal extremes of one of John Martin's interpretations in 1813, a picture exhibited at the Royal Academy four years later. Elevating the Bard to these heights, above the world of the soldier—that is to say, elevating the spirit of the muse above the material world—was central to Thomas Gray's intention and fundamentally important to the Romantic mind. It was a philosophical statement with implications for every aspect of life. Truth was to be found through the liberated vision of the artist, and since Truth was absolute, it was necessary to allow total freedom to the individual spirit to reach it.

This was a general message to mankind, of course, but one which was at the same time soaked through with English nationalism, as we have seen. Consequently, the Bard was invested with numerous difficulties as a symbol of

[10] Letter from Matthew Owen to the Gwyneddigion Society in London, 24 April, 1828. BL Add.Ms.9850. The memorial is as described except, unfortunately, for the bardic image. The reason for its removal or its not being included in the finished work, is a mystery.

Welsh nationality for those who were anxious to claim it back. The Last Bard had not only prophesied the ephemeral nature of the victory of the Norman (that is, French) Edward, a journey into an historical *cul de sac* redirected onto its proper course by the Tudor succession, but also 'with prophetic spirit [he] declare[d], that all his cruelty shall never extinguish the noble ardour of poetic genius in this island.' But to Thomas Gray it was, of course, the island of the English, and it was not the contemporary Welsh-language poets whom he understood as the inheritors of that tradition, but the English Romantics. 'I felt myself the Bard', he remarked.

Neither would Thomas Jones, Pencerrig, the monoglot English speaker, have perceived any particularly Welsh political message in the image. He followed Thomas Gray in minimising Llywelyn in his interpretation, and then went further by removing the subject from its Welsh historical context almost entirely through his emphasis on the Druidic legend. Thomas Jones, as a Welsh person, had been liberated in the Tudor union of the Welsh nation with the nation described by Edward Pugh as 'the intelligent and civilised English'—as compared to the child-like and superstitious Welsh. The main attraction of the Bard to Welsh people of this turn of mind was his new found popularity amongst the English. At last there was available to them a satisfactory image of a nationality which had been until recently a heavy cross to bear through life. They had become accustomed to being portrayed as the Poor Taff of the cartoonist, riding to London on the back of a moth-eaten goat. Thomas Jones, Pencerrig, and his ilk could now occasionally expose to the public their original national skins in the sunshine of the new Britishness in England.

The image of the Bard sowed the seeds of a state of mind which enabled Welsh people to enjoy the blessings of being homogenised within England and at the same time take pride in being different. Step by step, the Bard became not only a symbol of Brythonic roots for the English, but also of national pride—specifically Welsh, and not Brythonic or Celtic pride—for Welsh people. After all, the language of the Bard remained alive and well on the lips of the vast majority of them.

By the identification of contemporary Wales with the image of the Druid-Bard, the existence of the nation was elevated to the same heights and eternal condition as the muse in the mind of Romantics such as Thomas Gray. It was suggestively coupled with Truth and Freedom, which were the prerogative of the spirit of the artist. The idea of the nation was permeated with a sanctified, almost religious, aura, and with the suggestion of a license to eternal continuity whatever the condition of its material body. This misty and suggestive coupling of the national idea with the pseudo-religion of Romanticism during the first

Celtic revival would be confirmed by another and similar coupling a century later. The national haven of Nonconformist Christianity had the same reassuring resonance of eternal continuity for many of its zealous advocates.

The perception of national continuity in spiritual terms, suggested by both credos, was very convenient, since it justified for many the neglect of the political implications of their patriotism. It was easy to avoid doing something practical about the condition of Wales, safe in this knowledge of the guaranteed eternal continuity of the nation, and many persisted in their Anglicising ways.

In 1830 the painter Hugh Hughes confined his radical patriotism confidently to his Nonconformist faith and to the muse and the language: 'From the hour that the English showed goodwill to the Welsh, by extending to them the certainty of their freedom'—that is, in the Acts of Union—'an unsheathed sword was never seen again in the whole country, and there are no more peaceful neighbours and subjects than they to this day. Every Welshman also learns English, as best he can; but he loves the old Language for *old time's sake*, for the sake of the connection which will last forever between the memory of the language and the memory of the efforts which were made for *freedom*.'[11]

Byron, one of those who had inherited the early Romanticism of Thomas Gray, had already perceived that confining national freedom in the sanctified sensitive spirit of the Bard was entirely inadequate. He went to Italy and to Greece to fight for national freedom. In spite of singing the praises in poetry and prose of the efforts of those countries to achieve political independence, Welsh intellectuals held tight to the comfortable British deceit, identifying the nation with the sanctified spirit of *Barddas*. The other-worldly cry of the Bard is considered to this day to be an adequate response to injustice. Our painters and sculptors—to the great delight of the admirers of all things English—created an idol which is still worshipped and still a source of comfort in the face of national extinction.

Displaying the self-confident myopia so characteristic of English art historians, F.I. McCarthy[12] remarked of John Martin's huge picture of 1817: 'On this note, the Bard theme in art comes to a close.' As I have already suggested, Welsh artists and patrons had barely begun to explore it.

For example, under the influence of the very visual imaginations of Thomas Price, Carnhuanawc, and Augusta Hall, Lady Llanofer, the image of the Druid-Bard was displayed on the medals and ephemera of the Abergavenny Cymreigyddion. In 1845 the Abergavenny Eisteddfod provided the opportunity for William Lorando Jones to exhibit his heroic statue of *Taliesin Pen Beirdd*. 'The spirit of Amor Patriae is still alive', rejoiced Carnhuanawc from the stage, 'and a gentleman has brought a fine specimen of sculpture 150 miles to be

[11] 'Rhyddid, Cymdeithas a Llywodraeth', op.cit., p.293. In fairness to Hughes, this was a transitional remark, more resonant of his earlier attitudes than of the position he was about to take up.

[12] F.I. McCarthy, *'The Bard* of Thomas Gray, its composition and its use by Painters', *Cylchgrawn Llyfrgell Genedlaethol Cymru*, XIV, 1965/6. McCarthy is Australian—I refer to his attitudes rather than to his place of birth.

shown at this eisteddfod. The artist in this production has dared to look at the visions of glory which oppressed the aching eye of the bard: he has raised the spirit of Taliesin and made his spirit breathe from the clay.' According to the confident critic of *The Athanaeum*, 'We shall see it in marble!', but unfortunately it was never reproduced in that material or cast in bronze. A rather feeble engraving is the only visual record that survives. Yet the sculpture was a turning point in the history of the Eisteddfod—the first time that sculpture was given an honoured place as a part of the proceedings. [13]

The high point of the Bard in the first Celtic Revival came in 1848. The first art competitions in an eisteddfod were held at Abergavenny under the direction of Carnhuanawc. There was no competitor in the competition for a picture on the subject of *Bran Fendigaid introducing Christianity into Britain—Druids standing by the side of a cromlech frowning at the new doctrine*. Strangely, within two years, Holman Hunt would produce a picture on a very similar topic: *A converted British family sheltering a missionary from the Druids*. However, there was a great success in the sculpture competition. The winner was John Evan Thomas, supported by his brother William Meredyth. Their subject was *The Death of Tewdrig*. The legend of Tewdrig, King of Gwent, is to be found in the *Book of Llandaf*, where his name is connected with Tintern, not far from Abergavenny. [14] The sculptors were also local boys, from Brecon, although they were already established in a London studio. Like the lost King Arthur, Tewdrig had defended his Celtic Christian kingdom against the pagan English, but despite his military victory, he was killed:

> Well might the joy in the British troop
> Be mixed with wailing, too—
> Their hermit king, borne to his cell,
> His forehead cloven through.

Tewdrig was therefore an acceptable substitute for Arthur, and Tintern for Camlan. The Christian sub-plot was emphasised in the pieta-like composition of the sculpture, with the dying king in the arms of his daughter Marchell. But crowning the pyramid stands the bardic alter-ego of the king with his harp— 'The war song of the aged bard is heard amidst the din of arms', remarked a contemporary reviewer. [15] Formally, the Bard was on loan from de Loutherbourg's earlier rendition, but nevertheless, the sculpture as a whole was an *avant garde* piece. The medievalism of the king and his daughter comes early in the fashion confirmed by Tennyson and the Pre-Raphaelites. G.H. Greene's verses of 1879, quoted above, are the fruit of the golden age of that fashion.

[13] William Lorando Jones came from Merthyr Tydfil but was by this time working in London with his brother Watkin D. Jones. He is not to be confused with a number of other artistic William Joneses, in particular William Jones of Chester, c.1787-1874, born in Beaumaris, the painter of the 1819 Bard, above, and William Edward Jones, 1825-77, also of Merthyr but born in Newmarket, Flint, who painted the 1858 version, below. Jones's sculpture and other eisteddfodic images of the Bard are discussed in detail in *Y Chwaer-Dduwies* . . ., op. cit.

[14] The Abergavenny Cymreigyddion had recently published the text of the *Book of Llandaf*.

[15] *Monmouthshire Merlin*, 14 October, 1848.

The Death of Tewdrig, by John Evan and William Meredyth Thomas, bronze, 1848. The sculpture was conceived by John Evan Thomas, with advice from Augusta Hall, Lady Llanofer, and carries his signature, but it was modelled by William Meredyth Thomas.

Historical sculpture of this sort (that is, historical subject matter rather than historical portraiture) was still scarce in the English art world of the period, and it was even more unusual in Welsh art. William Meredyth had exhibited a statue of *Prince Harry* in the Westminster Hall exhibition of 1844, and would go on to subjects including *The Welsh Harper* and *Llywelyn mourning the Death of Gelert*. All these Welsh academic pieces are lost.

Carnhuanawc delivered his last eisteddfod address in 1848, and the Thomas brothers were there to hear it. William Meredyth was inspired by the experience to produce his portrait bust of Carnhuanawc, a Byronesque masterpiece. This was the first high art image to connect a contemporary writer or musician with the ancient Bard by visual metaphor since William Parry's (or Reynolds's) portrait of John Parry. John Evan Thomas described the circumstances of the making of the piece:

> We were much struck with the poetic cast of his countenance as we sat listening to his eloquent address. The poetic fervour, the vivacity of his manner, and the brightness of the eye . . . glistening with flashes of true genius, made a lasting impression on our minds. There he stood on the platform for the last time, the object of admiration and applause . . . My brother treasured up that noble countenance in his memory; and on our return to London, he employed his best efforts to embody those thoughts in sculpture.

The death of Carnhuanawc signifies the end of the first Celtic Revival, and spared him the painful years of national reassessment in the light of the Blue Books. The antiquarian mists were blown away and the intellectual atmosphere was changed. The new age was crystallised in a tidy *vignette* of its clash with the old at the Llangollen Eisteddfod of 1858. Faithful to the analytical principles of his profession, the Merthyr chemist, Thomas Stephens, offered an essay which unceremoniously ditched a favourite myth of William Owen Pughe and many of his contemporaries concerning the discovery of America by Madog, and the survival of a tribe of Welsh-speaking native Americans there.[16] His essay was judged the winner, but the prize was withheld. The committee could not bring itself to reward a man who had so muddied the clear waters of national tradition.

It became obvious to the younger generation of intellectuals that the misty Celticism which had enriched the ground in which Madog had flourished could not sustain their image of a new Wales. The Bard emerged victorious for the last time for half a century in the 1858 Eisteddfod. The painting competition was won by William Edward Jones, who like Stephens worked in Merthyr, with

[16] See: Gwyn A. Williams, *Madog, the Making of a Myth*, London, 1979.

117

his interpretation of Thomas Gray's *Last Bard*. 'The Massacre of the Welsh Bards' was again the set subject in the 1867 Eisteddfod, but the professional artists did not compete. According to one critic, 'The paintings sent in for competition were simply wretched, and are not worth notice', an observation which suggests that amateur painters, well behind the times, remained faithful to the old mythology. [17]

William Edward Jones's *Last Bard* is now lost, but it is known to us through an engraving in the *Illustrated London News* that carried the image to the heart of English society. But what had once been an exciting symbol of newly discovered ancient roots, and for the Welsh, of national respectability, was now a tired and old fashioned cliché. England had moved on. Rationalists in that country had lost their interest in the origins of society and man in his natural condition, the interest which had contributed to raising the profile of Wild Wales so high. In its place had come a commitment to utilitarianism. 'Progress' was the logo of the new age and in that same spirit Welsh intellectuals such as the educationalist Hugh Owen—and a number of visual artists—applied themselves to the re-education of the nation.

A group of Welsh artists in London were particularly active at this time, in particular William Davies, Mynorydd, Thomas Brigstocke and William Williams, ab Caledfryn. The eldest member of the circle, Joseph Edwards, had already exhibited his *Philospher exemplifying the principle Know Thyself* in the London Eisteddfod of 1855—a rather ironic choice of theme under the confused circumstances. The intention of these reformers in using the eisteddfod as a stage for their ideas was to find 'the artistic talent that may yet lie dormant in our secluded valleys and . . . correct the taste of our aspirants' to success in the English art world. [18]

In addition to the eisteddfod competition that brought forth *The Death of Tewdrig*, and the publication of the Blue Books, 1847 saw a third event of considerable significance for the history of our visual culture. Just as Welsh intellectuals began to reconstruct themselves into pragmatic rationalists on the English model an artistic reaction against the new values began in England. The Pre-Raphaelite Brotherhood was formed following the meeting of Dante Gabriel Rosetti with William Holman Hunt and John Everett Millais in 1847. In 1858, the year after the Bard's last appearance at Llangollen, Rosetti met Edward Burne-Jones and William Morris in Oxford to begin the Brotherhood's second phase which produced a flood of influential Arthurian imagery. It is an irony of our art history that the two young men who would crystallise in the English mind the medieval Anglo-Arthur out of Tennyson's poetry were of recent Welsh descent. As we shall see, when the row over the Blue Books had

[17] *Carmarthen Journal,* 6 September, 1867. A naive portrait based on de Loutherbourg's image, which may well be an eisteddfod competition picture from this period, survives in a private collection.

[18] *The National Eisteddfod, 1865, Aberystwyth*, p.7.

faded into the background, another generation of Welsh intellectuals would eagerly claim these two brothers in the hope of building a tradition of national painting.

In the meantime the London Welsh intellectual circle flourished, and in 1875 some of them formed *Cymdeithas y Vord Gron*—the Society of the Round Table. Among the members were Ceiriog and Edith Wynn, and from amongst the visual artists, Joseph Edwards and the photographer William Griffith, Tydain. The Round Table was a sort of secret Celticist society, modelled on the Freemasons. In the new intellectual climate the Bard had not so much gone to his grave as to a secret cave in the mythical far west. We catch an occasional reference to him in this dark period on the back of the canvasses of ab Caledfryn, painter of rather pedestrian portraits of respectable ministers, and in the work of Joseph Edwards. Ab Caledfryn was in the habit of signing his works in *Coelbren y Beirdd*—the Bardic alphabet; and the *Nod Cyfrin*—the secret sign of the Gorsedd—decorated several otherwise sober busts by the sculptor. According to Mynorydd, Joseph Edwards formed a 'personal allegiance to Hugh Owen that bordered on the superstitious':

> He began to conceive the idea that Wales was to be the home of that transcendentalism which has possessed his soul ... The Welsh race had been entrusted with the secret of poesy, and the order of bards, if once infused with the spirit of modern thought, would become the agent of a higher and more spiritual civilisation, which would supercede the superstitions of the churches, and emancipate the human mind from every law, except that of the good and beautiful. The perfect state was not to be found in human institutions, but in constant aspiration towards moral and intellectual excellence ... Welsh nationalism was to him essentially literary; the intrusion of the political element would have been to him an offence, and would have lacerated his delicate soul.[19]

The Bard was dressed up in the contemporary dress of the Victorian reformer but occasionally the trousers slipped down to reveal the ancient apparel underneath. In 1850 William Roos painted his masterly portrait of Talhaiarn which stands in the tradition of *The Blind Harper* of William Parry and William Meredyth Thomas's *Carnhuanawc*. On the back of his romantic masterpiece Roos added the sub-title, *The Bard in Meditation*.[20]

The desire for distinctive roots persisted, therefore, even in the face of the intense desire to be acceptable to the English and to be imperial partners. Celticism would rise again in this atmosphere once it had found a rational and therefore a respectable expression of itself. That expression came about through

[19] William Davies, Mynorydd, 'Joseph Edwards, Sculptor', *Wales* (OME) II, 1895, p.134.

[20] For Roos's portraits of Talhaiarn, see *Artisan Painters*, op.cit., p.35. *The Bard in Meditation* and Thomas's *Carnhuanawc* are reproduced in colour in *Y Chwaer-Dduwies* ..., op.cit., p.81.

John Jones, Talhaiarn—the Bard in Meditation, by William Roos, oil on canvas, 1850. The commission may well have been related to the Rhuddlan Eisteddfod of 1850, with which Talhaiarn was much involved. He designed the building in which it was housed.

the work of Sir John Rhys, the first professor of Celtic Studies at Oxford. He built his linguistic and mythological research on rational and analytical academic principles. In the new intellectual climate that resulted artists ventured into the field once again, creating a second Celtic Revival. This time it was primarily a stylistic revival, rational and studious, based on the illuminations in Celtic Christian manuscripts and on carved crosses rather than on the rebirth of some ill-defined Celtic spirit. Owen Jones, the son of Owain Myfyr, published Celtic designs as early as 1856 in his pioneering *Grammer of Ornament*. But it was the publication in the 1880s of the *Book of Kells* in facsimile that proved the turning point. It became a vital source for artists, designers and craftspeople in Wales as well as in Ireland.

Amongst the students of Sir John Rhys at Oxford was John Morris-Jones. When he was appointed professor of Welsh at Bangor, he became the focus of a group of New Celts in the north of the country who flourished around the turn of the century. The numerous Celtic revival crosses in the churchyards of the area, and the memorial to the Morris brothers, leaders of the first Celtic Revival, testify to the energy and visual inclinations of this group.

The stylistic revival was not on the same scale as that in Ireland, but nevertheless, it produced a substantial amount of work. Among the artists influenced by it was John Kelt Edwards who was described at the time as 'our national artist'. Lady Llanofer is reputed to have given him the name 'Kelt'. Among his Celtic style productions was the bookplate for the library of Sir John Rhys, dated 1916. But some years earlier, in 1902, he had produced a series of charcoal drawings (which were exhibited in the Salon in Paris) on the theme of *The Departure of Arthur*, which were not at all consistent with the stylistic revival. It was also in 1902 that T. Gwynn Jones's great poem on the same theme was published, of course. Romantic Celticism, and with it the Bard, was about to reappear.

Contemporary expectations of Kelt Edwards were quite unreasonable and certainly contributed to the personal difficulties which limited his career.[21] The hope of the nation's intellectuals for an artist who would produce national imagery and at the same time achieve high status in the English art world was fulfilled by the older contemporary of Kelt Edwards, William Goscombe John. In the year of T. Gwynn Jones's *Ymadawiad Arthur* and Kelt Edwards's drawings of the theme, Goscombe John exhibited his delicate small bronze *Merlin and Arthur* at the Royal Academy. The sculpture followed Tennyson's description (which had been illustrated by Doré) and would have been understood in the context of the work of that poet in England. But, whether consciously or not, Goscombe John was playing the old game of ambiguities in

Sir John Rhys bookplate, by Kelt Edwards, colour lithograph, 1916. Edwards designed a number of bookplates in this style. The bookplate for the library of Sir John Rhys was posthumous—Rhys had died in 1915.

[21] See: Peter Lord, 'Harry Hughes Williams—In Context', *Planet* 98, April/May 1993.

Merlin and Arthur, by William
Goscombe John, bronze, 1902.

*The memorial to Evan and James
James, composers of the National
Anthem*, Pontypridd, by William
Goscombe John, bronze, 1930.

his Welsh mind which allowed the patriotic home audience to enjoy a different
aspect of the image. It did not require much lateral thinking to understand the
Tennysonesque Merlin as the Welsh Druid-Bard, standing in the same
relationship to the new-born Arthur as the Bard stood to his king in *The Death
of Tewdrig*. Goscombe John's sculpture is not an isolated example of this
surrogate Last Bard. A sculpture was produced for a pub in Pontypridd around
the turn of the century which portrays Merlin carrying a harp, with a leek and a
goat at his feet—the whole visual paraphernalia of Welshness gathered together
into one work of popular art.

The occasion of the reappearance of the Bard-Druid in art at the start of the
twentieth century is significant. *Cymru Fydd* had failed some six years earlier,
and after the death of the political body, the spirit—the fantasy of eternally free
Wales—was released to roam abroad once more. T. Gwynn Jones's poem and
the first visual images of the lost king had not appeared in the 1880s to support
the Home Rule movement. The Druid-Bard was a refuge in defeat and artists
like Goscombe John were much happier in his company and in that context
than in the world of activist political art. Through the Druid-Bard they could

practise their ambiguous patriotism knowing that their Welshness would not contradict their Britishness. Goscombe John was one of the visual praise-poets of British Imperialism, his heroic and military statues appearing in various outposts of the Empire. The art of the spiritual revival of Wales flowered in the back garden of this extended England. Nearly all of its producers had established themselves in London and received the patronage of the establishment there. Loyalty was the word that defined their national spirit, as it had that of Hugh Hughes and his predecessors.

Goscombe John became a confident and respected member of the establishment. This enabled him to invest his good name in the Bard image on several occasions. In 1912 he designed a medal for the National Eisteddfod Association portraying Taliesin enveloped in the flowing robe of Thomas Jones of Pencerrig's *Last Bard*. He set him down against an ambiguous sunset or sunrise. The Druid-Bard was not so much a symbol of an unbroken tradition to Goscombe John and his contemporaries as of death and then rebirth in the new context of Great Britain. 'The national temperament of Wales slept, but after seven centuries, under the influence of the new light, that is the light of education, it awoke', said the art critic Thomas Matthews in 1911, in praise of Christopher Williams's *Wales Awakening*.

The high point of Goscombe John's use of the image would come years later in a very different national atmosphere, after the Great War. The finest child of the Bard of Thomas Gray in Welsh academic art was *The Memorial to the writers of the National Anthem* in Pontypridd. The James memorial did not belong to its period. It was the fruit of the art produced in Wales at the start of the twentieth century, although it was not a unique anachronism.[22] Dorothy Byeford Thomas received high praise at the 1926 Eisteddfod at Swansea for her *Bardic Group*, which incorporates the stylistic mannerisms of the 1920s, as does the plinth of the James Memorial. Goscombe John was the adjudicator.

In the years leading up to the Great War the combination of patriotic Celticism and English Imperialism reached its climax. About 1904 Christopher Williams, the young star of Welsh art, painted a portrait of Hwfa Môn, the embodiment of the visual tradition of the Druid-Bard, adding another work to the brilliant series of William Roos, William Meredyth Thomas and William Parry. In 1911 the artist again went to the north to record the investiture in Caernarfon. Artists and designers took the opportunity of this event to regurgitate all sorts of loyal national symbolism, from ladies in tall black hats, and dragons on the ring of the Prince (designed by Goscombe John), to Celtic interlace designs on the official invitations. The attention of the press was

[22] The idea for the memorial was conceived before the war. 'The war checked the movement but I understand it is intended, during the autumn, to take steps to bring the movement to a successful conclusion.' *Carnarvon and Denbigh Herald,* 3 August, 1923. It was completed in 1930. Goscombe John's medal, Christopher Williams's *Wales Awakening* and Dorothy Byeford Thomas's *Bardic Group* are illustrated in *Y Chwaer Dduwies . . .,* op. cit.

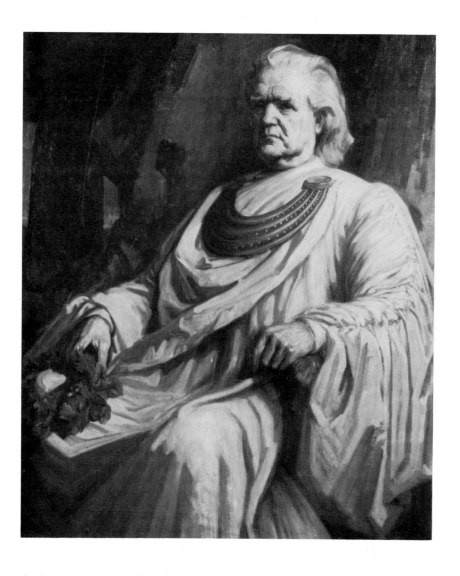

Hwfa Môn, by Christopher Williams, oil on canvas, 1905. Williams painted two versions of this portrait, in 1904 and 1905, the last year of the sitter's life. This version bears a strong resemblance to Herkomer's watercolour portrait of 1896.

particularly concentrated on the royal commission to Christopher Williams. 'Local boy makes good' was the line, and his wooden and uninspired picture was generally much over-rated. It was still this commission that came first in the minds of the press when the death of the painter was noted in 1934: 'Mr Christopher D. Williams—Welsh Artist Who Painted Royalty.'[23]

[23] Unidentified press cutting in the scrapbook of the Glynn Vivian Art Gallery, Swansea.

During the investiture ceremonies Goscombe John was knighted. To him, and to Christopher Williams, the investiture was the culmination of the Celtic Revival—England's recognition and compliment to the progress that Wales had made since the dark days of the Blue Books. Yet, in the same year, Christopher Williams celebrated the nation's achievement in a completely different way, in his huge allegory *Wales Awakening*. Its theme was the awakening of Gwenllian, daughter of Llywelyn, from her magical sleep. It is the female spirit of the muse that awakes rather than the masculine spirit of her father's war of independence. A century and a half earlier, Thomas Gray had embodied his national spirit in a different woman—Queen Elizabeth:

Girt with many a baron bold
Sublime their starry fronts they rear;
And gorgeous dames, and statesmen old,
In bearded majesty appear.
In the midst a form divine!
Her eye proclaims her of the Briton-line;
Her lion-port, her awe-commanding face,
Attempered sweet to virgin-grace.

In his contemporary analysis of *Wales Awakening*, Thomas Matthews referred to several favourite Welsh notions, and especially to the idea of the injustice of the conquest. But the most fundamentally important was the eternal continuity of Welsh freedom in the spirit of the muse and the language:

When Wales lost her freedom with the fall of Llywelyn, she showed to the enemy, or the enemy saw in her as a result of his arrogance . . . treachery where there was no treachery, and hypocrisy when she was forced to obey a rapacious enemy . . . But the true temperament of Wales was hidden from the enemy—to the children of her bosom alone was it made apparent—that is to say the spirit of *cynghanedd*[24] and rhyme and song. These virtues do not shine forth in a nation that has lost its freedom, any more than they are to be seen in a man who has lost his soul.

Cymru Fydd is no longer in its infancy, but the maiden of beautiful face and form awakes to the clear light of day. She is older than England; but since she has slept so long she is young, and she sees new hopes—new and boundlessly high—in the homelands of song and art.

As the new political expression of Wales sank in the sea of Imperialism, it would seem that the war brought relief to some of the intellectuals of Thomas

[24] *Cynghanedd* is the system of alliteration characteristic of Welsh poetry. The quotation is from *Cymru*, OME 1911, p.19.

Matthews's generation. Here was a simple and unambiguous cause where Welshness could be invested in the name of the justice it had always represented in their minds. Behold the Britain of King Arthur fighting the Christian battle against barbarism! During the war a book was published to raise money for the 'Welsh Army'. It was a wide ranging anthology of literature and visual art,[25] with an introduction written by the chief New Celt, John Morris-Jones, which crystallised the mentality of the times:

[25] *Gwlad fy Nhadau,* ed. J.M. Jones, London, 1915.

> It will undoubtedly be noticed how appropriate to today's situation are many of the pieces which express the patriotic tradition of the Welsh; the reason is that this is once again the old battle—between the spirit of the Celt and the spirit of the Teuton. Britain is more Celtic throughout than was previously supposed, and today it fights the battle of the Celt on behalf of freedom and civilisation against the military arrogance and barbarity of the Teuton.

The Bard, of course (drawn by Garth Jones, borrowed from the publicity material of the 1909 London Eisteddfod), was placed on the title page of the volume, the symbol of this confused perception of Welsh and Celtic spirit, and opposite, as a frontispiece, *Wales Awakening,* reproduced in full colour.

Thomas Matthews and his friends made use of the Welsh ancestry of those painters who had so successfully portrayed the Brythonic myth to weave even closer together the fate of the two nations. In that same fruitful year of 1911, the first book about Welsh art was published. *Welsh Painters, Engravers and Sculptors* was the composition of the Reverend T. Mardy Rees, but he had made use of information supplied by the contemporary circle of artists and art intellectuals. William Morris and G.F. Watts were both included in the book as Welsh painters but it was Burne-Jones who was eulogised above all the others. Mardy Rees quoted from C.E. Hallé's *Notes from a Painter's Life* to come to his patriotic climax:

> I was one day sitting with Watts in his studio, and he said to me, 'Whereabouts in art do you place Burne-Jones?' 'Amongst the first 12 or 15', I replied. 'I place him first of all', said Watts.

But simply connecting these painters with Wales through their lineage made an inadequate case.[26] The ultimate confirmation of their Celticness came in the presence of the spirit of the Bard in their works. It was a long lived fantasy. Edmund D. Jones noted of Burne-Jones in his *Camre Celfyddyd* in 1938: 'The characteristics of the Celt are easily perceived in his pictures. The mystical and poetic element is obvious, and the lively imagination which is the inheritance of the nation.'

[26] See: *The Aesthetics of Relevance,* op.cit., p.25, for a full analysis.

The Bard, by Garth Jones, 1909. Alfred Garth Jones was trained at Manchester, at the Royal College in London, and in Paris. He emigrated to New York where he specialised in decorative art. This is the version of the original colour poster used as the frontispiece to *Gwlad Fy Nhadau*, edited by John Morris-Jones, and published in 1915.

The confusion that was exemplified by Mardy Rees about how to define Welsh art and artists demonstrated the split in the national consciousness. Undoubtedly motivated by patriotism, the art intellectuals of the second Celtic Revival insisted on a distinct existence for Wales while at the same time binding the fate of the nation ever tighter to that of England. To Thomas Matthews, claiming Burne-Jones and Watts as fellow Celts was not deepening the national confusion, but exemplifying the contribution of the Celtic spirit of Wales to the united British race. It was a revelation, not an obfuscation.

The iconography of the fanciful Druid-Bard has been a living part of the evolution of the Welsh mind since the middle of the eighteenth century. The wider Celticism of King Arthur and of Llywelyn, and the stylistic Celticism that developed partly as a reaction to this mythologised core, has also been of great importance, because of its influence on the complexities of the relationship between Welsh and British consciousness. The Druid-Bard developed at one and the same time as a symbol of homogeneity and of particularity. It has been both a mirror to, and an active factor in creating the ambiguity which has deformed the national ideal in Wales. Because that ambiguity is unique to Wales it is also, ironically, strong testimony to the continuity of a particular national culture. Nobody else has anything quite like it.

TWO PICTURES IN A TRADITION

I think of a tradition as roads in a landscape. The mountains, towns and buildings are the poems, pictures and political events of a culture, but without the roads between them they are inaccessible to me. The roads establish the relationships between the features of the landscape and make it a practical setting for my individual and communal life. One of its most important features has a rather peculiar status. Take a trip upwards in a helicopter and the horizon is revealed to be only one of a series of larger concentric horizons. These horizons of the landscape are the conceptual frames around traditions—community traditions, national traditions and culture-group traditions. They have a different kind of reality from that of a mountain, but no landscape can be perceived as a coherent entity without one.

This metaphor holds, although it becomes much less tidy, when the helicopter moves sideways—when the metaphor is extended to recognise the multiplicity of landscapes in the world. Unfortunately, their horizons do not tend to meet neatly but to intersect, creating overlaid and ambiguous landscapes, areas of confusion and conflict. The road systems designed from their respective centres do not cohere well.

The landscape is not static—new features are added, new roads are built and old roads fall into disrepair. This creativity seems to me to be the most essentially human feature of life—we cannot help making new. That's the easy bit of course. I try and cope with the difficult bit, what on earth is the purpose of it, and how should I direct that instinct in myself, by means of a rather vague concept of enrichment. Creativity becomes enrichment, rather than simple addition, only if it is wedded to coherence. The main determinant of coherence, as I have suggested, is a clear vision of the horizon, and a knowledge of the roads within the landscape. The roads are the common property of us all, but if a substantial number of people in the landscape, let alone the government who erect the signs, are navigating by a different map, the result is likely to be pretty chaotic—incoherent in fact, and certainly not enriching.

In that situation the problem, of course, is who has the right map? Deciding on what constitutes coherence in creation is a matter of ethics. I am not persuaded (even if occasionally tempted) to think that both maps can be right—in other words, that there is no right. Visual artists especially, because they are creators of a self-conscious kind, are required to be concerned with this

This essay was first published in *Planet*, 92, April/May, 1992.

matter. They are not excused moral considerations, as they have so often tried to claim. No image can be without meaning—each one is a road sign in the landscape—and it is the duty of the image maker to make that meaning coherent. The making of images is a moral, indeed, a moralising business.

Trying to see the horizon clearly, and to locate the centre it implies, and then making new features and new roads coherent with that centre, is a basic requirement for moral art and for moral art history and criticism, therefore. As someone who tries both to make images and to write about them, I have to say, at great risk of sounding pompous, that I do not know how artists and writers can proceed with a clear conscience in this particular landscape with the current government-issue road map. To be fair, in the visual culture, there is no other map available on the shelf. Travel without one is more in the nature of an exploratory walk on a muddy track than an air-conditioned bus ride. I find that more interesting, I must say, as well as the inevitable consequence of a moral view of art, but it obviously doesn't suit everybody.

A room is the most intimate landscape of all. It has taken me ten years to get around to making a parlour in this rather spartan house. During the last six months I have done it, and in addition to quantities of concrete, plaster and paint, the two pictures which now hang there became a part of the progress of its design. The first picture to present itself was Iwan Bala's *Galarnad i Arthur* (Lament for Arthur) I have been enthusiastic about this painter for a long time, so much so that I was recently accused of putting him on a pedestal. I don't do that—putting things on pedestals in a culture as unsure of itself as this one and which consequently affects a cynicism about its own product, is an invitation to get them knocked off. Respect for and confidence in painters is fragile enough without exposing them to unnecessary hazards. All the same, *Galarnad i Arthur* is an outstanding individual in a notable series of works. It is a new picture and a moral picture—an addition to the landscape and a coherent addition. It is a picture about contemporary Wales which uses Arthurian and other mythological themes and references. Five physically seperated elements are held together psychologically by the tension of the design and the paint surface. There is a glowing cross on a mound which also suggests a sword, a ladder, an empty boat, an island, and a mourner. The isolation of the elements gives the picture a sombre mood despite its brilliant colour. It seems to me to be the work of a mature painter of great ability and seriousness in whose work the private complexities of personality and the public complexities of the culture with which he identifies are fully integrated. The search for this integration is, I think, fundamental to the ethics of image making. This is where coherence begins.

The second picture is of Borth, on the Ceredigion coast, and was painted in

1919. Reeds are being harvested on the salt marsh. The picture has the rather sepulchral tone characteristic of the late nineteenth-century water colour, even though it was done in another age. The painter was Frederick James Kerr from Barry. The earliest exhibition that I know of in which Kerr took part was at the National Eisteddfod in Cardiff in 1883, a massive affair organised by T.H. Thomas in the Taff Vale railway shed at Cathays. Having exhibited at eisteddfodau for nearly forty years, Fred Kerr himself organised a large and influential exhibition in his own town in 1920. It showed the work of all the prominent Welsh painters and sculptors of the period, but unlike the Cardiff show, did so in the context of an historical exhibition which ranged from Van Dyck to Monet. Into a setting just as unlikely as the railway shed—the Drill Hall in Barry—collectors (including the Davies sisters) emptied their houses for the elevation of the proletarian mind.[1]

These two pictures are visually very different and most observers would find few roads between them. Yet for me there would be no reason to hang these pictures together if they were not features of a single landscape. The map may be unpublished but these two pictures are linked together coherently within the landscape of national culture. I stressed Fred Kerr's commitment to exhibiting in the National Eisteddfodau at the turn of the century because it is reflected in a similar commitment from Iwan Bala today. This is not the marginal and inconsequential matter it might seem to many artists in Wales. The fact that participating in these exhibitions has at times been perceived as more of a professional handicap than an advantage only underlines the significance of the commitment of Fred Kerr and Iwan Bala. It is a public expression of a national allegiance they share.

Fred Kerr was a teacher as well as a painter. Among those he invited to exhibit at Barry in 1920 was his one famous pupil, Christopher Williams. Fifteen years previously, Williams had begun to work in 'a gold mine, untouched and full of Welsh fire and imagination'.[2] He had been inspired by his contact with John Morris-Jones in Bangor and the circle of New Celts that included the architect Harold Hughes and the painter Leonard Hughes, to begin thinking about his three Mabinogi paintings, *Ceridwen, Branwen* and *Blodeuwedd*, and his huge allegory of national awakening, *Deffroad Cymru* (Wales Awakening). The use of the myth of Gwenllian, bewitched daughter of Llywelyn, in this picture, in order to make a statement about the condition of the contemporary culture is reflected in both Iwan Bala's mythologised historical subject matter and in his purpose.

Fred Kerr's career spanned almost exactly the duration of the attempt made by Thomas Matthews of Llandybïe and others to design a road map of national

Frederick J. Kerr, by an unknown photographer, c.1920.

[1] For a detailed description of the exhibition and the consequent row— Margaret Lindsay Williams was excluded in her home town by Kerr—see: *Y Chwaer-Dduwies . . .*, op.cit., p76.

[2] A.D. Fraser Jenkins, *Christopher Williams Centenary*, Cardiff, 1973, p.7.

131

Self portrait, by Christopher Williams, oil on canvas, c.1905.

Thomas Matthews, Llandybie, by an unknown photographer, c.1910. Matthews was born in 1874 and educated at the University College of Wales, Cardiff. He interrupted his teaching career in order to study literature and visual art in Paris and in Rome. He died in 1916.

[3] Thomas Matthews wrote extensively on contemporary Welsh art and aesthetics in the magazine *Cymru* through 1911.

visual culture in parallel with the new national art features that Williams was building in the landscape. The exhibitions I have mentioned were a part of that attempt. Matthews was a moralist: 'His [the artist's] responsibility is to seek to awaken man to his duty', he remarked in 1911.[3] He attacked contemporary realism for its obsession with supposedly objective values and maintained that moral painting was both a necessity for all art and a particular strength of his perception of Welshness in art. It was found most clearly in allegorical painting—hence his location of Williams in a central place—although also in poetic landscape as practised by Fred Kerr, for instance. He wrote about both men.

Matthews's writing draws me personally into the common landscape of the two pictures. I identify strongly with what he tried to do and with his moralising standpoint, although the conclusions I draw from the application of ethics to art in a Welsh national context are very different to his. In the same way, the politics of Iwan Bala's *Galarnad i Arthur* are very different from the politics of Williams's *Deffroad Cymru*. The road travelled by Matthews is overgrown and out of use, but it remains a feature of the landscape, a part of its contemporary coherence.

I always felt quite at odds with the received wisdom of my so-called art education in the 1960s that told me that art was somehow about the way things looked, as if that was a matter disconnected from the rest of life—the dogma of amoral or meaningless art. This mumbo-jumbo of pure vision in which I was educated and which still locks up many image makers is incomprehensible to me. So when I look at pictures I see them surrounded by other pictures, by their makers, and most of all by the perceptions outside art which generated them. I need to say here that this does not mean that looking at pictures is not an emotional experience. On the contrary—coherence can be very moving, as anyone moved by hearing and seeing a symphony orchestra at work will know. It's just that the emotion is in the meaning, not in the means. The dissimilar formal aesthetics of my two pictures is for me little more than a matter of mechanics, not irrelevant—nothing is irrelevant—but trivial by comparison to meaning. My sense of tradition is not of a tradition of style but of allegiance, not an aesthetics of form but an aesthetics of relevance[4] to a national idea. When I make images or when I write, each new piece is an exploration within the landscape of this particular culture. Ignorance of the roads of tradition results in getting lost, in creation as incoherent addition and not as enrichment. More clouds obscuring the horizon of Wales.

[4] See: *The Aesthetics of Relevance*, op. cit.

Iwan Bala, photograph by Branwen Nicholas, 1989. The arrest took place at a protest meeting organised by *Cymdeithas yr Iaith Gymraeg* at the Welsh Office in Cardiff. Iwan Bala had sprayed a slogan on the wall.

The Caravan, by Augustus John,
etching, (c. 1901-14). The etching
appears to show John himself.

ART AND PATRIOTISM

In a letter written in 1952, Augustus John remarked that Winifred Coombe Tennant's patronage of Evan Walters had been motivated by patriotism. Sean O'Casey, another friend and supporter of Walters, had been motivated by ideology, presumably socialist ideology.[1] John's meaning, of course, was that they had resorted to these motives because Walters was a second-rate painter and that the quality of his work would not have been sufficient in itself to occasion their encouragement. The sourness of this and other comments in the letter was intensified by the fact that John had perceived the underlying failure of his own work by that time, and by the fact that both men were Welsh. John lacked intellectual and moral drive, resulting in vacuous painting and an inability to come to terms with the complexities of identity bequeathed him by his birthplace, compensated for by a great deal of anti-ideology bluster. Meaninglessness, we are told by an advocate, was the essence of his art—'the picture is the thing, its message a secondary affair.' It would all end in the tears Michael Ayrton witnessed in the early 1960s through which John, in his dotage, whined 'My work's not good enough.'[2]

Early in his career John's anti-ideology was energetically enough applied to approach the condition of ideology, for all its negativity. Whatever his protestations, his gipsy paintings are certainly not devoid of content or meaning, and for that reason, for me they are his best. The gipsies were a group manifestation of outsiderness—a metaphor for the outsiderness of his own experience which he projected in his bohemian public persona. One manifestation of it was his proverbial lechery, of course. To add to the mythology, William Nicholson's daughter once remarked to me that John needed sex almost as much as he needed paint. She had this from her mother who had been savaged by the bearded Don John in the back of a taxi on the way to the Ritz towards the end of the Great War. Something to do with the creative urge, apparently. Yet by 1927 he was an academician so that this bohemian persona was heavily underpinned in pecuniary and in social terms— and undermined in philosophical terms—by a position as a pillar of the English establishment and a country gent.

John was a monoglot English speaker from Pembrokeshire and so his difficulties with Welshness would seem unremarkable were it not for the fact that he was born in 1878, only five years after Christopher Williams, and

This essay was first published in *Planet*, 93, June/July, 1992.

[1] John to David Bell, 30 July, 1951, Augustus John Papers, NLW Ms.22779E.

[2] Malcolm Easton and Michael Holroyd, *The Art of Augustus John*, London, 1974.

therefore into a generation that sought to manifest patriotism in visual art more than any other before it. John was not insulated from this. Over a typically snide remark written in Paris in 1907—'In Wales, as I am told, lies hidden the soul of art; the body being doubtless no less reticent and inconspicuous'—he laid the patriotic appeal to 'rouse the old Mervyn from his slumbers of ages and welcome Arthur back!'[3]

This general negativity overlaid with flashes of patriotic sentiment is characteristic, of course, of a variety of Welshness manifested by many other artists—the 'Land of my fathers—and my fathers can keep it' variety. Dylan Thomas became a close friend of Augustus John in the 1930s. He eventually married one of John's innumerable lovers, Caitlin MacNamara, daughter of his friend Francis MacNamara. I find the psychology of these anti-patriots who kept each other's company outside Wales very fascinating. John could not escape his Welshness, and was not allowed to anyway by compatriots at home. His fame only aggravated the problem at a time when success in England was still considered the ultimate achievement for a Welsh person. As a result he was regularly asked to involve himself in such things as adjudicating at the National Eisteddfod, necessitating hypocritical public posturing. In 1936 he observed privately that 'The works of art seemed to have been dug out of some mouldy Victorian sea-side lodging house.' In fairness I should add that he was in a position to speak with authority on this matter as he was born in one.[4]

Christopher Williams and John were not quite the last prominent Welsh painters trained in the English neo-classical tradition, as Margaret Lindsay Williams was at the Royal Academy from 1906. John's rejection of Wales was entirely consistent with his rejection of that kind of art—a manner to which the other two broadly adhered and through which Christopher Williams, in particular, sought to assert Wales, albeit in the muddled context of empire. Yet the art for art's sake of John, which replaced art for the nation's sake, was equally imperialist and far more incidious by reason of its subtlety.

The forms of formalism are meaningless only if considered isolated within a formalist frame. The celebration of colour for itself, for instance, especially in the realist mode characteristic of John, is not difficult to understand in a wider frame as a metaphor for his establishment bohemianism. Both John and his pictures were certainly extremely colourful, but ultimately not beyond the capacity of the establishment to absorb. That kind of celebration of colour was a distillation of the aesthetic system which lies at the root of the European post-Renaissance high art tradition. It is an axiom of that tradition that its product expresses the highest human values and aspirations—that is why it is called high art.

[3] *Wales: Today and Tomorrow.* The fact that John later joined Plaid Cymru emphasises the complexity of his attitude.

[4] NLW Ms.22778D. The occasion was the Eisteddfod at Fishguard and it was a source of irritation to John not simply because of the paintings. John had driven from London with Caitlin MacNamara. The two were joined at Laugharne, to John's surprise if not to Caitlin's, by Dylan Thomas. They 'osculated lasciviously' on the back seat of John's 'large and powerful car' for the rest of the journey. I quoted John's account more fully in *Y Chwaer-Dduwies*, op.cit., p.104, but since then Alfred Janes, who was also present, has told me of the *denouement* on the return to Laugharne. Janes was following John in his father's car: 'John, I suppose in response to his novel situation, drove at breakneck speed: it was too much for my father's car ... and at St.Clears a big end gave out. Meantime the others disappeared heading I assumed back to Laugharne ... But no. They had—I understood later—gone on to Carmarthen where a beery squabble ensued.'

Caitlin MacNamara, by Augustus John, oil on canvas, c.1930. This portrait was painted by John over another of a different sitter who remains clearly visible, upside down, in the lower part of the canvas.

It is not a coincidence that high art critique grew up in those European cultures which developed into the imperial powers of the modern world. Successful colonists need the self-confidence that springs from knowing that the culture they export is a gift and a liberation, however painful its imposition may seem at the time. On the pyramid model of culture which it follows, its values mark a single high point for all humanity. They stand above nationality, true for all places and all times. It just happens that the colonist's culture, especially if it is English culture, has been divinely directed to them first. Hence the art of the imperial nations, as carrier of these values, assumes the status of a universal or international language. In an essay written in 1865 the art critic and painter Evan Williams expressed himself 'full of hope for Britain in every branch of knowledge and art, believing that she will carry out the command of the poet— "Let England not forget her privilege to teach the nations how to live".'[5]

[5] 'Sefyllfa Celfyddyd ym Mhrydain', op. cit.

High art critique was an important—though often unrecognised— pillar of imperialism, and is proving to be one of the hardest to demolish. A contrary critique that proposes that artefacts are to be understood and assessed as a part of the culture complex in which they arise, and that all cultures have equal value, might seem to have gained some acceptance in the last ten years or so. In fact, ten years of re-education have resulted in little more than lip service being paid to it. The occasional expression of patriotic sentiments about art in Wales is still confused by tired old appeals to the virtues of art as an international language. There is no language that does not have its origins in a particular culture and that does not, therefore, carry the particular values of that culture with it. The languages of visual culture are no different, and the spurious elevation of one of them to the heights of universality is imperialist clap-trap.

In August 1990, a rather more venerable art historian, Marina Vaizey, wrote a little piece in *The Sunday Times* which illustrates that unreconstructed art imperialism is alive and well in England. Her article—'Nothing to show for going native'—was inspired by a visit to Edinburgh Festival, and was wittily sub-titled 'Marina Vaizey advises Scottish galleries not to make an exhibition of themselves': 'Splendid though many of the exhibitions are in Edinburgh this summer, they are not the festival visitor's reason for making a pilgrimage to the city', she suggested. 'Staged as a tourist draw . . . they have nothing to do with the festival, but a great deal to do with Scottish cultural politics, a public search for identity, and what often appears a wilful refusal to go beyond the parochial.'

This is the classic vocabulary of imperialism—the suggestion in 'wilful' of childishness, and the assumption in 'parochial' that there is one centre and Marina Vaizey lives in it. We are well used to this vocabulary in Welsh visual

culture. In his foreword to *Art in Wales* in 1984 Eric Rowan was insistent that he meant to avoid 'an insular, regional viewpoint'. But I digress—the pejorative linguistics are so obvious as not to need explanation. 'Indeed', continues Marina Vaizey, 'Edinburgh seems unable to put on big exhibitions ... except during the summer tourist season, and in particular at festival time. While the international blockbuster show is now a feature of the cultural life of all leading cities, for reasons perhaps beyond the ability of the outsider to fathom, Edinburgh has withdrawn from the game. And not only withdrawn, but retreated at times into a Scotch mist of misguided patriotism.'

Marina Vaizey's Englishness (adopted—she is Jewish American) is quite touching here. Like many English immigrants in Wales, and their forebears in India, she is genuinely hurt to discover that the natives will not love her and clutch her values to their bosoms. She feels personally betrayed by the nationalism of the Scots to whom England has given so much. Recovering herself, she defiantly asserts in the face of rejection by this misguided patriotism that 'Nationalism in art has now become outmoded practically everywhere in the West', a truly astonishing assertion in a year of national revolutions all over Europe in which artists played a prominent part.

Her *coup de grâce* concerned the funding by the Scottish Office of a feasability study for a new National Gallery of Scottish Art:

> If you are, against the tide, going to make a permanent museum devoted exclusively to a national school, that school had better be, in the increasingly sophisticated climate of media access and international travel, pretty dazzling. And, to be blunt, what is publicly available in Scotland is not good enough for such permanent exposure. Rooms full of MacTaggart, W.G. Gillies, J.D. Fergusson, even Cadell, Peploe and glorious Mackintosh ... are just not the equal of galleries of Turners ...

Vaizey is a true Victorian. She not only recycles its imperialism, but also its jokes. In 1866 *The Times*[6] reviewed an exhibition of Welsh art and industry at Chester: 'All the progress and civilisation in Wales has come from England, and a sensible Welshman would direct all his endeavours towards inducing his countrymen to appreciate their neighbours instead of themselves', remarked the editor. However, 'This is an age of exhibitions, and so far as it affords any pleasure to Welshmen to make this exhibition of themselves and their antiquated customs, we have nothing to say against it.' *Plus ça change* ...

[6] *The Times*, 14 September, 1866.

Dewi Prys Thomas at Falling Water, by an unknown photographer, 1984. Dewi Prys was a great admirer of the work of Frank Lloyd Wright and interested by how the Welshness of his upbringing might have affected it. He was not able to visit Falling Water in the USA until late in his life, a journey he described as a pilgrimage.

THE *GENIUS LOCI* INSULTED

Recognition of the importance of the *genius loci* in Welsh architecture has a long history. Edward Pugh had things to say about it in his *Cambria Depicta* written at the beginning of the nineteenth century. William Cornwallis West, connoisseur and amateur artist of Rhuthun, discussed it and other related matters at a meeting of the Cymmrodorion at the 1885 National Eisteddfod. Amongst the practices that drew his fire in a lecture he called 'Art Culture in Wales' was 'a positive mania for whitewash . . . among the humbler classes.' In 1939, the architect Dewi Prys Thomas illustrated what he later referred to as 'a kind of manifesto' with two photographs of such whitewashed cottages.[1] The caption reads '*Y pla gwyn*'—the white plague. This ninteenth-century fashion was a rejection of the poverty of the past represented by the unadorned stone— architecture as symbol. To Cornwallis West and to Dewi Prys, the same stone symbolised the sacred particularity of the place—a clash of perceptions between the architect and the unsentimental consumer.

In 1977 Dewi Prys wrote about 'The *genius loci* insulted, too many new buildings—reflecting in their design only the transitory fads of fashion—appear as if they had crawled along the road from some drawing board in Stoke on Trent.' He described this as 'dispiriting' because, for him, respect for the particularity of the place was a spiritual matter. He underlined the sacred nature of the experience of the *genius loci* with a religious metaphor, comparing the pain of the architect confronted by bad building to that of the minister in a wicked world: 'The more sensitive the minister, the more appalled he is by the sin around him.'[2] Dewi Prys was himself a kind of minister, and he preached with great power. I only heard him once, in 1985, and I was fortunate to do so because it turned out to be his last sermon.[3] For a number of his former students from the Welsh School of Architecture who were in the same audience it was a return to source. It was an emotional affair—we all knew he was dying of the cigarettes that burned constantly while he talked about the images on the screen beside him. The emotional impact of what he said, heightened by this knowledge, was certainly calculated. It was the result of a lifetime's refinement of the material and of the skill of delivering it. Being dimly aware of this only intensified the experience—it was a great performance as well as an important message. Its climax was a dramatic display of the beauty of resonant simplicity in architecture. He led us through a discussion of the European high art

This essay was first published in *Planet*, 94, August/September, 1992.

[1] W. Cornwallis West, 'Art Culture in Wales', *Annual Report of the National Eisteddfod Association*, 1885, p.31.; Dewi Prys Thomas, 'Pensaernïaeth a Chymru', *Tir Newydd*, 1939, p.8. William Gilpin remarked on the same phenomenon but on gentry houses, about 1770.

[2] *Artists in Wales*, 3, ed. Meic Stephens, Llandysul, 1977, p.9.

[3] The occasion was a Gweled conference and the place was Plas Menai near Caernarfon, designed by Bill Davies, 'a very Celtic building' in Dewi Prys's estimation.

tradition to a slide of the Acropolis above Athens. The image changed to a simple stone barn on a hillside above Dolgellau called Beudy Hengwm. After a long silence in which the profound significance for a Welsh audience of this juxtaposition sank in at a level far beyond any words, Dewi Prys asked us, simply, to 'look at the stone'. This barn was as majestic as the Acropolis, the drama of the contrast as great as that made by the affirming organ chords that open the final section of the Saint-Saens *Third Symphony* after the fugue. This was our particular acropolis and it was to be loved as such. Dewi Prys's gift to his students was to enable many of them to understand this and to sense the implications for their lives as architects. 'I believe that architects should recognise a fundamental duty always to design so that the *genius loci* may say "I have awaited, all these centuries, for you to make me whole",' he said.

One of Dewi Prys's students, David Thomas, has recently built a house in a place not dissimilar to the hillside of Beudy Hengwm. He has designed the house around a hall constructed over oak crucks, cut mostly from timber growing nearby. It incorporates unrebuilt stonework from a previous building on the site. The structure of the building determines a set of relationships of scale which both surprise and resonate deeply. The relationships between wall thickness and height, the eaves level and eye level, and so on, are quite different from those in a building determined by the regulated dimensions of new and artificial materials used in isolation, according to their own logic. The resonance that the resulting building sets up in relation to the observer is with a tradition of building as old as the culture itself.

David Thomas has not, however, simply imitated a medieval barn and added windows. This is a building made of new as well as of old materials which meets the requirements of lives very different from those lived in that place in the distant past. By utilising the slope of the site away from the approach to the cruck-built hall for the ancillary rooms, he has achieved a large house with the variety of specialised spaces required by his contemporary culture. There is no doubt in my view that the building both pleases the *genius loci* and moves the culture forward. Dewi Prys began his 1939 manifesto by stating that 'Architecture is an art'. Symbol and metaphor are the first languages of art, and therefore Beudy Hengwm, like all other building, is symbol as well as function. In fact, I believe that Dewi Prys was telling us that building is symbol before function. This is not a difficult assertion to verify by considering the purpose of the advance factories which speckle the landscape like chapels a century ago. They are there to tell us that the government cares—their success in generating investment and jobs is a secondary consideration. Their symbolic efficiency is much more important than their functional efficiency. A leaking roof on a new

building only affects the life of the occupant, and it can be patched. A failure of the symbolism is a failure of the whole building, it affects every one of the people who see it as they pass by, and it is not easily modified. For Dewi Prys the efficiency of the symbol (in other words, the quality of the building) was judged by the extent to which it expressed the *genius loci*—the extent to which the architect was carrying out his or her moral responsibility to the culture of that place. Dewi Prys did not talk about the *function* of architects, but rather about their *duty*—architecture, because it is art, is a moral business.

So that in the mind of Dewi Prys (and, I'm sure, in the minds of many of us who listened to him), Beudy Hengwm symbolised not the visual genius of that particular landscape, but of the metaphorical landscape of the national culture. We have all been brought up in a tradition of high-art history which has locked us into associating particular nationality with particular style. This is a false association. A nation no more needs a single and exclusive style to achieve coherence than it needs everyone to share the same politics—discord is much more characteristic of nation than concord. Searching for an archetypal Welsh style and finding the elements of it in Beudy Hengwm is not at all what Dewi Prys meant. It is not a matter of finding a reflection in the stone from which it is built of the stone lying in the fields all around, a sort of simple-minded game of snap played between the face of the building and a generalised perception of

what constitutes local materials, exemplified by stick-on stone panels on the
bungaloids of Dyfed. Sensing the *genius loci* is about sensing people not about
the kitch manifestation of the new idolatry of the natural. It is not the stone
itself but the culture of the stone and the place of that culture in the landscape
of all human culture. The beauty of Beudy Hengwm is misunderstood if it is
identified as an aesthetics of style. Its beauty lies in its resonance with an
invisible complex of tradition and allegiance that was the foundation of Dewi
Prys's identity. Its aesthetics are those of relevance to that tradition, of
belonging, of having its place in the interaction of all the human activities which
gave that national culture its particular coherence.

On a scale which perhaps Dewi Prys could not have envisaged even as
recently as 1977, the assimilation of Wales into the landscape of somebody
else's culture is being effected on the drawing boards of Stoke on Trent,
superimposing on this place the *genius loci* of that place. Unfortunately, not
just good architecture but all architecture is symbol, even if most of it is symbol
by default. It all speaks, even the Barrett Home, which resonates with the
genius of the security society, elevating the pension scheme, company Ford

Sierra and soporific marital bliss, to the place of the ultimate human experiences offered by British culture. I drove back from Dewi Prys's lecture with David Thomas and we stopped on the coast road somewhere near Harlech to watch the sunset throw Ynys Enlli and Pen Llŷn into a dramatic silhouette. There didn't seem to be any problem at all about determining the *genius loci* of the nation that day. Yet defining the *genius loci* in order to express it in new building seems to have become a huge problem in the minds of architects who believe in the idea of nation, leaving them with a professional life in which they create symbols in conflict with their identity. Architects who recognise that there is a lack of coherence between who they are and what they make often name two factors as the cause of their difficulty. The first is the client problem, and the second is the planning and the building regulations. Most architects see themselves as business people (however attractive some may find the appelation 'artist') and as such, client-led. Because there are too many architects (more per head of population in Britain than in any other place in the world), they feel that they cannot afford to be selective about whom they work for. But their clients, in almost every case, will not share their cultural identification, because an architect, like anybody else in Wales who believes in the national idea, is part of a tiny minority. The planning and building regulations to which they adhere and which they feel constrain them stylistically, in fact constrain them at a much deeper level. They are highly culture-specific to English attitudes and social structures, both as a concept and in their particulars. We tend to assume that, like double yellow lines, building regulations are a sort of universal necessity of modern urban life, determined by rationale, as if rationale was not as culture-specific as everything else. The real significance of the double yellow line dawned on me one day years ago when I was sitting in a small and crowded square in Granada. It seemed to contain far more traffic per square metre than the middle of Bangor or Cardiff, and certainly contained a great many more people, and yet—despite the absence of yellow lines—it did not seize up. Other cultures have other ways of dealing with a parked lorry blocking the street. They hoot, or they drive round on the pavement. Life goes on. Building regulations, like double yellow lines, are an expression of English culture, not of a divinely inspired and universal logic. The difficulties of architects who fail to achieve coherence between their anti-British politics and their art is underpinned by the professional framework in which they work. Architects, in my experience, are particularly obsessed with the idea of themselves as a profession. Their professional association is a trade union designed only to protect the financial interests of its members, and to enhance their social standing. Its code of practice has become an excuse for mediocre design and a refuge from moral

responsibility. Surely the spirit of Dewi Prys's teaching was that an architect's first duty is not to the profession but to the culture with which he or she identifies outside of that profession. They are citizens before they are architects. Surely he was saying that their duty is to refuse to participate in the accretion of symbols of somebody else's culture, and the persecution of the *genius loci* to extinction? A building speaks like a painting, a dance or poem. Architects must use their language like all other languages, to talk about the things they care about. They are not excused moral responsibility because they have a client, a planning authority, and a regulated scale of charges. Politics is degraded to a hobby if it is not carried into the activity which occupies 90 per cent of the artist's time.

In architecture, as in everything else in Wales, this means being on the outside and the sacrifice of social status and financial reward that always comes with working for change. We need a counter visual culture—a body of work of distinct quality made on the basis of ideas rooted in the *genius loci* of Wales. It need only be a small body of work—widespread changes in perception can result from small but concentrated creativity. It is crucial that architects do theoretical work, publish and exhibit, as well as build buildings. Creativity and ideas do not end with graduation from college. There are architects in Wales thinking about building at a deeper level than making the drains work, but there is little interaction between them, and no public perception of a discourse particular to this culture. There is no polemicising about architecture going on. It is crucial that distinctness as a political metaphor in a body of buildings and ideas is asserted and widely publicised. This distinctness must be constructed into an indigenous tradition by historians and critics. A high public profile for the discourse is essential to the development of a broadly based sense of national identity.

There is a model for polemicising and making on the outside in the career of Imre Makovecz in Hungary. Makovecz has recently suffered the indignity of being taken up by the English art establishment who have constructed his career into a spurious and self-congratulatory metaphor for the triumph of capitalist freedom and variety over the oppression and monotony of east European Communism. My attention was first drawn to him nearly ten years ago by David Thomas, before the fall of Communism facilitated the construction of this deceit. He told me about his admiration for Makovecz while we were working on the building at Cofeb Hywel Dda in Whitland. Makovecz was obliged to deal with the client problem by by-passing the prevailing mainstream, working under the patronage of the forestry authority in Hungary and directly with community groups for whom he built communal buildings.

Cultural Centre at Sárospatak, drawing by Imre Makovecz, 1984.

The Dragon's Face—Cultural Centre at Sárospatak, by Imre Makovecz, 1984.

Revolutionising the client-architect relationship was the necessary foundation for a revolution in building—a revolution dedicated to symbolist architecture in celebration of the *genius loci* of Hungarian culture. His example—and indeed, in a small way, the example of Cofeb Hywel Dda—demonstrates that the moral architect, like any other artist in this culture, is required not only to build the building but first to construct the situation in which creative building can take place. In order to create the opportunity for the Hywel Dda building conservative and cautious people had to be persuaded or cadjoled, large sums of money borrowed, and much emotional energy expended in the politics of art.

The result was a fine Welsh building but the way it was done was certainly outside its architect's experience at that time. Artists of all other sorts—sculptors, musicians, dancers—are constantly having to go through this exhausting and dispiriting process. It is a constant search for the means to the moral end. As for the building regulations, break them. If the law is unjust, break it. The well-behaved British 'democratic way' is simply a means of ensuring nothing changes. Find the money and the supporters and build the outrageous building that breaks all the rules, and make the moronic operatives of regulation take you to court, make them knock it down and have a public row that shows that this culture is alive and going its own way. This is, again, only being true to the spirit of the teacher who concluded his personal statement of faith in 1977 not with an appeal to RIBA professional standards, but with an appeal to the methods of *Cymdeithas yr Iaith* and for self-government in Wales. He concluded in that way because he knew that architecture is a moral business and that therefore its practitioners may not consider their work apart from their politics, their language and all the rest of what they value in their cultural baggage. As the head of the School of Architecture he observed that 'Even in these troubled decades, my colleagues and I on the staff deeply sense the onerous responsibilities of our office as creators of architects—as creators of creators.' Creators in this culture, if it is to survive, will have to break regulations and ignore professional conventions—not allow themselves to be rendered impotent by the conflict of loyalties set up for precisely that purpose by all the structures of Britishness in Wales.

THE BEAUTIFUL EMPTY PLACE

In an interview nearly 15 years ago I was surprised to hear myself say that before I came to Wales it had never occurred to me that there might be people living here. I was surprised because I hadn't realised how much my understanding of what place was had changed through the experience of being here for a year or two. My concept of the country had been of an open and empty space punctuated by castles and narrow-gauge railways. Had I been aggressively questioned about this I would clearly have had to concede the existence of Welsh people, but I would not have been able to fit them into my concept of the place. This perception of a land available and unclaimed is of course common to most people who were educated in England, and landscape art has a lot to do with its hold on the English mind. It therefore has much to answer for, because the notion of available space precedes the urge to colonize, and as they say in the Westerns, the rest is history.

I was asked by *Planet* to write about the Cadw exhibition of landscape art currently touring Wales. I mention that I did not fall but was pushed because I am not an expert on topographical prints or on landscape art in general, and yet this field is the only one in Welsh visual art where experts do exist. This is significant because it denotes a respectable *genre* with a certain status in the Anglo-centric mainstream of art-historical writing. Back in 1976 *Planet* itself published a typical piece[1] in which the great potential of the subject for the making of judicious distinctions between the beautiful and the sublime, and for the minute dissection of the finer points of aquatint technique was well exploited. This approach tends to leave the rest of us feeling bemused and vaguely excluded because, to us, these are just pictures of places.

On the face of it, then, the exhibition is a simple and unpretentious affair—a selection of work mainly by well-known names, extending over a period from the mid-eighteenth century to the present day, illustrating Gerallt's stopping-off points. Some original drawings made in preparation for familiar prints enliven the show, and especially the drawing by one of the Bucks of *Carmarthen Castle* in which the slightly Japanese feel of their work—due to use of high viewpoints and simplified perspective—is particularly noticeable. The Rowlandson of *Newcastle Emlyn* also struck me, probably because, as a cartoonist, he of all visiting artists is the most earthy. Indeed, the one thing conspicuous by its absence in nearly all this landscape is the smell of the earth.

This essay was first published in *Planet*, 72, December/January, 1988/9. The exhibition to which it refers was entitled 'A Journey through Wales in the footsteps of Giraldus Cambrensis'.

[1] Austen Wilkes, 'Landscape into Art', *Planet* 31, March 1976, p.37.

Newcastle Emlyn, pen, ink and wash drawing by Thomas Rowlandson, 1794.

Much of the work is pretty wimpy stuff and it gets worse the nearer it gets to the present day. The only reason I can imagine for including two dismal pictures by Kenneth Rowntree is to plug what the selector perceived to be a period gap in the 1940s and 50s. The pictures exude ration books, powercuts and wet gabardine macs. I wondered whether the new works of Falcon D. Hildred and David Gentleman, commissioned by Cadw, would have sufficient integral strength to remain in an upright position for the duration, and not collapse into wilted heaps at the bottom of their frames like Oldenburg's soft typewriter.

Being possessed of a moralizing turn of mind, I began to ponder the implications of this view of Wales. Anodyne as the idea for the exhibition appeared to be, I suspected deeper issues lurking there. Gerallt certainly came to Wales on tour, but he equally certainly didn't come to admire the view. His business was people and politics, and I'm fairly sure that he regarded mountains and rivers as a damned nuisance and nothing much to wax lyrical about (although to be fair he wasn't immune to the charms of one or two places, especially his own Manorbier). Many of the landscapes in the exhibition show not just nature but the material culture as well, in particular, bridges and castles; and some of the pictures, especially the earlier ones, also include people.

It was the role of these human elements in the scene which I found most thought-provoking.

I'm sure that today neither lay-people nor most artists have any perception of landscape art as having moral content—by which I mean that there is no perception of the image embodying value systems which have implications for human behaviour. This is consistent with the general notion that visual art stands outside particular culture—often expressed the other way round in the idea that art is culture and the rest of life something else. From the period before non-figurative art, landscape is particularly subject to being perceived in this amoral way, not simply for the obvious reason that it is relatively bereft of human activity, but also because of the all-pervasive influence of the supposedly objectivist art of Impressionism. The vilification of the latter (which sought to depict the effects of the play of light on solid objects in the open air) when it first appeared is not simply attributable to the shock of the new, or to a reaction against techniques which broke the rules of painting—which is the view generally taught to students today. Rather, the objectivity of the art, and therefore its implicit moral neutrality, was read as nothing less than immorality in the mid-nineteenth century, in an age when mainstream art *was* assessed in terms of its moral content. I think our own experience of the results of the depiction of Wales as a landscape shows how justified this criticism of Impressionism was. David Bell introduced his book about art in Wales, written in 1957, with a remark of staggering impertinence: 'I have tried to treat Wales not as a people but as a geographical entity.'

In my view, there can be no such thing as an amoral image, although a distinction does need to be made, as far as the artists are concerned, in terms of intent. There are pictures which the artist and the patron (whose vital role in all this is usually forgotten) intend to have specific moral, and therefore ultimately behavioural, implications; and then there are those who suppose themselves to be objectivists, whose images convey value systems, only, as it were, by default. With the possible exception of the very earliest visitors like Kip and the Bucks in the early eighteenth century, whose work seems almost pictogramatic (that is, an extension of early map making), the moralists preceded the objectivists. Their art, however, is now almost always misconstrued in objectivist terms.

One of the essential features of the *genre* was established very early on. The grander examples of human habitation are exhibited in a harmonious balance with an equal portion of tidied-up nature, but the human beings themselves, creators of the grand features depicted, only appear, ant-like, in their shadows. This tendency was exaggerated in the more self-consciously arty products of Sandby and others in the second half of the century, so that the people appear

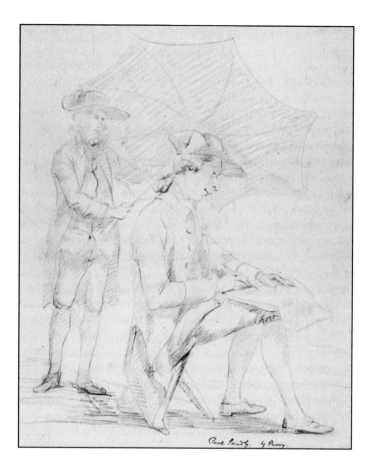

Paul Sandby sketching, drawing by William Parry, 1776. The drawing was made some years after Sandby's tours in Wales with Sir Watkin Williams Wynn. Sir Watkin was also a patron of Parry who had returned from working in Italy the previous year.

utterly unrelated to the buildings. It is not that they appear subjugated by the Edwardian castles but rather that it is inconceivable that these creatures could have built such Leviathans or posed such a political threat as to have occasioned their building.

This curious and unnatural dissociation of the people from their works is an aspect of the colonialist state of mind. For instance, European historians until quite recently refused to believe that the extraordinary buildings of Benin were the work of the ancestors of today's Nigerians. Years ago I was several times invited to dinner by the owner of a holiday cottage in St Dogmaels. This lady, an artist living in Putney, was a great collector of beautiful Welsh objects— everything from wooden spoons to oak dressers, bought at sales when they

could be had for 7/6d. The house was a veritable St Fagan's. But after dinner the conversation would usually degenerate into an extended diatribe against the natives of Cardigan for their visual ignorance, tasteless habitations and general incomprehension of the finer things of life. This puzzled me at the time because the particular logic at work was then unknown to me.

For us, the greatest of the moralists is Wilson who, formed by Poussin, transferred the manner and references of Classical and Neo-classical culture to a Welsh context.[2] This must have seemed an audacious departure at the time, not dissimilar in its effect to David Jones's transformation of Christian iconography in his annunciation in a Welsh hill setting, the *Cyfarchiad i Fair*, which revives meanings and makes them relevant and immediate by dramatically changing their location. But the intellectual framework which rendered Wilson's meanings comprehensible is dead. The pictures no longer operate as tokens of a patrician value system as they were intended to, but simply as lovely if rather limpid scenes. I was awakened to these unsuspected depths of landscape art when, as a student, I listened fascinated for nearly two hours to a tall and elegant lecturer, speaking without notes, who led us coherently and stylishly through the complexities of Poussin. I had not heard of him at that time, but his name was Anthony Blunt and his obsession with the subject, viewed in retrospect, makes a great deal of sense—Poussin's (and Wilson's) art is a very political matter.

Turner shares with Wilson and Constable the influential position of the table-mat artist to the English nation. His period is one of great change—he developed against the background of the French Revolution and the Napoleonic War but would live into the high Victorian age. Early Turners, painted in the period when he was visiting Wales, are consequently a curious *mélange* of elements, essentially eighteenth-century pictures, much indebted to Wilson and to notions of antiquarianism, yet carrying the early signs of a fundamental change. Welsh mythology and history make a fleeting appearance in this developing Turner—the Bard, Owain Goch and many a ruined castle. Turner was not unaware of the difference between an English and a Welsh castle and it has been argued that the dramatic events alluded to are to be understood as having contemporary political implications. But my feeling is that the subject is drama itself, based on a notion of the fruitlessness of political action seen against the forces of nature and time, and not any particular history. Looking at Turner's work, we can follow a process of change towards a different use of nature. In his later paintings his love affair with the forces of nature would exclude all else. These pictures reinforced by the work of the French painters of the second half of the nineteenth century, would together set landscape firmly

[2] For the meaning of Wilson's landscape, see David H. Solkin, *Richard Wilson—The Landscape of Reaction*, London, 1982.

153

into the objectivist, and therefore supposedly amoral, mould. The advent of middle-class tourism and the cheap paintings and prints produced to meet its demands would crystallize the image of Wales as the beautiful empty place.

With the exception of Wilson and Moses Griffith, the Cadw exhibition does not include Welsh artists and so does not explore the often ambiguous attitudes of internal tourists. Pennant, who employed Moses Griffith, opens his *Tours in Wales* with the dramatic remark: 'I speak now of my native country', and Edward Pugh in his introduction to *Cambria Depicta*—a *Tour Through North Wales by a Native Artist,* emphasizes that his will be a different approach:

> The many volumes published under the appellation of 'Tours through North Wales', have invariably been found defective in their description of the people, their manners and customs: nor is this deficiency surprising when we recollect that these descriptions have generally been undertaken by complete strangers . . . [3]

The result is a much more prominent place for the people in his massive collection of prints and text, although still perceived with the tourist-eye of the period for 'curiosities' like *Siani Bwt* and the *The Infant Hercules.* The original drawings were recently rediscovered at a London book sale.

The ambiguities become most obvious within the National movement proper, at the end of the nineteenth century. Like it or not, Welsh art seemed to the intellectuals of the period to be substantially landscape art. Thomas Matthews and T. H. Thomas worked hard to widen the range of the tradition in their extensive writings in the periodicals of the time. They felt deeply the need for a national school of art but clearly felt constrained to place landscape in its centre, thus involving themselves—as moralists dealing with a *genre* perceived as devoid of moral content—in considerable mental gymnastics. S. Maurice Jones writing in *Cymru Fydd* in 1891 remarked (much more perceptively than he could have realized) of the picturesque yokels who inhabit the Betws-y-coed landscapes of David Cox:

> It could truly be said that the brush of the artist David Cox explains as much of the life and customs of the Welsh of 60 years ago as does the pen of the Welshman H. M. Stanley of the customs and style of the inhabitants of central Africa in these days.

Thomas Matthews, whose approach was to interweave in his art criticism voluminous quotations from the poetry of the period in order to impart some indigenous cultural credibility to the work, offers us the suggestively ambiguous lines:

[3] Pennant was writing in 1773 or shortly thereafter; Pugh's remarks are taken from the introduction to *Cambria Depicta,* dated Rhuthun, 10 May, 1813.

The Welsh Funeral, chalk and stump drawing by David Cox, 1847. This is a preparatory drawing for one of the several versions painted by Cox of this subject. The picture became very popular and widely distributed as a print. The setting was Betws-y-coed.

Pwy, Gymru fad, heb deimlo'i hun, ynghanol
Y mawrwych olygfaoedd hyn
Yn rhydd ac anibynnol?

Who, dear Wales, could but feel themselves, in the midst
Of these wondrous scenes
Free and independent?[4]

[4] Thomas Matthews, 'Arddanghosfa Conwy', *Cymru*, OME 1911, p.113.

As an artist S. Maurice Jones was unable to use landscape as a vehicle for the national ideas he espoused and completely misconstrued the nature of Wilson's art as well, so committed was he to the objectivist landscape school. 'The influence of the grandness and cloudless skies of the old pictures of Italy had paralysed Richard Wilson to such an extent that he did not possess the suitable forms and images to show the wildness of his native land', he says in *Cymru Fydd* in 1891. 'But in the pictures of David Cox one feels that he is faithful to nature and to himself.'

The tradition of Cox and Maurice Jones persists as the mainstream of landscape painting in Wales and continues to be a negative force by not seeking to be a positive one. I have emphasized before in *Planet* the need to create an art history in Wales which will give a roundness to the larger cultural tradition with its consequent benefits for our self-esteem, and for the making of new work which will be relevant and purposeful. To do this requires a good deal of serious thinking about the meaning of landscape art in particular. Those artists who today persist with the landscape tradition of social and political agnosticism need more than ever to confront rather than side-step the question of their role as the image makers of a nation in crisis.

THE MYTH OF RICHARD WILSON

Dear Editor,

In his article about Richard Wilson published in the August/September issue of *Barn*, Prys Morgan effectively summarised two different critiques of the painter's work. However, I feel that both these established critiques are today rather marginal if we want to consider Wilson from a Welsh standpoint.

In his last paragraph Prys Morgan mentioned the importance of Wilson in the formulation of 'our image of Wales'—an image reinforced by the poetry of the second half of the nineteenth century. He also mentioned Wilson's position (according to Ruskin, although the idea is much older) as the father of English landscape painting. However, he failed to observe that these two ideas of landscape are very different. It is true that both are corner-stones of national identities, but the soft romanticism of the English rural idyll is a very different construct from the dramatic romanticism of the mountainous homeland of the Bard and the site of his battle for the freedom of the Welsh soul. It is interesting to note that this difference was embodied in two works by a single English poet, Thomas Gray, and that early in the nineteenth century George Beaumont connected these two poems with, on the one hand, Wilson, and on the other, the English painter Gainsborough:

> Both were poets, and to me 'The Bard' of Gray, and his 'Elegy in a Country Churchyard' are so descriptive of their different lines that I should certainly have commissioned Wilson to paint a subject from the first, and Gainsborough one from the second; and if I am correct in this opinion, the superior popularity of Gainsborough cannot surprise us; since for one person capable of relishing the sublime, there are thousands who admire the rural and the beautiful.

The iconographical complexity of the work of Richard Wilson coupled with the lack of contemporary information about his aesthetics (only three letters and a few notes about the mundane aspects of his every-day existence survive) make him ideal material for the construction of traditions—even traditions which contradict each other. In 1801 Henry Fuseli was of the same mind as Beaumont:

> Though in effects of dewy freshness, and silent evening lights, few have equalled, and fewer excelled him, his grandeur is oftener allied to terror, bustle and convulsion, than to calmness and tranquility. [1]

This letter was published in Welsh in *Barn* 345, October, 1991, in response to Prys Morgan's article in the same magazine, 343/4, August/September, 1991.

[1] For contemporary comment on Wilson, see: W.G. Constable, *Richard Wilson*, London, 1953.

On the other hand, in 1898 Samuel Maurice Jones thought that:

> The splendour of the old masters and the cloudless firmament of Italy paralysed Richard Wilson to such an extent that he did not possess the forms and appropriate images to show the wildness of his native country. We find him setting calm to rule in the house of the storm, and he portrayed the etched slopes of Snowdonia without a single cloud to throw a shadow over their nakedness.[2]

To S. Maurice Jones, Wilson's perception was foreign, connected to an English Classical tradition. We see, therefore, how contradictory interpretations of Wilson's work can be—and I have also chosen as examples quotations which stand the conventional Welsh/English conflict of interpretation on its head. As far as I know, S. Maurice Jones was the only Welsh painter who was brave enough to follow through to its inconvenient conclusion the rationale of identifying the national soul with the sublime landscape, and so reject Wilson. S. Maurice Jones wanted to construct a coherent and credible tradition of Welsh painting. By the time he was writing, the aesthetics of the sublime had been complicated by a substantial dose of the picturesque and of naturalism. This mixture dominated not only the product of the *Arlunfa Gymreig*, the Welsh Studio, as Jones put it, but also its contemporary poetry.[3] The fame of the studio of Dyffryn Conwy, Betws-y-coed and Snowdonia was founded on the reputation of David Cox and his English followers. Making the best of a bad job, S. Maurice Jones attempted to nationalise the studio, and contemporary Welsh landscape painting in general, on the basis of the aesthetics of Cox, who grew to heroic proportions in his mind. He saw clearly that Wilson's work was inconsistent with this popular aesthetic, and therefore rejected the great man.

Everyone else, including the most important art critic of the period, Thomas Matthews, was willing to play any sort of verbal trick to avoid losing Wilson, by reconciling him with Cox. This included re-baptising the Englishman as *Dafydd Goch*. Because of his enormous status, they were desperate to keep a claim on Wilson as the father of English landscape painting while at the same time elevating him as the embodiment of the Welsh national soul. Edmund D. Jones was still playing this game as recently as 1938 when he described Wilson, among the painters of Wales, as 'the most Welsh in temperament and style of them all'.[4]

If we study history with the intention of coming to understand our contemporary condition, the events (or in the case of the visual culture, the pictures) are not in themselves the most significant phenomena, but rather how the pictures have been constructed into a tradition. There is no 'truth'

[2] Samuel Maurice Jones, 'Yr Arlunfa Gymreig', *Cymru Fydd*, January, 1891 p.25.

[3] Also much quoted by Thomas Matthews in the context of visual culture. Among his favourites was Eifion Wyn who would also be favoured, if not idealised, by a landscapist of the next generation, Timothy Evans.

[4] Edmund D. Jones, *Camre Celfyddyd*, Aberystwyth, 1938, p.77.

Samuel Maurice Jones painting at Trefriw Mills, by an unknown photographer, c.1900.

concerning the meaning of the pictures of Wilson to be found by comparing the interpretations of *Solkin*[5] and Ruskin, or even of S. Maurice Jones and Thomas Matthews. The most important thing for Welsh people about Wilson over most of the two hundred years which have passed since his death, was not his pictures, nor even the interpretations of his pictures, but his status in the English art historical tradition. The success of this Welsh person in the English world became a part of the mythology of the nation.

The work of the pupil of Richard Wilson, Thomas Jones, Pencerrig, is of great interest in the evolution of the image of the Welsh landscape. One could well argue that that his aesthetics were far more consistent with Welsh landscape at the end of the nineteenth century than those of Wilson. And yet, in the nineteenth century, Welsh art historians and critics ignored him completely because—whatever the 'true' quality and originality[6] of his pictures—he had

[5] *Richard Wilson—The Landscape of Reaction,* op. cit.

[6] See: Lawrence Gowing, *The Originality of Thomas Jones,* London, 1985.

159

no place in the English tradition as constructed by Ruskin. He was not to be counted amongst the great painters like Wilson. It was, therefore, Wilson's status in the English tradition that attracted those Welsh intellectuals who were so desperately keen to establish the worthiness of their nation as a contributor to British imperial greatness. Time after time, Wilson and John Gibson (who was seen as a sort of sculptural side-kick to Wilson) were held up as an example of what Welsh people could achieve if they would only direct their efforts correctly. 'I think that when a country like this one can be the birth-place of a Gibson and a Wilson, I may say we are not so very much disgraced', opined Sir Watkin Williams Wynn to the delight and great applause of the *eisteddfodwyr* at Denbigh in 1860, following a highly critical oration from the stage on the subject of the visual failings of the Welsh. [7] And here is Chancellor Williams writing after the Aberystwyth Eisteddfod of 1865:

> Wales has contributed works of art, such as those of Wilson and Gibson, that may well be held up to stimulate the artistic talent that may yet lie dormant in our secluded valeys, and to correct the taste of our aspirants.

The myth of Richard Wilson was blown out of all proportion in the Victorian age. In 1889, in an article in *Y Traethodydd* [8] he was described by Isaac Foulkes as 'our only Welsh painter'.

For all that, the power of the myth of Richard Wilson is not to be accounted for entirely by his status in England. There was a sub-plot which appealed mightily to the ambiguous patriotism of Welsh intellectuals. As Prys Morgan has noted, in the mid 1770s Wilson's career faltered and he descended very rapidly into a condition of poverty before returning to Wales to die at his mother's family home. Paradoxically, this dismal end admirably suited the requirements of the architects of the myth of the Welshman who established English landscape painting. Wilson had not been treated fairly by the English. He had not been appreciated as he deserved by the sister-nation in his own life-time. The Welshman had given his all to the English, only to be betrayed and rejected by them. But his native country remained faithful to him, offering him refuge at the end.

Very conveniently, amongst the rather scarce facts about Wilson's career lay the apparently nefarious activities of a villainous Englishman, an embodiment of the treacherous nature of that whole nation. He was Sir Joshua Reynolds. According to Isaac Foulkes:

> As a portraitist, Reynolds stood at the head of the list in this country . . . But for all his talents and privileges, he was a small *man*; conceited, selfish, and

[7] Given by John Francis, Mesuronydd.

[8] Isaac Foulkes, 'Y Bro-Arlunwyr Cymreig', *Y Traethodydd*, 1889, p.105.

jealous of his glory. He could suffer no-one to come close to his throne; and it was natural enough for him to feel concerned for his influence when one of Richard Wilson's abilities came among the same constellation as he. He was a sly malicious gossip who poisoned with a hypocritical smile, and who damned with faint praise. He persecuted Wilson till his death, and after that under a thin mantle of lies and fake friendship . . .

The story of Richard Wilson was a perfect metaphor for the story of the nation as a whole—for those with ears to hear. Looking back on it today, the myth that was created, with its secret sub-plot, was just as accurate a metaphor for the ambiguous patriotism which reached its peak at the end of the last century and which persists to this day. To my mind, it is in this myth that we find the meaning of Richard Wilson. After all, only a tiny number of the Welsh people who were familiar with the name and the story of the man in the last century had ever seen one of his pictures, even in the form of a print. It is easy to overemphasise the importance of pictures in a visual tradition. The myth of Richard Wilson and not his pictures was the active force in the culture at that time, as it may well remain today.

The Myddleton Memorial, Chirk, pen and wash scaled drawing by Robert Wynne, 1719. The figures are cutouts. The drawing is inscribed 'This is a draft picked upon by Agreement with the Honourable Madam Myddleton the 5th of May 1719 to be Made and Erected in ye Church of Churk by me Robert Wynne, 17 Foot High & 6 inches, 8 Foot Broad, all of Italian Marble.' It was carried out with little alteration for £400.

LIFE BEFORE WILSON

It became the custom in the nineteenth century to write about Welsh art as if it had begun spontaneously and without prior warning in the person of Richard Wilson. Wilson was the only painter with any status in the hierarchy of English art, and the object of the exercise was to point out that his contribution and others like it entitled the nation to its share of imperial credit. Unfortunately, the image of the immaculate conception of Welsh art about 1757 outlived the empire it was invented to serve. Eric Rowan's *Art in Wales*, to whose intellectual mediocrity I am greatly indebted for an abundant supply of quotable inanities, reaches p.105 before a Welsh artist of any sort is mentioned by name, and that name is, of course, Richard Wilson. Over the last few years I have tried to suggest ways to reconstruct our perception of the subsequent hundred and fifty years; it may now be time to start a reconstruction of the previous, apparently blank, hundred and fifty.

In 1773, or thereabouts, Thomas Pennant visited the church at Ruabon,[1] a public gallery of modern and ancient art, and wrote a criticism. As a modernist, Pennant was particularly impressed with the monument to Lady Henrietta Somerset, Sir Watkin Williams Wynn's first wife. He regarded this depiction by Nollekens of Hope reclining on an urn as being in 'fine taste'. He was not so impressed by the patronage of Sir Watkin's grandfather, however, in the form of the huge Baroque memorial to Henry Wynn, tenth son of John Wynn of Gwydir, who had died in 1671. 'His dress is a full buttoned coat, short skirts, and square shoes, a most unhappy subject for the sculptor', he remarked—an observation strangely prescient of the criticism of another Welsh classicist about seventy years later. Finding himself an endangered species, a relic of the Neo-Classicism that Pennant's generation had ushered in, John Gibson remarked of the New Sculpture movement that 'The human figure concealed under a frock-coat and trousers is not a fit subject for sculpture, and I would rather avoid contemplating such objects.'[2] The Victorians had reinvented the Baroque convention of displaying the great and the good in their contemporary dress, rather than masquerading them as Homer.

Below Henry Wynn in the Ruabon sculpture kneel two other life-size figures, Sir John and Jane, his wife. 'Sir John is represented blind: this accident (in his extreme age) is mentioned in his epitaph as a benefit, since his inward

This essay was first published in *Planet*, 95, October/November, 1992.

[1] At the start of his first tour, p.365 of the Sir John Rhys edition, Caernarfon, 1883.

[2] *The Biography of John Gibson*, op. cit.

163

perceptions were improved by this bodily defect.' This reminded Pennant of a couplet by Waller, 'in which the same idea is much better expressed'.

Some years later, Pennant was only a little less dismissive of another massive Baroque piece, the monument to Maurice Jones of Llanrhaeadr. 'His figure is lying down, leaning on his arm, in his gown, with his wig in excellent curl, and surrounded by weeping genii, and much funebrial absurdity.' Pennant was almost certainly criticising the work of the same sculptor on both occasions. His name was Robert Wynne and he was born near Rhuthun about 1655. He trained in London under a mason called Peter Roberts in the 1670s. Little is known of his career in London, perhaps because he worked there for other sculptors and carried out few pieces in his own name. [3] By 1707 he had returned to Rhuthun to work in his studio known as 'The Elaboratory' and a certain amount of information about his subsequent career survives. In addition to the memorial at Ruabon and almost certainly that at Llanrhaeadr, Wynne produced the magnificent memorial to the Myddleton family at Chirk, again consisting of three life-size figures in an architectural setting. The piece cost £400 and one of the sculptor's drawings for it has survived. The Myddletons were political rivals to the Wynns, and it seems equally competitive in their art patronage. We should remember also that the Davies brothers were working on the gates at Chirk at the same time. Wynne was not an isolated example of internal patronage.

Wynne seems to have developed an extensive practice—he certainly worked as far away as at Llanbadarn Fawr—although it would all come to an end in the debtors' prison. He died in 1731 but by that time the art education not only of Richard Wilson but also of an older contemporary called Edward Owen had begun. Owen died only ten years later in his early thirties and did not make a stir in the art world during his short career. However, he is of considerable interest, for at least two reasons. Firstly, his forgotten existence further undermines the myth of Wilson as a unique phenomenon in a nation without interest in visual culture. Secondly, whilst he was training in London, Ned Owen wrote a series of fascinating letters home to his family which take us close to the everyday experience of an apprentice portraitist in the period. No record whatsoever of Wilson's training survives other than that it began under Thomas Wright in 1729. By then, Owen had been for four years in the studio of Thomas Gibson, considered a much more distinguished party in his day.

At shool in Oswestry in 1724 Ned Owen wrote that 'I draw picktures very much', and asked his not particularly well off mother to 'alow somewhat to buy books to draw and engrediens to paint.' It was suggested he become a clergyman. 'I like a limner best', he replied, and his sister was of the opinion

[3] But no one, as far as I know, has researched the matter. Some information on Wynne has been collected by D. Leslie Davies, Wrexham. See: 'A Welsh Sculptor—A Very Rare Bird', *Country Quest*, October, 1980, p.40. However, the title and his remarks about 'the Principality' being 'an artistic desert' are unfortunate and ill informed.

that, since he knew his mind, 'it is best to let him follow it, & no doubt but with God's Grace he may make a competent honest livelyhood. No time ought to be lost in placing Him out . . .' This suggests that becoming a painter was not considered a particularly controversial choice for a Welsh person in the period, contrary to the impression given in the nineteenth century.

Ned Owen met his master for the first time in January, 1725, and in March wrote to his mother that 'I find my business vastly expensive to what I thought it would be when I was first bound, theres not a week passes but it costs me above eighteen pence only in pens, pencils, chalks, blew, brown & white paper, besides what it costs me in things to coppy after as drawings, prints and plaister figures. My master tells me it will yearly cost me 10 pound in my business, it is not meerly coppying makes a painter but seeing and buying great masters performances, and minding where in one excell'd, where in another.'

There is art world tittle-tattle and personal drama. Owen wrote that following the death of a famous history painter and the auction of his studio, 'Mrs Lloyd's Landlord married this painters maid who proved a very good fortune to him left her by her master which was about 1500 pound as people say for standing naked for him, and for other favours.' In 1732 he was mugged:

> The fellow that riffled me using me a little roughly, I told him there was no necessity for it since I did not offer to interrupt him in his search. He replied very cras—damn you for a Rascal, we will use you as we please. When he had done they gave me a shove from them, that the Gentleman who was to chastise me might have his full stroke at my head, what became of them afterwards I can't tell for I was so stund I could neither see nor hear . . .

In 1729 Owen had become frustrated as an apprentice, and enamoured with the fashionable ideas and work of Jonathan Richardson. This was awkward as Richardson was a competitor of Gibson, and 'whilst I continue with my Mastor I know he would take it ill if I were to coppy any Paintors works but his own.' Richardson was one of the most influential writers about art in the period, not least because of his patriotic asserting of the potential of contemporary English culture to rival the Classical model. Ned Owen's admiration for him is of particular interest to us because he was the teacher of a third Welsh painter of the period, John Dyer.

Dyer went from Carmarthenshire to London in 1720, only a year after his master had published his *Essay on the whole art of criticism in relation to painting*. His high-powered studio seems to have set Dyer up to cut a much more trendy figure than Owen would ever manage, frequenting the coffee

houses in the company of the *avant garde*. When Ned Owen arrived in London Dyer had already gone to Italy. His poems, in particular 'Grongar Hill' and 'The Ruins of Rome', reveal a mind in the forefront of the fashion for ancient Britain which facilitated the reinvention of Wales. Dyer was born two years before Lewis Morris and was a very early part of that process, twenty-five years before the foundation of the Cymmrodorion. His work is punctuated with patriotic references such as this to Inigo Jones: 'Here, curious Architect/If thou assay'st ambitious to surpass/Palladius, Angelus, or British Jones . . .' He knew Celtic history, and the Welsh landscape, two of the essential elements of the emerging national identity. There is an extended reference to Macsen Wledig, and in the pine trees around the Baths of Caracalla he saw 'Britannia's Oaks/On Merlin's Mount or Snowden's rugged sides', an image which Wilson would invert years later by transposing Italy onto Wales.

Dyer painted landscape in Wales well before Wilson, but most of the work is lost. The paintings of Ned Owen have suffered the same fate, though several of them, including a self portrait, were known until as recently as 1927 when Isaac Williams commented with some surprise on discovering them whilst organising the Holyhead Eisteddfod exhibition.[4] Robert Wynne's massive sculpture would be difficult even for Wales to lose, but I suspect much more of it remains to be identified.

I see no reason to doubt that the pattern of recovery of significant amounts of nineteenth-century work that has taken place in the last few years can be repeated for the earlier period. Although the particular problems of interpretation of the work are rather different, the principle which can facilitate its recovery is the same. The system by which we evaluate the visual culture must be changed, so that we appreciate artefacts first of all for how they enlighten us as to the world view of artists, patrons, critics and ordinary people in the period, and also through subsequent changes of perception. In other words, they must be related to the evolution of the Welsh culture complex as a whole. This is a principle devoted to integration and opposed to the hidden agenda of English art history which supports the politically driven process of disintegrating one culture and assimilating the decontextualised pieces into another.

Thomas Pennant opened his criticism of Robert Wynne's Ruabon group by remarking sarcastically of the main figure that 'His attitude is that of a fanatical preacher.'[5] The Methodist revival was then in its enthusiastic prime—Daniel Rowland converted Thomas Charles at Llangeitho the same year that Pennant wrote. Such goings on were quite at odds with his rational classicism. However, the fact that Pennant bothered to make room in his art criticism for a dig at

[4] The present whereabouts of only one of these paintings is known.

[5] Sir Watkin Williams Wynn, the father of the contemporary incumbent of Wynnstay when Pennant wrote, had been a famous persecutor of Methodists.

166

Title page of *The Ruins of Rome,*
by John Dyer, published by Gilliver,
London, 1740.

Ann Owen, Penrhos, Anglesey, by
Edward Owen, oil on canvas, 1731.
Ann Owen was the mother of the
painter, to whom most of his
surviving correspondence was
addressed.

them is significant. The great Welsh connoisseur looked at a Welsh sculpture
and thought about Methodism—art, religion and politics, it was all one world.
It is much more important for us to know about this reaction than about some
recent assessment, of the Ellis Waterhouse kind,[6] of the quality of Wynne's
carving relative to that of his English contemporaries—and much more
interesting too.

[6] This reference is to suggest that
Waterhouse is typical of a kind of
English aesthete art historian,
interested mainly in constructing
hierarchies of quality which confirm
his own taste and Anglo-centric world
view. When writing his *Dictionary of
British Eighteenth Century Painters*
he is said to have telephoned the
National Museum for information
about landscape painting in Wales.
He incorporated their response in his
text: 'In Wales, as far as I know,
there is very little to report', he
remarked.

CULTURAL POLICY

This paper was written for the Art Committee of the Arts Council at the invitation of Michael Clarke, chairman of Artists' Panel, and submitted in September, 1986. The quotation from David Jones is to be found in his essay 'Art in Relation to War', *The Dying Gaul and Other Writings*, London, 1978, p.123.

In our world, the loss of a thing as artistically formidable as say the culture of the Incas to two dozen Renaissance fire-locks and a few cavaliers is something which strikes a note of questioning and of despair in our hearts, which the comfortable arguments do no more than aggravate. We have no conception of the arithmetic by which such accounts are audited. It is 'of faith' that they ARE audited. That is the most we can say. I choose this tragic and outstanding example, not because it is unique, but because on the contrary it is a glaring example of something which is ubiquitous and universal and which is happening all the time in many millions of lesser ways—to lesser perfections of all kinds; it is in fact, history, your history and my history no less than world history.

David Jones.

1. Definition

1.1
A cultural policy is an overall statement of understanding and intent which provides a framework for action related to the particular limited sphere of activity of an institution or group within that culture. In the case of this paper, the culture is that of the geo-political unit Wales, and the particular sphere of activity is visual arts funding.

1.2
Any course of action, including the disbursement of public money, involves choices between alternatives. The understanding of the culture embodied in the policy informs the choosing.

1.3
If the Arts Council's Art Committee wishes to disburse its funds with coherence and purpose, it should have a view of the culture within which it operates and objectives implied by that view. In the case of Wales, that view will undoubtedly be **complex,** but this is not the same as having **no view.** A number of Art Committee members have expressed the opinion that the choices presently made

are not coherent.[1] Decisions are arrived at both by the operation of differing criteria from case to case, and also by individual committee members operating varying criteria in particular cases.

1.4

A public body should be seen to be operating a policy which, if complex, is at the same time coherent, for at least two reasons:
 i) so that those who are affected by its decisions are able to assess, criticise and influence its work from the outside.
 ii) so that those within the institution (officers, council and committee members) know with what they are identifying themselves.

1.5

The Arts Council does not have a cultural policy. It has periodically defined a policy for **arts funding** (*Priorities into Practice,* 1984, and at the visual arts level *The Next Steps,* 1984) but in the absence of a defined cultural context the purpose of these policies is unclear. *Priorities into Practice* deals with arts funding either in a vague and incoherent cultural context or from within the idea that art itself is sufficient context given a liberal approach to the range of forms funded.

2. Analysis

2.1

No clear understanding of the relationship between culture, art and language is evident in Arts Council policy. The resulting confusion is not unique to the Council however but reflects a widespread state of mind in Wales, and as far as culture and art is concerned, wherever English is the dominant language. The world 'culture' has shifted its ground so much (not merely in popular usage but also as used by practitioners and critics) that it is now frequently used as a synonym for 'art'. It has become necessary to add qualifying adjectives to restore a distinct identity to the word, giving, for example, the 'popular culture' of the late 1950s.

2.2

This paper attempts to clarify some of the philosophical confusion in order to create a base for policy decisions within the Art Committee of the Arts Council.

[1] The other Artist's Panel members at this time were the photographer and designer Marian Delyth, and the artist Paul Davies.

The starting point for this process is a recognition of **particular cultural circumstances within Wales.** The nature of the particular culture of Wales will determine the policy decisions.

2.3

Priorities into Practice recognises the existence of two cultures in Wales in the following statement:

> 2.6 Two Cultures
> Wales is a land of two interpenetrative cultures. It is not solely a matter of language. The council have indigenous responsibilities in which the language is not the main factor. For example the archive of Traditional Welsh Music, Anglo-Welsh literature, some art and some craft activities, all offer opportunities to support and make the arts more accessible to our own multicultural society.

This statement could have been important had it been taken as the starting point for developing a philosophy and thence a policy for arts funding. It is stated that there are two cultures in Wales and it is recognised that only one of them is indigenous. **It does not confine that indigenous culture to the Welsh language.** The other culture is not identified, but we may understand it to be the culture of England (although it might not necessarily be properly identified as English culture). Sadly, however, no attempt is made anywhere in *Priorities into Practice* to follow the implications of this statement. Indeed by the time it has been made at point 2.6 in the document it has already been rendered irrelevant. **Points 2.3 'High culture to Community Arts' and 2.4 'Accessibility of the Arts' have already defined the nature of the arts activities to be supported.**

2.4

The *modus operandi* of Arts Council policy is therefore to begin by defining the arts activities to be funded and subsequently to modify the funding policy to cater for deviant cultural patterns present outside the context in which the definition was devised. Point 2.6 concerning the nature of Welsh culture and its requirement for state funding is considered in relation to pre-existing concepts of art-funding policy.

Historically, the arts council is an offshoot of the Arts Council of Great Britain and its philosophy is similarly rooted in ACGB philosophy which it has modified at the level of application as a response to what it calls 'special circumstances'. This puts the cart before the horse, and is the source of much of the confusion noted above.

2.5

The peculiarity of the situation in Wales is not simply the presence of another culture, but the fact that **that culture is the indigenous culture of the country.** *Priorities into Practice* makes brief mention at the start of point 2.6 of 'certain indigenous responsibilities', but a truer picture of the attitude of the Council soon emerges. Of funding opportunities in Wales's 'multicultural society', point 2.6 goes on to remark:

> This is increasingly a concern in England too.

This statement clearly implies a parallel between the indigenous culture of Wales and that of black immigrant communities in England. ACGB now sets aside 4% of its budget for funding 'cultural minority' art activities, a principle which could set a dangerous precedent for Wales. Wales consists of 20% Welsh speakers who have direct access to the whole indigenous tradition through the language and perhaps 70% Welsh born people[2] who, though English speakers, have a sense of identity which flows historically from the older indigenous tradition (although this connection is often unrecognised or even denied). To suggest that a Pakistani in Birmingham and a Welsh-speaking person in Gwynedd or an English-speaking Welsh person from the Valleys are in a similar cultural situation may be convenient, but it is also wildly inaccurate. It is, however, a parallel which is implied with increasing frequency by the indiscriminate use of the term 'Ethnic Minority'. Welsh speakers have in the recent past been described as an ethnic minority by an Art Committee member of the Arts Council, by a panel member of West Wales Arts and by members of the Association of Film and Video workshops, for instance.

[2] This guesstimate was far too high, as the census of 1991 would show.

2.6

The second paragraph of point 2.6 'Two Cultures' makes no attempt to follow through the implications of the first paragraph and goes on to deal exclusively with the language:

> In addition, however, the Council have seriously attempted to secure for Welsh language artistic activities a continued base of support. This is not cheap, nor is the Welsh Arts Council grant directly increased to meet the cost. The formula which determines the Council's grant was settled at a time when the costs of nurturing the Welsh language were relatively low— certainly much lower than today. Those costs are now high; indeed, to give a measure of their support for the arts in the language, the Council estimate that over £1 million will be spent on Welsh language activities in 1984/5. The

Council have supported such activities, even when these have faltered, at the expense of the arts in general. The Council will continue to offer their substantial arts expertise in administering appropriate grants for the benefit of the language. But if any Welsh language activity fails to meet criteria of artistic excellence, the Council's duty to support it will lapse. For valid artistic activity the Council are glad to continue their support.

The terms of reference and general tone of this paragraph are used nowhere else in *Priorities into Practice* with regard to English-language or non-linguistic practice. It is remarked that supporting activities which operate through the medium of Welsh is 'not cheap, nor is the Welsh Arts Council's grant increased to meet the cost'. In fact, Welsh-medium work costs no more (or less) than comparable English-medium work. What the statement is telling the reader in fact is that Welsh-medium work is regarded as an **extra** cost. The status afforded to that part of the indigenous culture is of an **additional burden** which the council, because it operates a liberal policy of minority toleration, will condescend to fund.

Secondly, there is no doubt that the Arts Council **has** used the language as a bargaining factor in its negotiations with ACGB even if this factor is not reflected formally in the Goshen Formula. The fact that 'the cost of nurturing the Welsh language' was, when the formula was devised 'much lower than today' is because the Arts Council and its predecessor, the Welsh Committee, did not then choose to support the language to any significant degree and not because, as is implied, some sort of natural cost inflation has occurred which makes the language currently more expensive.

These costs are described as 'high' but no attempt is made to show high in relation to what. The figure quoted (with no statistical analysis) is £1 million in 1984/5. Welsh National Opera, which serves a tiny audience relative to the number of Welsh speakers in Wales, received a grant of £1.56 million in the same period. This is not an argument against funding WNO but it **is** a way of providing a perspective that *Priorities into Practice* fails to provide, and counteracts the clear implication that the Welsh language, as a 'minority interest', is receiving more than its share.

The comparison is then made between support for 'such activities' and 'arts in general' saying that the latter have suffered at the expense of the former, as if there were no interaction or relationship between language and art. The Welsh language is just as appropriate a medium for the presentation of the 'arts in general' as the English language, and, in addition, those forms which operate through the medium of English in Wales are enormously enriched by the particularity of Wales, of which the language is the primary agent and symbol.

The indigenous culture is relegated by this statement to the language, and the language is relegated to the status of a minority art form which the Council supports 'at the expense of other forms'.

Finally, Council felt it necessary to issue an explicit warning to Welsh-speaking artists that if 'any Welsh language based activity fails to meet criteria of artistic excellence, the Council's duty to support it will lapse'. Nowhere is a similar warning issued about activity through the medium of English and nowhere are the criteria of artistic excellence defined.

2.7

To recap, Arts Council funding policy is muddled because of a failure to address the problem adequately at the philosophical or cultural policy levels.

 i) Council begins with inherited ideas about art and arts funding and attempts to apply them to the particular cultural circumstances of Wales.
 ii) Welsh culture is regarded, as a result, as an **extra** responsibility because it falls outside the framework of these borrowed ideas, is afforded the status of an 'ethnic minority' art form, and is funded in a way appropriate to that status.
iii) In practice, Welsh culture is defined as the Welsh language.

3. Culture

3.1

Progress towards a cultural policy and coherent arts funding based on that policy can only be made by dealing first with concepts—before making judgements. This is an inherently contentious process and particularly so in a confused cultural situation where the concepts are not impersonal abstractions but involved with every individual's sense of identity. However, the only thing to emerge from avoiding these issues will be the continuation of a *status quo* which, in the opinion of some Committee members and many outside the Arts Council, is unsatisfactory. The Council's own recent statement on bilingualism perhaps reflects an awareness inside the institution of the need to reassess policy.

3.2

It appears that Council's policy making begins with ideas about art[3] and seeks to adapt them to cultural circumstances which do not match them well. There

[3] My original footnote here reads: 'In this paper "art" is generally used only in the context of Arts Council's use of the word which is usually the name for a list of activities such as painting, dance and literature. "Image making" is the preferred term to describe these activities elsewhere.'

is, however, an alternative way to proceed, beginning with the view that image making must always happen within a particular cultural context, and that the images made are therefore an aspect of that particular culture. According to Saunders Lewis:

[4] 'Art is the creation of society. It cannot be a private act.' Saunders Lewis, 'Swyddogaeth Celfyddyd'.

Creadigaeth cymdeithas yw celfyddyd. Ni all fod yn weithgarwch preifat. [4]

Raymond Williams puts it in more mechanistic terms:

The painting, like other visual objects has itself to be interpreted and received. The sensory information which comes to us from a painting is no more 'like' that painting than the sensory information which comes to us from a stone or a tree. The painting, like other visual 'objects' has itself to be interpreted and described before, in any normal sense it is seen. We realise, from this, the necessary social basis of any art, for nobody can see (not understand but *see*) the artist's actual work unless he and the artist can come to share the complex details and means of a learned communication system. [5]

[5] Raymond Williams, *The Long Revolution*, London, 1961.

A culture is the way a people are—according to the *Oxford English Dictionary* a 'particular form or type of development or civilisation'. It is also, and essentially, as the use of the word 'form' implies, the material and behavioural expression of that being, which includes image making. The complexity and interpenetration of the cultures of the western industrial world have obscured the nature of this link between image making and particular ways of being.

All material and behavioural expressions of being are potentially images. It is the understanding of them as signs which elevates them to this level, of course. Visual artists, designers, actors, film makers and so on are the agents of this process who self-consciously make or fix images in the knowledge that they may be signs for something other than their own material.

The word 'culture' is also related to growth in the natural world—to organic and cyclic development. Similarly the flow from culture into image is not from one static form into another in a single constant direction, but an organic and cyclic process of reinvestment. Every material expression of the way of being becomes itself a new factor in the culture and effects its continuing evolution. Indeed, the fixed, recreated, or made image is clearly one of the most important factors effecting the course of a culture.

It is because of this effect that the Arts Council (as an important facilitator of image making) has a responsibility to define clearly an attitude to the continuing process which brings the culture to its contemporary condition. The necessary expression of that responsibility is to create policies which respect the meaning

of the process and which are not contrary to the identity which is embodied in it.

3.3

Agreeing on an understanding of the process in Wales is, of course, a problem. People's differing senses of identity are located at various points on a spectrum extending between contending cultures. However, there can be little doubt that the cultures **are** contending.

Clearly what is involved is not a process of evolution by coming together, resulting in the forging of something new and distinct, but the overwhelming of one thing by another. J. R. Jones has called this process 'death by assimilation'.[6] **Whatever the 'other' is, it should be possible to agree that it is not Welsh.** According to Cliff McLucas:

> Like instant food, it is more or less at home anywhere, goes equally well or badly with any other dish, and it fills your belly . . .

> McLuhan spoke of the 'global village' but 20 years on we might prefer the term 'global housing estate'.[7]

How the Arts Council expresses its responsibility in this situation is the crux of the matter. It must recognise that the situation is fundamentally different from that facing ACGB and regional arts associations in England. Then it must decide to which of the contending cultures it is mainly responsible (or perhaps, towards which end of the spectrum in a situation of increasing 'penetration'— the terminology of *Priorities into Practice*—it should incline), and then it must be clear about how to distinguish between them.

3.4

The key to deciding **which culture** lies in understanding **now as part of an unfolding process** (3.2). The indigenous culture increasingly looks the same, sounds the same, has the same economic base and the same political structure as the contending culture. However, the fact that many people in Wales still feel themselves to be, or express a desire to be **distinct,** is the best indicator of the continuing validity of the two-culture view. This sense of identity can only derive from an awareness, however vague or confused, that the cultural process which brings Wales into the present has been a distinct one. Working backwards into this process will undeniably take us onto a track which diverges from that of our neighbour. This paper argues that Arts Council's responsibility is **a**

[6] J.R. Jones, 'I Ti y Perthyn Ei Ollwng', *Ac Onide,* Llandybïe, 1970, p.169.

[7] McLucas was writing in a paper on cultural policy presented by him to the Film and Video Panel of the Arts Council in August 1986 (unpublished). At this time McLucas and I were working at the Barn Centre in Aberystwyth, an independent arts workshop and social centre at which issues of the kind raised in these two papers were of particular concern. The Arts Council refused to core-fund this project, a decision which ultimately led to its demise.

cultural one, and that the culture is the result of **a process.** Surely then, the Arts Council's responsibility must be to that **particular process which belongs to Wales.** Whatever the superficial similarity of the competing cultures **now,** the implication must be that the central responsibility of the Arts Council is to assist in the continued assertion or reassertion of the distinctness of this process for tomorrow. Eric Larabee, quoted extensively in *The Next Steps,* describes this responsibility as:

> to identify conserve or sustain a cultural resource and
> to develop a resource through controlled growth.

3.5
It might be argued that assimilation is a benign phenomenon and no more than the natural outcome of the process of Welsh culture. The argument asserts that, in the end, one identity (and the culture in which it manifests itself) is as good as another, and that the assertion of distinctness is divisive. It then follows that the Arts Council's rōle is to resist divisiveness by speeding the process of assimilation. In Matthew Arnold's infamous words:

> It must always be the desire of a government to render its dominions, as far as possible, homogeneous ... Sooner or later the difference of language between Wales and England will probably be effaced ... an event which is socially and politically so desirable.

This is too large an argument to be dealt with here. However, a simple observation of a state of mind increasingly apparent in England and the United States may be useful. Within the 'other' (3.3) culture there is now surely a consensus that the distinctness of cultures is a positive, beneficial and enriching factor in human life. A fascination with what are now called 'Ethnic Arts' and with political issues of imperialism and the right to self-determination and cultural integrity is apparent to anyone who absorbs the output of newspapers, television and radio. There can be little doubt what the media view would be of the situation in Wales could it be described in terms of an African or an Asian nation. According to Brian Friel, the dramatist:

> ... you've got to produce documents, sounds and images in order to make yourself distinctive ... If there is a sense of decline about how the country is, it's because we can't readily produce these identification marks. [8]

[8] Brian Friel, 'Crisis in the Arts', *Report of the Working Party of the Association of Artists in Ireland.*

3.6

It has been suggested that in practical terms the act of differentiating between the 'two cultures' (*Priorities into Practice* 2.6) is made within the Arts Council in terms of the Welsh language. Further, the language is not used merely as the indication of the presence of another culture, but is regarded in practice as being in itself the indigenous culture. The reason for this is fairly obvious. The language is, to the non-speaker, indisputably **different,** to him or her, perhaps the **only** indisputably different element in Welsh life. This view has, so long as it is not contested, the virtues of simplicity and clarity, and enables the Arts Council apparently to discharge its responsibilities by allocating an identifiable sum of money. Any argument about the two-culture situation then tends to focus on **how much** money, thereby distracting attention from more fundamental questions.

3.7

The relationship between language and culture (that is, to emphasize the point once again, the relationship between language and a way of being) is complex and has the nature of a constant interchange. It is one of the most powerful binding forces in any culture and is structurally involved with the way of being at the most fundamental level. The Royal Commission on the Teaching of English in England expressed this fact clearly:

> We state what appears to us to be an incontrovertible fact, that for English children no form of knowledge can take precedence over knowledge of English, no form of literature can take precedence over English literature and that the two are so inextricably connected as to form the only basis possible for a national education. For English is not only the medium of our thought, it is the very stuff and process of it, the element in which we live and work. It is, in itself, the English mind.[9]

[9] This revealing passage was quoted to great effect by Saunders Lewis in his *Tynged yr Iaith*, 1962.

However, in the presence of a neighbouring and dominant cultural tradition operating in a different language, an indigenous language may become distorted to the extent that it becomes merely a medium for the expression of concepts and relationships which belong to the other culture. Although it remains superficially distinct by having different sounds, the structure (grammar) of the language and the names for concepts and complex ideas may mutate to match the usage of the competitor. In this way the indigenous language may begin to lose contact with the culture to which it historically belongs and ultimately the culture may die whilst its associated language gives the appearance of living on.

This process of change in a language can be a most insidious poison to a culture having to compete with a dominant neighbour, and is one which is often remarked upon as being at work in the Welsh language now, particularly in television and through the increasing number of Welsh speakers who have learned the language as adults.

3.8
Simply investing money in the Welsh language is not therefore a way of guaranteeing the survival of a Welsh culture. On the other hand, **the loss of the language will not be sustainable** if a Welsh culture of substance is to survive and develop. The language is the path which leads back through the process of the culture, *hi yw cof y Cymry,* it is the memory of the Welsh, and memory is the foundation of identity. Further, as underlined by the quotation from the Royal Commission, the language **is** the existence of a people in the sense that it is the existence of their distinctness by means of its structural relationship with their way of being ('mind' in the quotation).

Although it would be grossly simplistic, indeed plain inaccurate, to call the 'other' culture simply 'English', its primary vehicle is certainly the English language. This gives special symbolic importance to the existence and obvious public presence of the Welsh language. It has a fundamental role for the Welsh identity as an oppositional symbol and as such **is available just as much to non-Welsh-speaking people as to Welsh speakers.**

But beyond this symbolic role the important question remains the **health** of the language rather than its formal existence. Its health and the health of the culture it manifests are inextricably mixed. As far as the Arts Council is concerned, a language policy alone is not enough—indeed it might be seen as a let-out. Bilingualism—which in practice means translating everything into Welsh—does not indicate health as much as a guilty conscience. What is required is to create an environment in which a significant proportion of the creative work of the culture (and the internal administrative work of the Arts Council) is made initially through the medium of the Welsh language. If it is not a medium for creativity, it can have no **meaningful** future. The health of the whole culture (and the language a part of the whole) and a desire to ensure its distinctness in the future, are the fundamentally important elements.

4. Visual Tradition

4.1

'Visual art' is a culture-specific term—a concept which arises from and is used within a particular group of cultures and which has no meaning in many other cultures. The way of thinking which it manifests and the range of forms it commonly includes **do not define** the range of possible visual manifestations of ways of being. [10]

This paper has argued that the Arts Council's responsibility is ultimately a cultural one, that is to say, a responsibility to a particular **way of being** [11] which is both identifiable in history and to be made in the future. It should not be assumed—although it usually is—that the models for image making presented by the dominant but not indigenous culture are the appropriate ones for the particular circumstances of Wales. According to *Priorities into Practice*, 2.3:

> Opera, orchestral concerts, mainstream theatre, art galleries, much literary activity, offer long established landmarks in the arts scene in Britain . . .

They may, on the contrary, carry with them the ability to undermine the indigenous culture. The pervasive influence of American television is a constant focus for complaint within England, for instance.

4.2

Even in its most simple form a culture is an interaction of specialisms. In a healthy culture there is present a binding force which holds each specialism in place within the range of specialist activities. This binding force is signified by an equality of balance or exchange between specialisms, the quality of **integration** which any well organism manifests.

Specialisms can, however, become so complex that they acquire the appearance of cultures in themselves with their own linguistic code and history. Image making, in the western cultural group, has acquired this pseudo-culture status.

4.3

Detached specialisms, operating over the range of the western cultural group, can be powerful forces for disintegration within a small culture. For instance, Welsh students interested in making images will receive an art education from school onwards in which Welshness has no role. It will be given at college level either outside Wales, or if it is within Wales, in an institution modelled on the

[10] By which I meant that there are many visual manifestations of ways of being which lie outside its interests—a great deal of visual culture lies outside visual art.

[11] That is, rather than a responsibility to particular art forms.

English pattern. The nature of the institution is both symbolically important and important in terms of what is taught. The instruction will be in English and classes will almost always contain a majority of non-Welsh students. The education may expose those students to what is apparently a wide range of attitudes and philosophies present in western art, but these will all share the underlying assumption, symbolised by the apart structure of the art college itself, that art is an activity carried on in the context of itself. That context owes little to Wales.

The pseudo-culture nature of the specialism is by now such a powerful focus that it frequently acts as the agent which detaches the Welsh student from the matrix of place, language and history which creates what may be called a 'natural identity'. The conflict between this natural identity and identity as an artist can seriously inhibit the flow from the felt way of being into the way of being manifested in the images. Many Welsh people have manifested this duality. Some like Ceri Richards made periodic attempts to join the two (in the Dylan Thomas drawings, for example); others like Ivor Roberts-Jones have kept the two in almost total isolation. Roberts-Jones spoke Welsh as a child, but *Y Ddau Frenin* is his first attempt to confront the question of Welsh imagery. [12] David Jones is, of course, one of the very few who have made the question central to their work.

4.4

Another effect of the dominating presence of the pseudo-culture of visual art is the general perception amongst the public and specialists alike that Wales is deficient in a visual tradition. The non-specialist often expresses the view that 'art has nothing to do with us'. This perception is of fundamental importance in inhibiting the healthy interaction between image making and the rest of the culture. The perception is frequently reinforced by specialists operating from within the pseudo-culture context suggested above, and often compounded by a particular view of Wales. David Bell expressed this notion in this way.

> At no time, since the Norman conquest at any rate, has the Welshman had any visual artistic tradition: [13]

Here, once again, muddled thinking about culture and art manifests itself. A visual tradition is not simply the accumulation of all the art that has gone before, or even of all the objects that have gone before. The tradition is the **story** of those objects, which is a construction made up of the **recognition** and **understanding** of them within a consciousness of Wales as a **particular cultural context.** This construction hardly exists at the moment so that the general

[12] *Y Ddau Frenin*—The Two Kings—is Roberts-Jones's sculpture on the theme of Bendigeidfran at Harlech, recently installed when this paper was written.

[13] *The Artist in Wales,* op. cit.

180

perception that Wales lacks a visual tradition may be said, in strict terms, (bearing in mind that those who commonly say it are very far from strict in their use of the terms) to be correct. **What is not correct, and is very damaging to the cultural development of Wales and to the practice of the specialism, is the assumption that there is no potential for the creation of this tradition.** The material and the context certainly exist: what has been lacking up to now is a particular understanding which will bring these two together and present the results with a profile sufficiently high to change the general perception. [14]

4.5

The making of this case, as against simply stating it, is not possible, of course, in this paper. This may present a real difficulty for the Art Committee in terms of a credibility gap in the argument. Neither is the most recent and most ambitious ever attempt to say something about the visual tradition of Wales, *Art in Wales,* of any help. [15] Indeed, its two volumes indicate the crucial nature of a particular **understanding** in creating a tradition and also serve to show that blindness to **cultural context** can seriously affect **recognition** of the building blocks. The effect is not merely to pervert the interpretation but to preclude important material.

The underlying perception of these books is consistent with that of *Priorities* into *Practice,* that is to say, of Wales as **marginal,** or as a branc of something else:

> We should regard Welsh art as a small but vigorous tributary to the mainstream of modern art.

The writer's view of Wales as being peripheral to something else is compounded by an opinion that:

> Neither is Welsh subject matter as a whole adequate to sustain a separate category [of art].

In addition, overall notions of what is relevant make an unrewarding outcome inevitable:

> We may look for works of art therefore on two counts, as reflecting a skill and as reflecting an aesthetic impulse.

and

> Only the new and most accomplished skills are represented, and hence folk art has been excluded. [16]

[14] This passage, and the incredulity with which it was greeted, was the starting point for my subsequent work in art history and aesthetics.

[15] op.cit. Rowan's *Art in Wales* had been an Art Committee project which doubtless increased the sensitivity of officers to criticism in this paper. It had gone vastly over budget and over time.

[16] These last two comments are taken from the first chapter of the first volume of *Art in Wales*, p.11, and were written by John Ingamells, not Rowan.

Apart from this exclusion of whole categories of relevant material, a substantial list of individual works which would have fitted the narrow range of permitted categories is inexplicably not included, but most important there is no discussion of the relationship between the images presented and the identity of Wales, which is the necessary link in establishing a particular visual tradition. *Art in Wales* is a view from the outside—what is required is a view from within which values what we have because it is ours, not because of how it matches up to international art. 'A poor thing', it might be, according to some peoples ideas, 'but mine own.'[17]

4.6

The relevance of these comments to Art Committee's role in making decisions on funding is that an unquestioned belief that Wales is deficient in a visual tradition will be highly prejudicial in the forming of a cultural policy as a base for those decisions. On the other hand, working from within a perception that an unstated visual tradition does exist, it seems clear that one of the main aims of cultural policy should be to bring out and display this latent resource.

Art Committee might seek to develop the understanding that:

i) It is possible to draw from and develop indigenous forms as a medium for contemporary expression, as the literary tradition facilitates contemporary poetry.
ii) It is possible to develop new forms, and develop new kinds of interaction with the rest of the culture, which will be particular to Wales.
iii) It is possible to draw with care from the dominant international forms, elements which may be appropriate for the expression of a particular identity, as twentieth-century English music has done.
iv) It is possible to find forms within other presently marginalised cultural traditions which may be brought to bear to develop the indigenous tradition, as some contemporary theatre in Wales has sought to do.[18]

5. Conclusions

5.1

The first four sections of this paper have sought to:
i) Define 'Cultural Policy' and argue that it, rather than visual-art funding policy, should be the base for action within Art Committee.

[17] 'A poor virgin, sir, an ill-favoured thing, sir, but mine own.' Shakespeare, *As You Like It*.

[18] I had in mind, in particular, the work of Brith Gof, at that time based in the Barn Centre in Aberystwyth.

182

ii) Analyse present Arts Council policy. This analysis suggested that Council applies a preconception of art to the particular cultural circumstances of Wales with the result that the indigenous culture is regarded as peripheral. In practice this peripheral responsibility is defined by the Welsh language.

iii) Suggest an alternative view that image making is an aspect of culture[19] and that policies should be formulated consistent with that view. The paper suggests that in a situation of contending cultures, the indigenous tradition should be central and that the relationship between culture and language should be more carefully examined.

iv) Look briefly at visual expression of the indigenous culture. The paper suggests that the isolated nature of the specialism as now practised internationally can be a disintegrating factor in Welsh culture, and comments upon the view that Wales lacks a visual tradition.

[19] By which I meant to emphasise, again, that it is not, itself, culture.

5.2
The argument leads to the general conclusion that:

i) Art Committee should formulate a **cultural policy** as the base for its work, and should publicise that policy.

ii) The **culture** in question should be the culture of Wales, flowing from a recognition of its distinct origins and particular contemporary situation.

iii) The **policy** in question should develop from an analysis of the historical origins, growth and present pattern of the culture. An internal structure should be created, services offered and funding directed to facilitate the growth of the culture out of a consciousness of the indigenous tradition, and in opposition, where necessary, to the submersion of that tradition by the competing model.

5.3
The dominance of the competing model over the indigenous tradition in Wales makes it likely that achieving an agreed cultural policy which changes the focus of existing policy will be difficult. This paper might be seen as an introduction to that process of change, but it is intended to be practical and to have an effect on policy. Its final section will therefore indicate some of the ways in which part iii of the general conclusion, 'The Policy', might be effected.

5.4
The Art Department is already active in some appropriate areas of activity. The cultural policy would set the activities within a coherent context of a wider range of activities and provide consistent and well founded criteria for choosing between competing projects. In the past the Art Department has been involved

in a wide range of appropriate activities, but in the last few years the emphasis has shifted from direct funding towards operation through intermediaries. This process has had the effect of drawing more people, both as professionals and as volunteers, into arts administration, which may or may not be a good thing, but it has left the Art Committee increasingly in the position of an intermediate and neutral administrator of funds, primarily responding to applications (except in the case of VADOs) rather than as an active force in the development of the culture. [20]

The Arts Council has a statutory responsibility for the practice and accessibility of the arts. It has been argued that this is a cultural responsibility operating in Wales in a situation of contending cultures. In that situation, to decentralise decision taking to a variety of bodies **who do not have such an overall responsibility** (County Council officers, AADW, the Sculpture Trust [21] etc.) leaves the Art Department decreasingly able to carry out its part of the Arts Council's responsibility. To effect a cultural policy the Art Committee will need to adopt a policy of **intervention rather than devolution.**

In addition, for reasons indicated in 3 and 4 above, it may be that, even in the event of a public statement from Art Committee indicating a shift of emphasis in policy, a flood of applications of a significantly different nature to those received at present (which largely reflect the dominant cultural model) does not materialise. The ideas coming from outside are heavily constrained by the particular cultural circumstances of Wales and by the funding-box system currently operated by the committee. The matter at the core of the argument is consciousness. Carrying out its cultural responsibility in Wales involves Arts Council in seeking to develop and widen that consciousness in order to stimulate the appropriate funding applications.

5.6
Art Committee might:

i) Initiate and fund (either internally or by creating partnerships) **projects** [22] specifically designed to develop the relevant consciousness; **exchanges** of practitioners, work, theoreticians and historians with countries chosen for their relevance to our situation; **public works** in celebration of the indigenous tradition; **exhibitions, conferences** and **publications** which ensure the appropriate balance within the overall context of these activities generated from non-Arts Council sources.

ii) Involve itself in school and college education by **seeking to persuade** the WJEC, and art departments in colleges and the University of Wales to provide curricula in which the indigenous tradition is explored and to

[20] This is a tendency which has continued to dominate policy, resulting in an ever lower profile and a decreasing awareness amongst the public of the purpose of the Arts Council. VADOs were Visual Art Development Officers. The Art Committee had pressed county councils to appoint such officers by advancing funding on the basis of a gradual withdrawal of support over a specified number of years.

[21] The Association of Artists and Designers in Wales. The Sculpture Trust subsequently became Cywaith Cymru/Artworks Wales and is now a substantial client fulfilling a number of tasks, including project supervision, formerly carried out by the Arts Council itself.

[22] Here I footnoted as an example of intervention a Welsh-language community arts project in Cribyn, Ceredigion, instigated by West Wales Regional Arts Association and carried out by Gweled. The project was a response to activity through the medium of English by The Pioneers community arts group in Welsh-speaking areas which was felt to be reinforcing perceptions of visual culture as an English phenomenon.

persuade at least one department to offer a practical and art history degree course through the medium of Welsh.[23] Art Committee might assist in this process by promoting, in association with others, the **writing of appropriate course material** in both languages.

iii) Establish criteria for decision taking about grants to organisations and individuals. These criteria should include (the precise emphasis and wording depending on the particular grant applied for) a **consciousness of issues** within Wales and a **commitment to working** in that context. For instance, in the case of a travel grant one of the criteria should be the ability and desire to inform people in other countries about the particular history and cultural circumstances of Wales.

iv) Operate the Council's notional language policy, that is, to ensure the ability exists within the department to communicate **directly** with clients in Welsh. More important, to train officers and to appoint officers as the opportunity arises who are able, and who desire, to work creatively to develop policy and projects through the medium of Welsh.

v) Require public institutions (chiefly galleries) in receipt of grant aid to operate a language policy giving Welsh an equal status to English as a condition of continued support.

vi) Reconsider the way in which committee members are selected **to ensure continuity in policy.** Two places on the committee might be filled every year by inviting applications in the press. Appointments would be made after interview on the basis of fundamental commitment to the cultural policy and the ability to work creatively to develop it.

vii) Seek to increase the level of communication at committee member level, as well as at officer level, between specialist areas and seek to initiate joint projects. Council should be pressed to **combine the art and craft departments** into a single new department. The isolation and division between specialisms is not conducive to development in the cultural circumstances of Wales.

viii) Seek to influence Council to campaign for status **independent of ACGB** with direct funding from the Welsh Office. This would be an important psychological step towards changing consciousness internally, an important symbol for those outside the institution, and would remove an unnecessary level of art administration.[24]

ix) Seek to influence Council to develop and publish an overall **cultural policy** as a base for decision taking and for reviewing the whole structure of art funding in Wales (the Arts Council and the Regional Arts Associations, the internal division of the institution, its location and so on).[25]

[23] The rejection of this suggestion was particularly unfortunate. We are still in the position where no such course exists. It is worth noting that it was first suggested by R.J. Derfel in 1864, op.cit.

[24] This proposal was rejected specifically and emphatically in the Art Director's response. It was implemented in 1993.

[25] The structure is now (1993) in the process of fundamental change. However, there is still no published cultural policy to inform those changes.

A street in the West Quarter of Exeter, photograph by Peter Lord, c.1965.

THE BELLS OF LÜBECK

I was born just after the war. In the interests of clarity I should say that I mean the Second World War, as it's now over half a century since it began. It remains *the* war to me, a measure of how much I was formed by it, even though I didn't live through it. In fact, the further it recedes into the past, the more I become aware of how much my attitudes were shaped by it. My father was a soldier, and his father had been a soldier as well—a professional soldier, I mean, not a conscript, and an ordinary soldier, not an officer. So my father was born in Egypt and grew up in India, though he swears he never heard the word 'Raj' till they started making television programmes about it. My moral education in this background in the 1950s consisted almost entirely of a list of don'ts, can'ts and mustn'ts. The army short back and sides to which I was condemned on a fortnightly basis seemed to encapsulate for my father all moral rectitude and the virtues of discipline and order which had made Britain great. Life ever since has been a struggle to replace obedience with imagination and fear with confidence, and trying to keep the lid on a deep abhorrence of institutionalised authority of any sort.

Outside the framework of my family the earliest things I remember are also to do with the war—prefabs and bomb sites. The bombs had fallen eight or nine years before the things I remember, and I know now that the huge damage they did had been compounded by the demolition of most of what had survived. The Georgian brick facades left standing free of their burnt interiors were knocked down. My new town was planned by Thomas Sharp, who had already had a go at Coventry. He published his plans in a book called *Exeter Phoenix*, of which my father had a copy. It had many pictures of the bomb sites—which perhaps I remember as much as I remember the places themselves. It was an inspiring book. It awakened in me the excitement of making on a grand scale, a young person's modernism, but all in celebration of the story of a place with which I identified totally. No other place had much reality for me. I regret to say that Sharp's ability to realise his fine aspirations for the particularity of the place was inadequate.

Part of the inspirational effect of Sharp's book came through the quality of the object itself—it was beautifully and inventively designed, emanating from an arty intellectual culture of which it was my first experience. It was one of only two real books that I remember from my childhood, although I did have

This essay was published in *Planet*, 96, December/January, 1992/3.

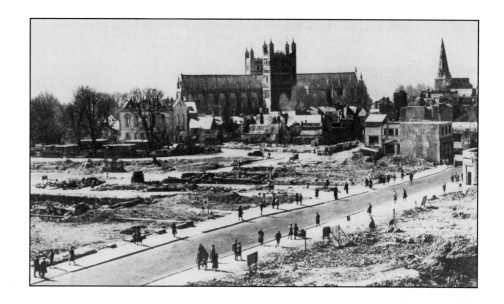

The centre of Exeter after the bombing of 1942, by an unknown photographer, c.1944.

Thomas the Tank Engine as well—it would be wrong to give you the impression of a childhood totally devoid of imaginative stimulus. I'm pleased to say, though, that my deprivation did extend to that wimpy middle class *Wind in the Willows* stuff. The other book that I realise had a great effect on me, also reached me through its mystery as an object—I read only a bit of it. It was large, black, and printed on soft thin paper in about 1943, with many surreal looking touched-up half-tone press photographs of people in long coats I'd never heard of. Its first line went like this: 'It has turned out fortunate for me that destiny appointed Braunau-on-the-Inn to be my birthplace.' I don't have to refer to *Mein Kampf* to check that quotation, because it is one of the very few lines of anything that are so deeply embedded on the mysterious continuity of my memory that I expect to remember them until I die. Its epic resonance excited me by the potential it suggested was in all of us to change the world. The other quotation I shall carry with me till I die says: 'We have chosen as targets the most beautiful places in England. Exeter was a jewel. We have destroyed it.'

 These were the words broadcast from Germany on May 4th, 1942, learned from frequent re-reading of Sharp's book, and they had indeed destroyed it, or much of the middle of it, which takes me back to the bomb sites and to the wonderful smell of buddleia in flower, the most beautiful and evocative smell, always associated for me with still summer air and the places of the greatest

desolation. This association of beauty and ruination—beauty and the evidence of the past, split open and therefore vivid like no tidied-up monument ever can be—indulged my romantic inclination to history in a very particular context. This was not the large history of the book of kings and queens, which never meant anything to me, but tangible history, a relationship between me, my people and my place. The angular branches of buddleia stuck out from the broken brick and red stone walls.

The love I felt for all this was trampled on in the 1960s when, in a second wave of destruction, much of what had survived was pulled down to make way for the nasty buildings and desolating road schemes of the period. I was deeply hurt, but it was a most important experience, like the failure of first love always is. It sensitised me to the importance, indeed the sanctity of continuity—and to the power of money. My first experience of the politics of culture was trying to excite uncomprehending contemporaries in school about the sacrilege being committed. I photographed the desolation and wrote my first article and sent it to the local newspaper. They didn't publish it, but a couple of weeks later an editorial appeared which pinched most of it, word for word.

The German wireless's words in 1942 resonated for years afterwards with all these memories and the love I had for that place. They became for me an absolute point of reference standing outside time, their meaning was poetic not factual. They had no history or prelude as presented in my childhood gospels, and no consequence either. I never felt hurt by that first desolation, or angry, and I suspect that the difference in my feelings about the first desolation as compared to the second was not simply a result of my tangible relation to the second compared to my imaginative relation to the first. The two texts never seemed to me to be in conflict, or even related to each other except in their complementary ability to move me. The destruction of the war had a quality associated with the heroic scale of the forces involved, and the sense of destiny, however misguided and evil, which inspired me in the opening lines of *Mein Kampf*. The destruction of the 1960s was, like the previous tacky decade which matured the self-satisfied aldermen and small-minded councillors who connived in it, carried on not for the sake of a vision but for a grubby profit and their self-aggrandisement. So although I hated my own people with great intensity and anger, it never occured to me to dislike Germans.

My father's furthest flung experience of the war was in Hamburg. It was flattened when he got there and when he described it to me, I saw it in terms of Exeter. Two years ago I went to Hamburg for the first time, and found a continuing historical parallel in a city whose visual mediocrity is only a little surpassed by that of Exeter in the 1960s. This was not entirely a negative

experience—a contradictory part of me responds to the community of ordinariness. I felt pleased to be European. But the ordinariness of the surface fabric was penetrated one day, releasing a rush of emotion about something not ordinary at all. I was riding in a bus down a wide, innocuous and crowded new street when I saw a very large concrete building to one side but standing out of line with the rest. It had no windows and was covered with murals of the rainbows, blue sky and puffy white cloud variety. I pointed and asked my friend what it was. 'Air raid shelter', she said disinterestedly. I cried— inconspicuously I hope. I think it was the most complex and deeply rooted experience of an image I ever had. I felt grief and distress and guilt, and incomprehension about how we could ever have done that to each other. But most of all I felt great love for, and community with the anonymous people on the bus around me. I am involved with these people and this place—we share much more than our ordinariness—the continuities of our distinctness are entwined.

More recently I went to Lübeck, to look at the brick churches. This was a confusing experience for someone brought up to associate brick with modernity

and stone with age. The churches looked as if they could have been put up last week, so strong was my symbolic sense of material and so weak my sense of style. Many of the churches are six-hundred years old. When I got to Lübeck I discovered that, like Exeter, it had been bombed in 1942. Most of the churches and much of the town had burned, although looking around it was hard to believe. The facades of the buildings left standing in 1942 were not demolished but restored, and the 1960s seemed not to have happened at all. Inside the churches the destruction was more apparent. A great deal of seventeenth- and eighteenth-century encrustation was burnt or blasted away leaving only fragments. However, in the restoration, medieval paintings were uncovered, and now, in place of baroque ornamentation, there are white-painted brick walls interrupted by fragments of painted panels and sculpture, purified by fire. Like bomb sites, these fragmented images have a greater power now than in the completeness their makers intended, to evoke an affirmation of the importance of cultural continuity. As the Marienkirche burned the bells fell from the tower to the stone floor. They remain where they fell, split open and embedded in the paving. The roof was rebuilt over them, and the bare brick walls painted white, but beyond this simple frame the picture was made without artifice, recognised not constructed. This image of the sanctity of continuity released the same rush of emotion that I had felt in Hamburg. Its potency was an aspect of its dignity, and dignity is the great characteristic of the rebuilding of all the churches of Lübeck. I have to say that it is not a characteristic I recall in much of the rebuilding of England.

A few weeks ago I visited Exeter and found an exhibition in one of the museums about the Blitz. The exhibition was packed with people on a Saturday morning looking at period-flavour Anderson shelters, ration books and gas masks. I was drawn to a group of documentary photographs of the bomb sites, many of them familiar even at a glance from a distance from Thomas Sharp's inspirational book. I went to the first image, taken from the air the morning after the raid, with the roofless buildings still smoking. The caption came as a shock. It went something like this: 'Lübeck, 1942. Exeter was bombed in May, 1942, as a reprisal for the allied attack on the medieval town of Lübeck in north Germany. Lübeck was of no strategic importance.'

ACKNOWLEDGEMENTS

Illustrations are reproduced by courtesy of the National Library of Wales, with the exception of the following:

The Ashmolean Museum, Oxford, 155
The Lady Lever Art Gallery, Port Sunlight, 36
The National Museum of Wales, Cardiff, 36, 100, 106, 116, 120, 122, 134, 137
The Royal Collection, Windsor, 152
The Welsh Folk Museum, Saint Fagans, 80, 87, 89

Cwmni Sain, Llandwrog, 39
Cymdeithas Hanes y Methodistiaid, 74
English Heritage, 106
Gwynedd Archives, Caernarfon, 13
The United Theological College, Aberystwyth, 68, 76

Branwen Nicholas, 133
Martin Roberts, 122
David Thomas, 143

Private collections, 55, 72, 82, 89, 106, 110, 140, 144, 167